captureventuracounty ™

★ Presented by VenturaCountyStar.com

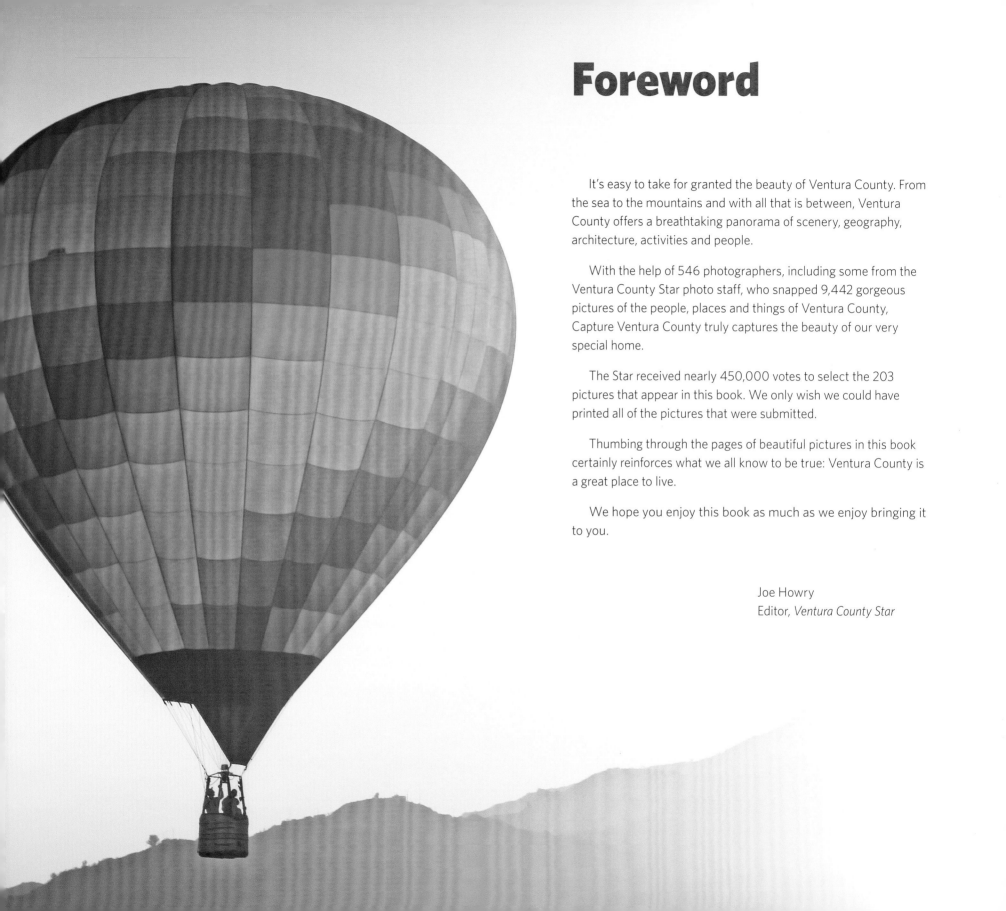

Foreword

It's easy to take for granted the beauty of Ventura County. From the sea to the mountains and with all that is between, Ventura County offers a breathtaking panorama of scenery, geography, architecture, activities and people.

With the help of 546 photographers, including some from the Ventura County Star photo staff, who snapped 9,442 gorgeous pictures of the people, places and things of Ventura County, Capture Ventura County truly captures the beauty of our very special home.

The Star received nearly 450,000 votes to select the 203 pictures that appear in this book. We only wish we could have printed all of the pictures that were submitted.

Thumbing through the pages of beautiful pictures in this book certainly reinforces what we all know to be true: Ventura County is a great place to live.

We hope you enjoy this book as much as we enjoy bringing it to you.

Joe Howry
Editor, *Ventura County Star*

Table of Contents

About this book.

Capture Ventura County is the most unique book project ever conceived. It started with a simple idea: lots of folks take lots of pictures of Ventura County, many of which would be worthy of publishing in a fine-art, coffee-table book. Knowing that thousands of photos would be submitted, the question was then posed: how do we pick the best from the rest? The answer was genius. We put the editing power in the hands of the people. Local people. People who know Ventura County. People just like you. Through an immersive online experience, we asked photographers, doctors, union workers, musicians, moms, right-handed people, pants-wearing folks, or anyone from any walk of life to vote for what they considered to be the photos that best capture Ventura County. From nearly 10,000 photo submissions for the pages of this book, almost a half a million votes helped shape what you hold in your hands. It's something that's never been done before: publishing by vote. Enjoy it.

 VenturaCountyStar.com

How to use this book.

Open. Look at the best pictures you've ever seen. Repeat. Actually, maybe there's a little more to it. First, be sure to check out the prize winners in the back of the book (also marked with ★ throughout). You'll also want to watch the DVD. It's got more than a thousand photos on it! Here's the caption style so you can be sure to understand what's going on in each photo:

PHOTO TITLE *(location on page):* Caption, mostly verbatim as submitted. 📷 PHOTOGRAPHER

Copyright info.

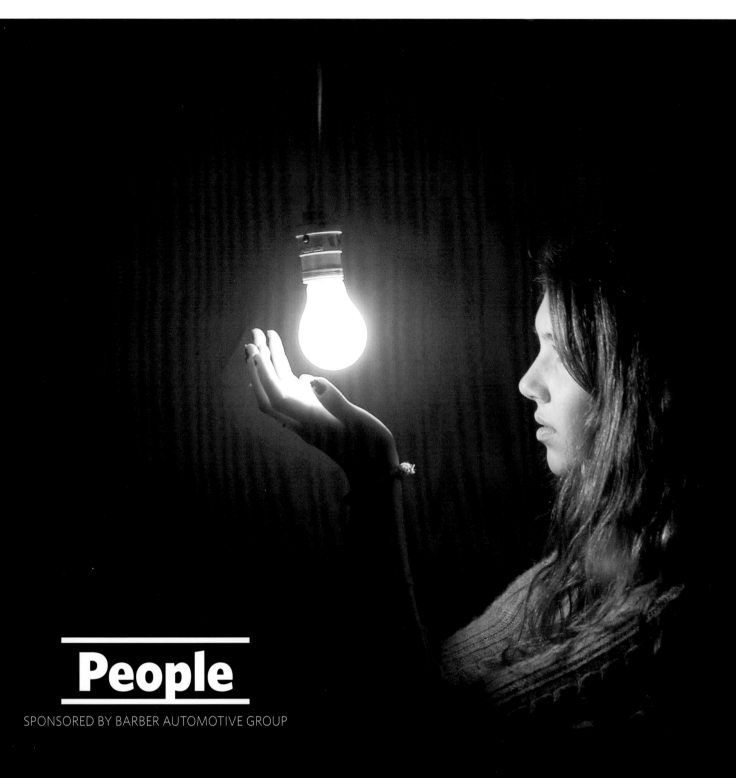

People

SPONSORED BY BARBER AUTOMOTIVE GROUP

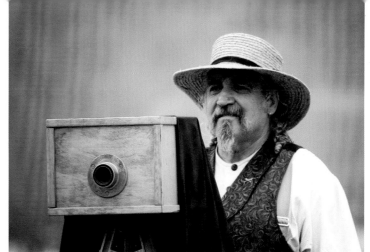

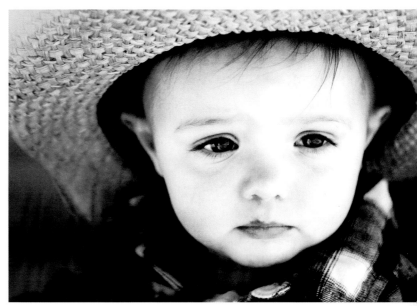

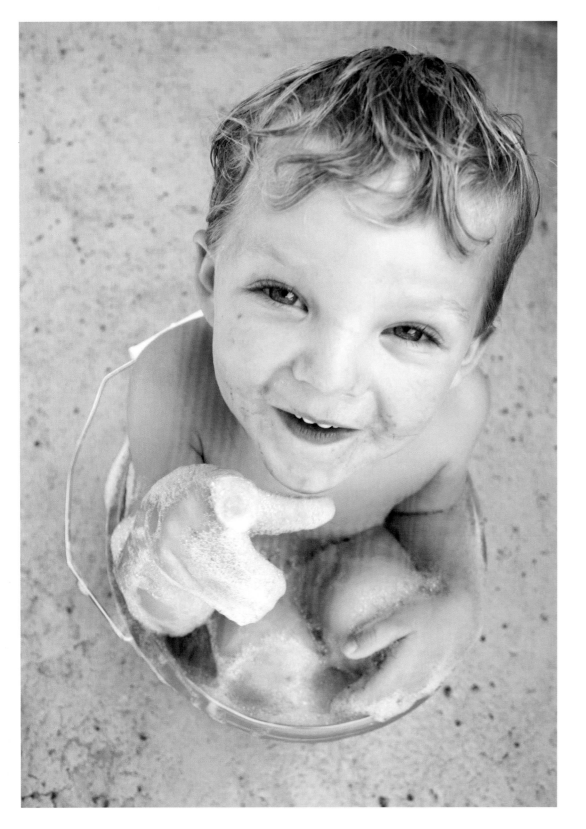

A COWBOY IN THE MAKING. *(above):* Everett Fritz, contemplating his future as a cowboy. 📷 STACI HENDERSHOT

PHOTOGRAPHER IN THE FIELD *(top):* Capturing it all. 📷 JEAN CASTAING

BOY IN BUCKET *(left):* My son, happily playing in a bucket of suds! 📷 ROB HERR

UNTITLED *(opposite):* I was experimenting with using a light bulb in my photos. 📷 LYNDY SCOFIELD

★ **WAITING FOR ICE CREAM** *(following left):* At Foster's waiting for Daddy to bring him a nice big bowl of vanilla ice cream. His reflection seen in the sleek, stainless steel table provides for that double cuteness overload effect! 📷 KRISTEN CALDWELL

SWEET GIRL *(following right):* Playing at the beach. 📷 WHITNEY HARTMANN

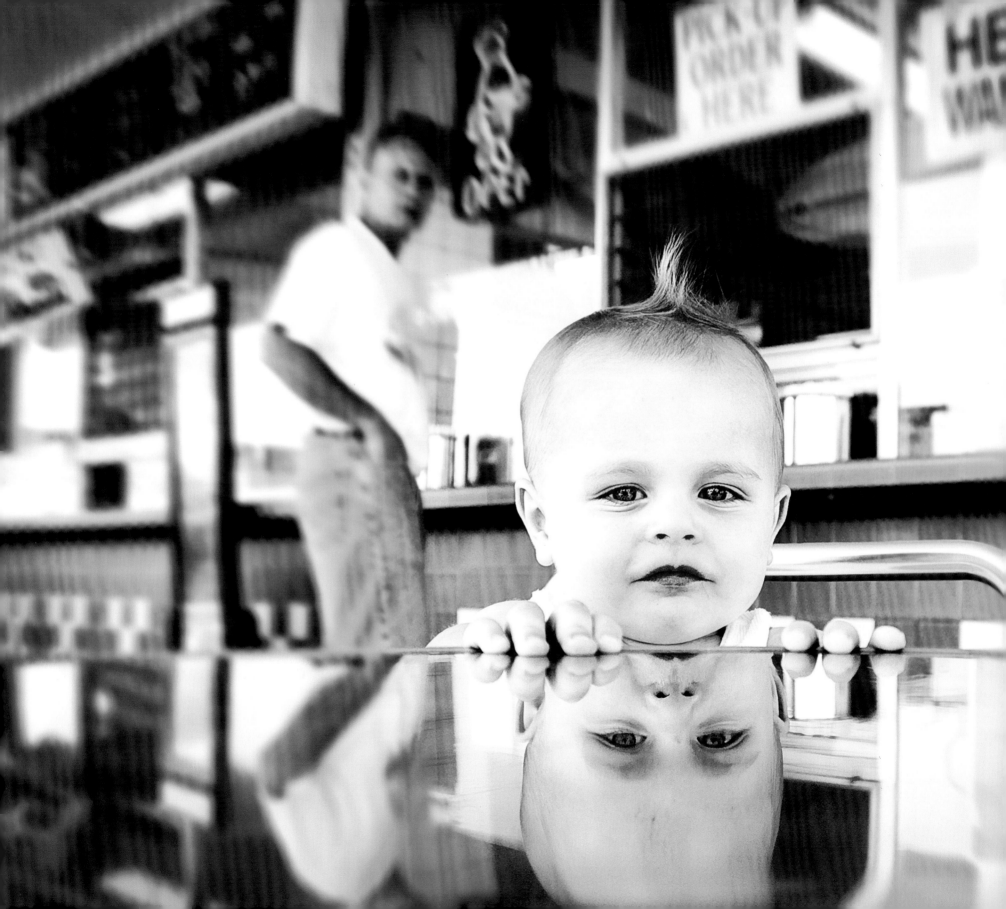

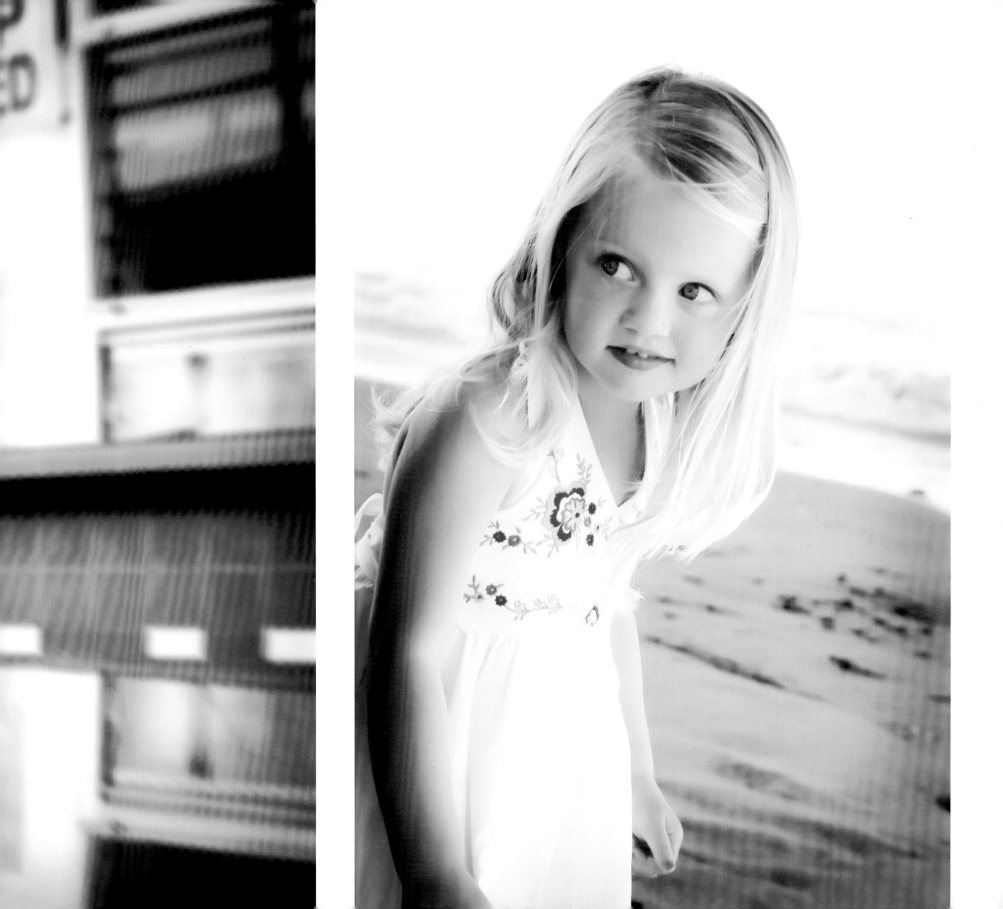

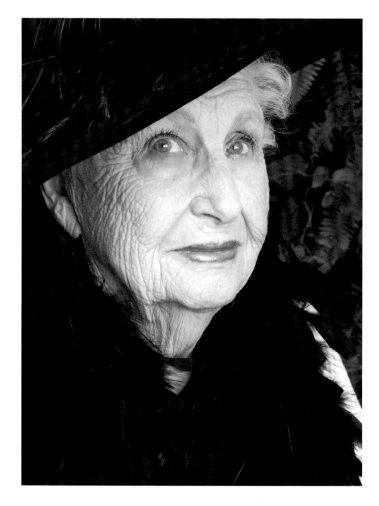

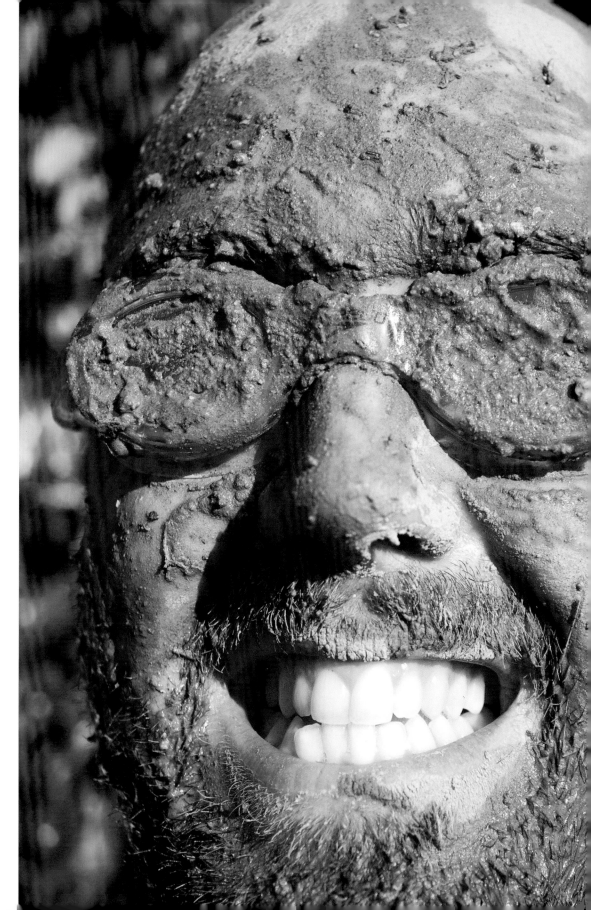

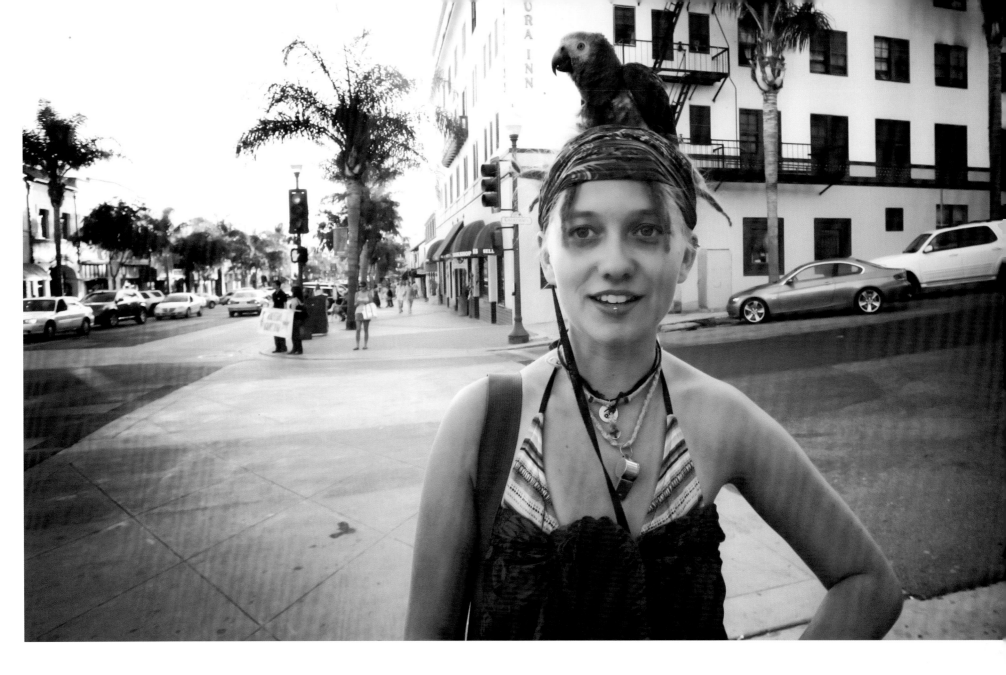

BIRD GIRL (*above*): Just another one of downtown Ventura's locals with her feathered friend at the corner of Main and California streets. 📷 THOMAS GAPEN

IF ONLY HE COULD DRIVE IT (*opposite top*): Every kid should have a T-bird. 📷 DANIELA FAILLA

PORTRAIT OF A 90-YEAR-OLD (*opposite bottom*): This is Charlene Griggs, a longtime Ventura resident. She remembers the year it snowed at the beach and when Ventura High School was an ivy-covered brick building. 📷 ANITA GRIGGS

MUD PLAY (*opposite right*): Dirty from mud! 📷 JACLYN SMITH

SLEEPING BEAUTY (*following top*): My daughter was three weeks old here and the most precious thing I could hold in my hand. She is bigger now, but is just as precious as ever. 📷 JOSH GRANT

TAKE TIME TO SMELL THE FLOWERS (*following bottom*): Take time to smell the flowers. 📷 JODI LUKER

FIRST SNOW (*following right*): I still see this same wonder and joy in my boy whenever it snows. He asks about it all year long, just waiting for the sky to fall. 📷 JOSH GRANT

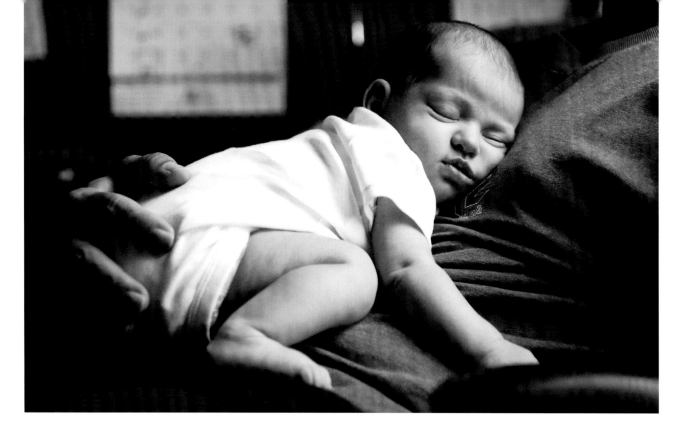
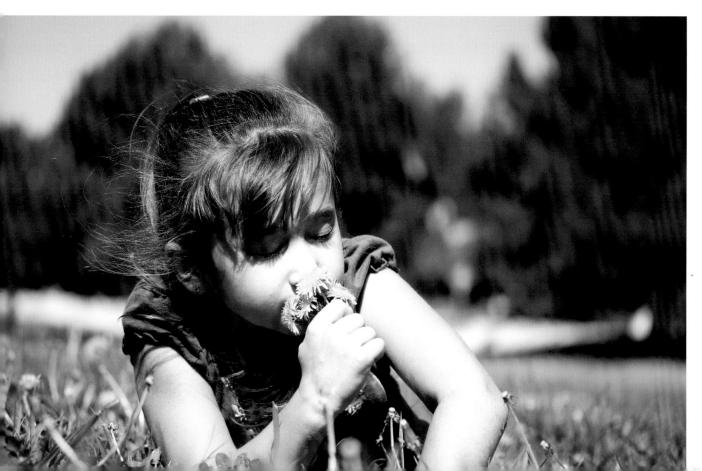

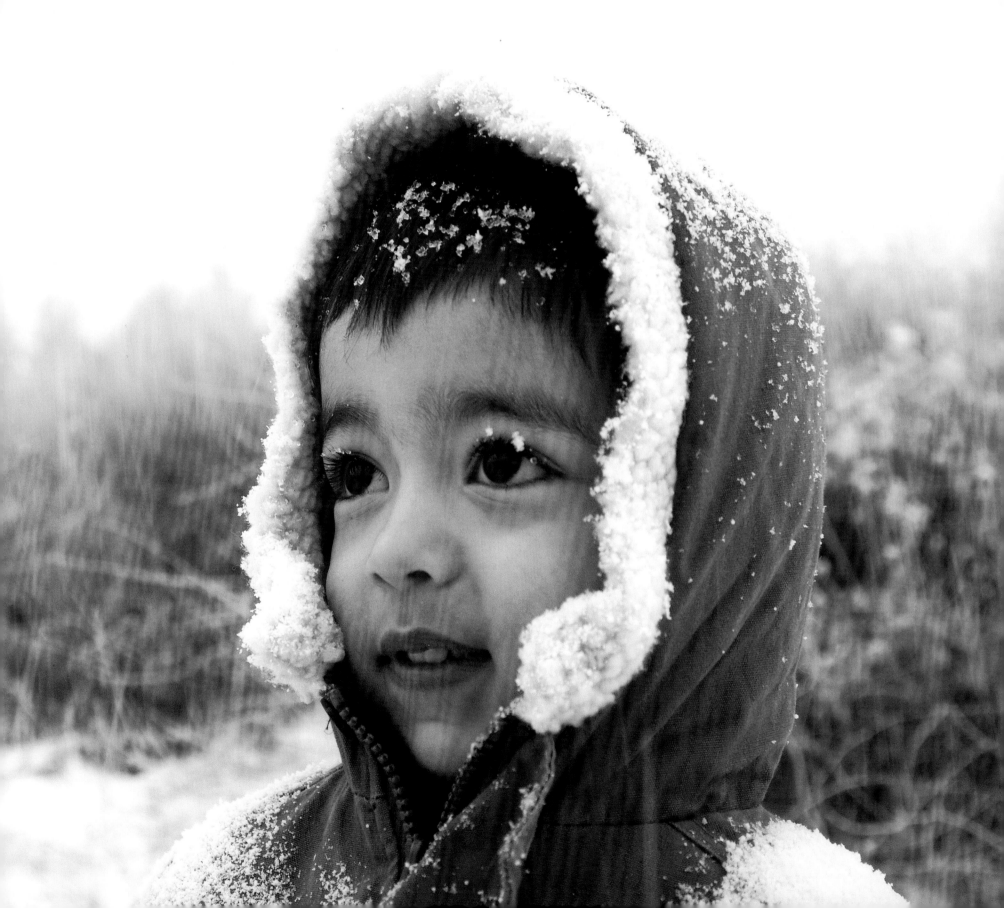

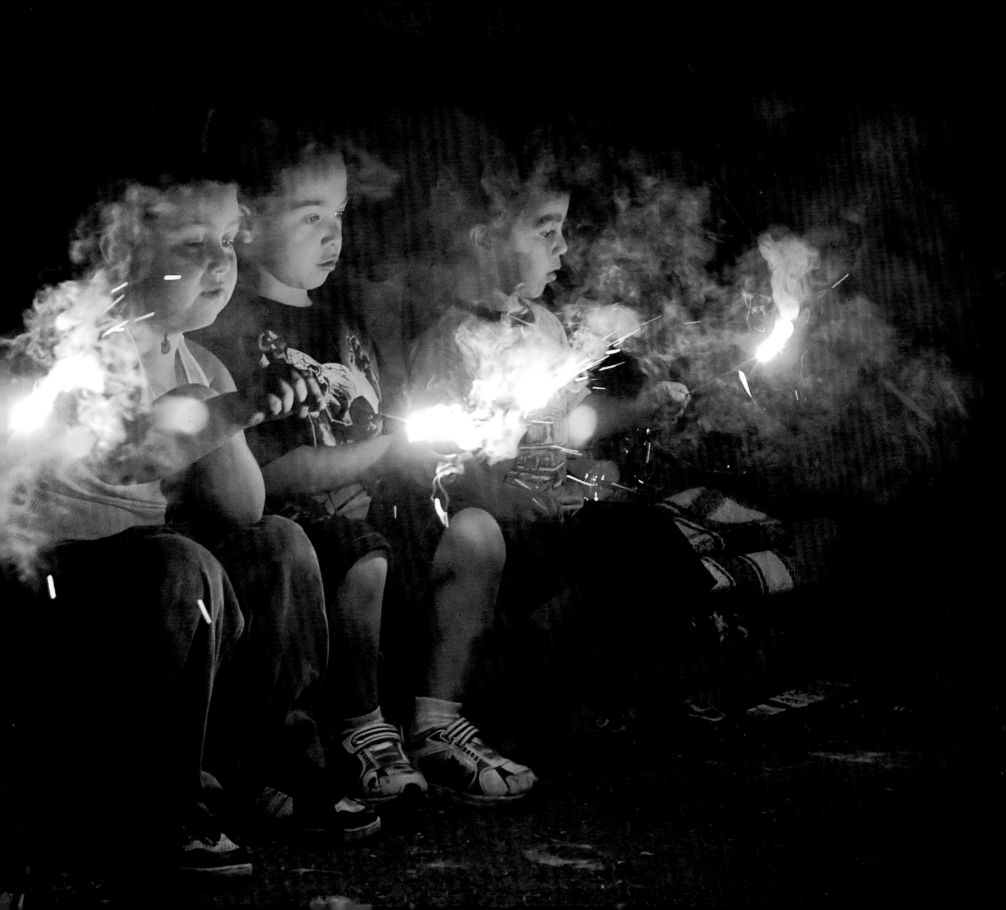

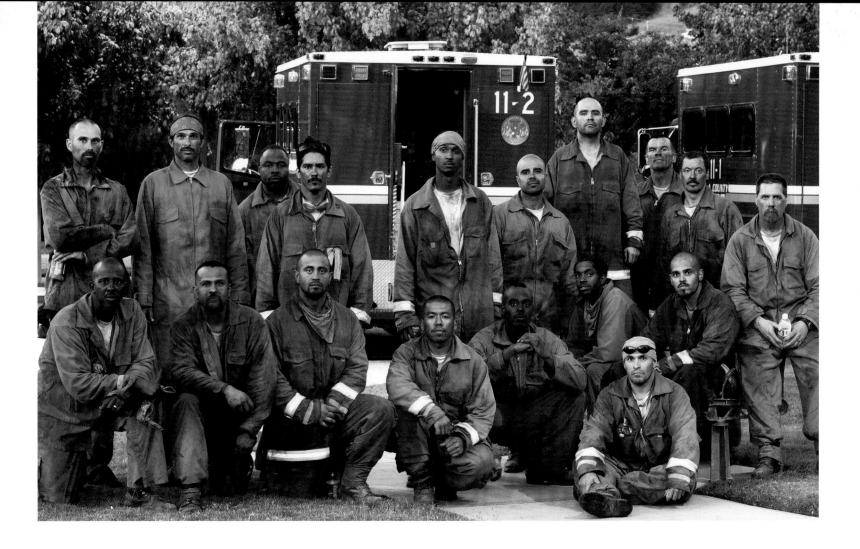

UNITED! (*above*): Captured in early evening, this photograph portrays a diverse mix of men who unite and work together as one. These men work all day long to help keep our county safe. This photo was taken during a wildfire in Calabasas in August of 2008. This group of brave, hardworking men end their day looking as if they have exited a coal mine. I tip my hat to these men for their bravery and hard work.
📷 THOMAS WOTKYNS

★ **FASCINATION WITH FIREWORKS** (*left*): Children enjoying sparklers and fireworks in Fillmore on the Fourth of July, 2008. 📷 JULI CROMER

TAKING IN THE VIEW (*right*): Two men at the top of Mount Allen observing the great view. 📷 RANDY ROBERTSON

★ **MARINA PARK** (*following left*): Great backdrop. This is the ship at Marina Park. 📷 WHITNEY HARTMANN

NICK (*following right*): Nick in the fields with the oldest cell phone around.
📷 ANDREW UVARI

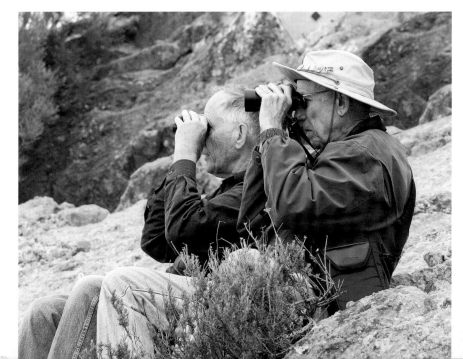

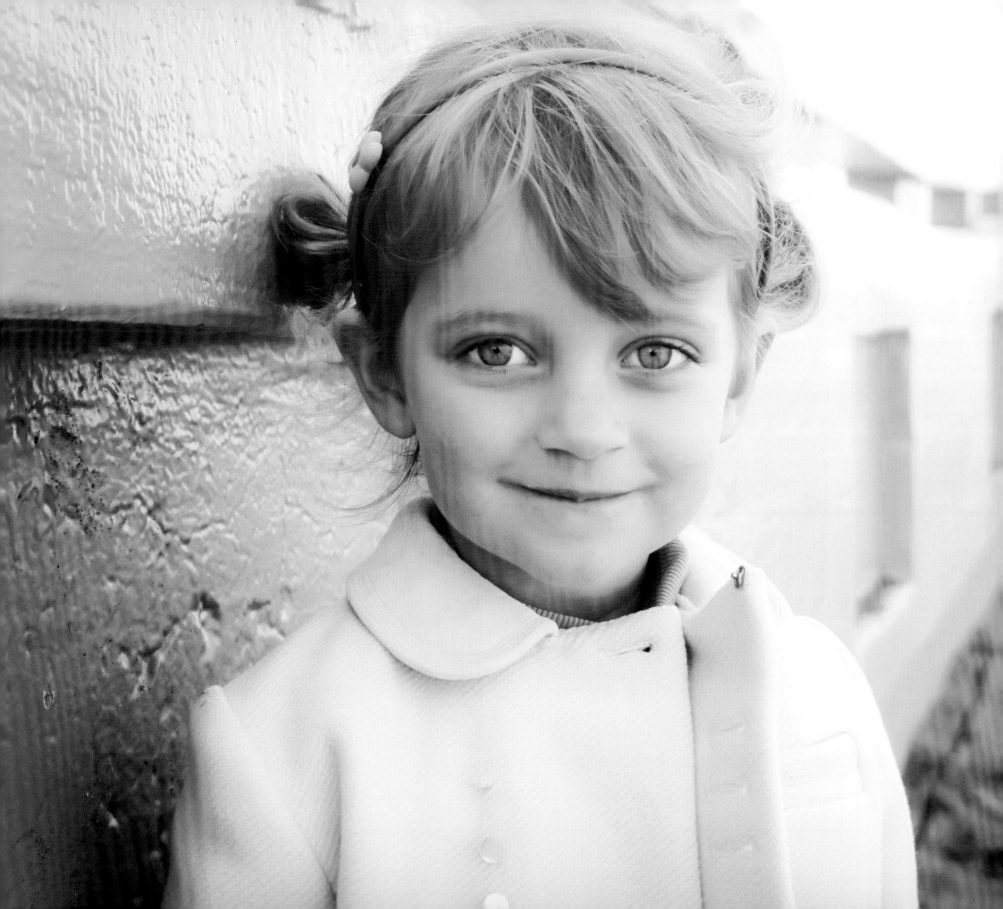

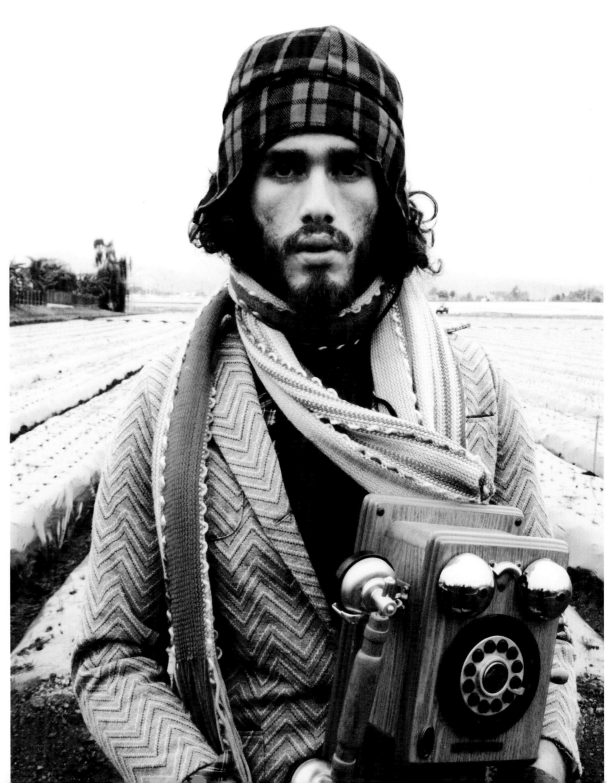

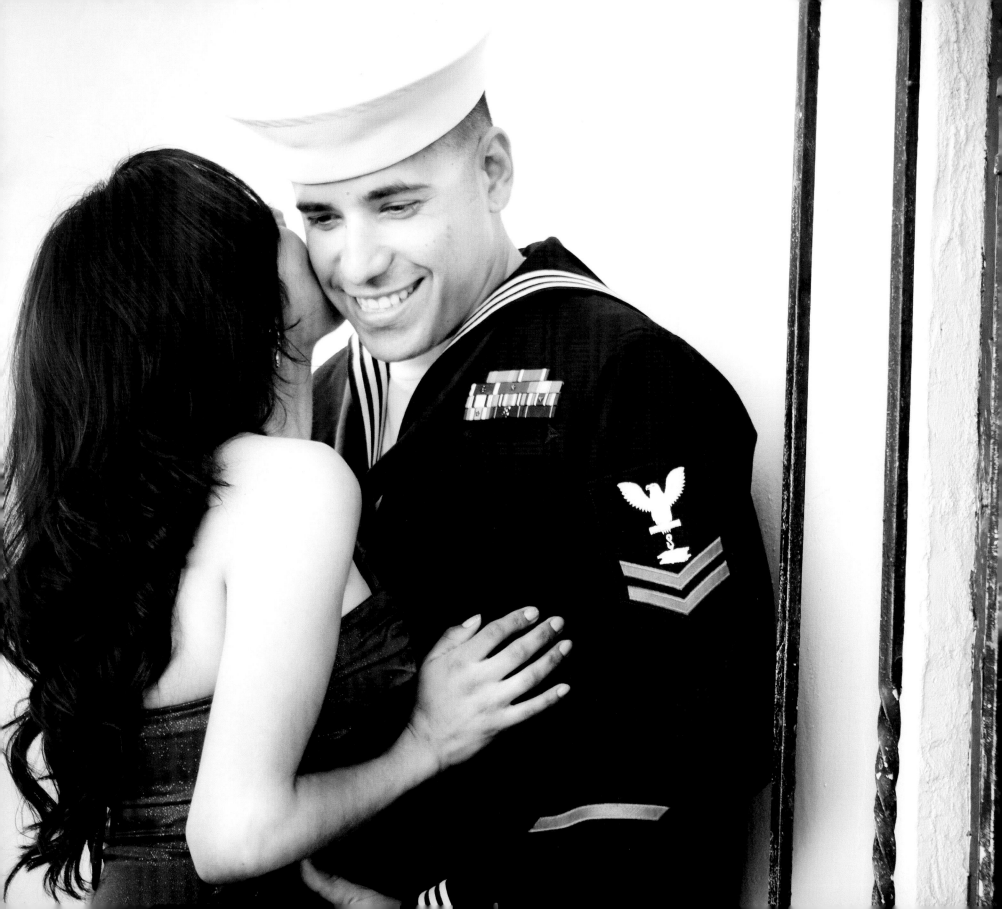

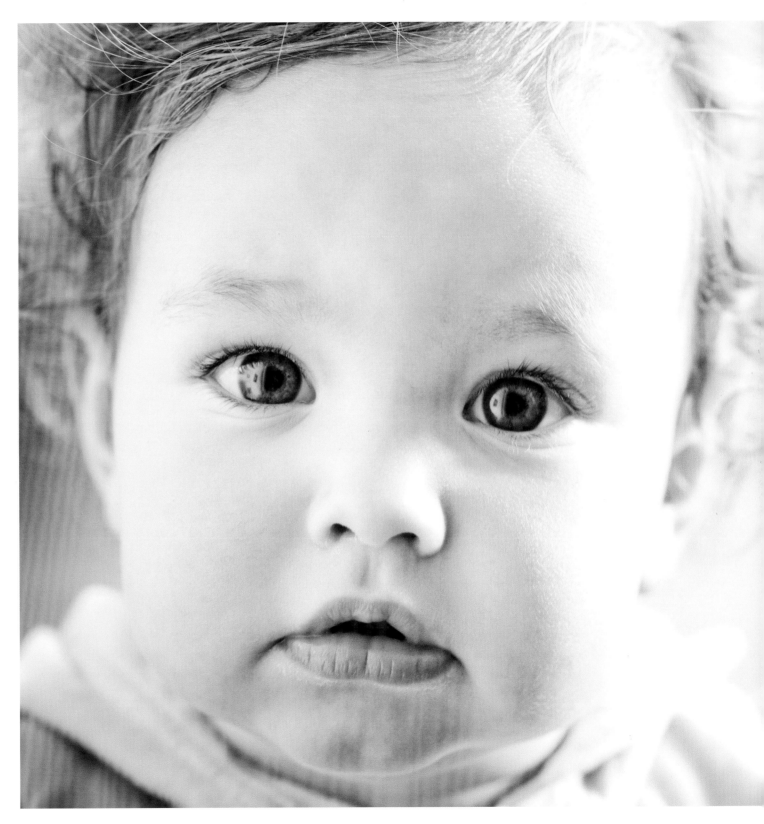

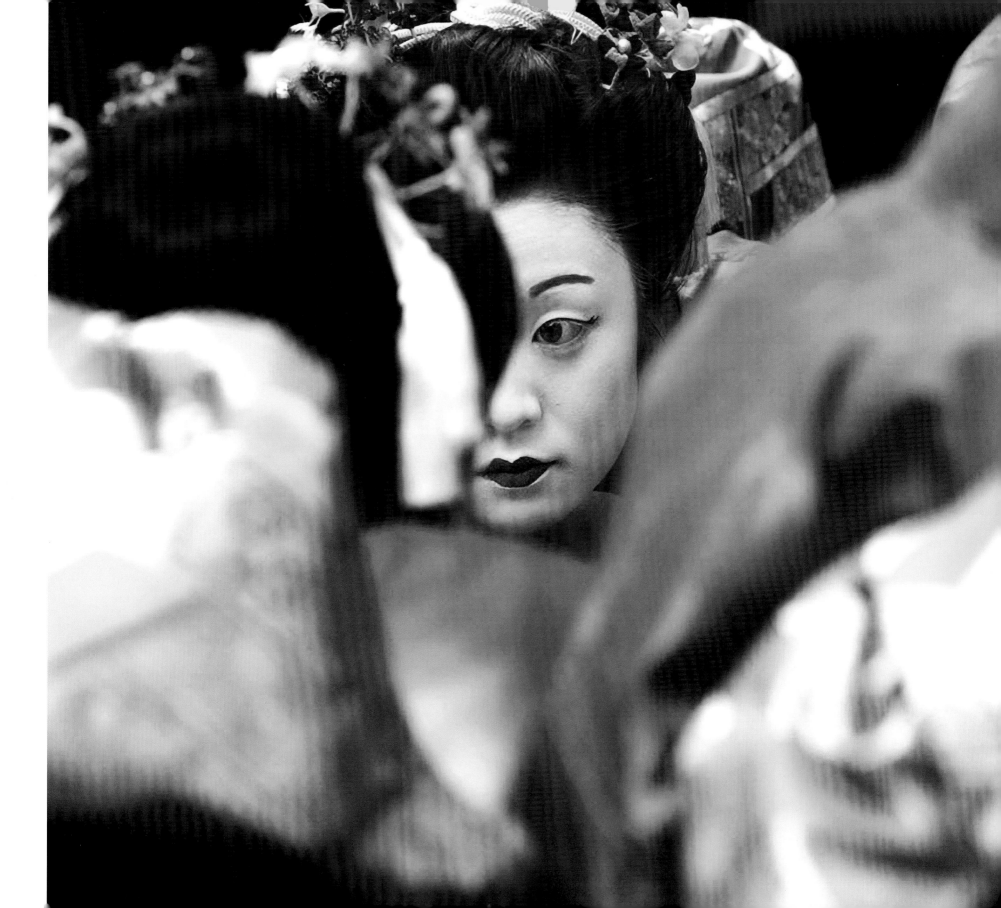

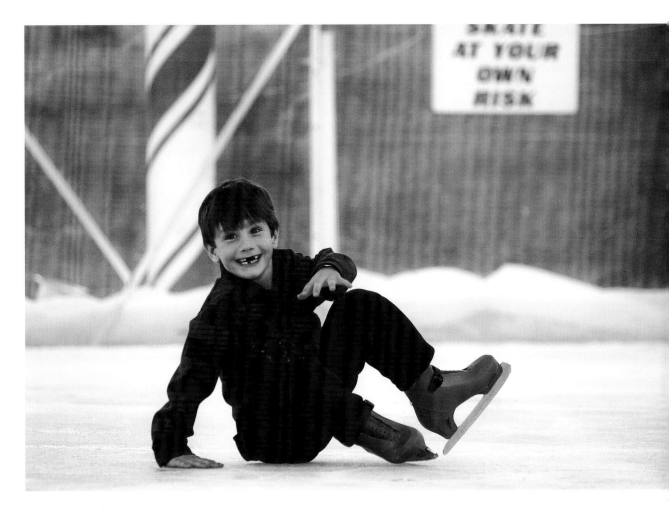

UNTITLED *(above):* Five-year-old Westlake resident Oliver Misiroglu finds fun on the ice at The Lakes Shopping Center outdoor ice-skating rink in Thousand Oaks. 📷 DAVID YAMAMOTO

PREPARATIONS *(left):* Carly Tanaka, 16, Camarillo checks the mirror while getting ready for An Afternoon of Classical Japanese Dance, a performance at Thousand Oaks High School. 📷 JAMES GLOVER II/VENTURA COUNTY STAR

NAVY SECRETS ON MAIN ST. *(previous left):* A Navy Seabee and his love, sharing a moment on Main Street, Ventura. 📷 STACI HENDERSHOT

HARPER CARLSON *(previous right):* My niece, Harper, poses for a head shot. 📷 AMERY CARLSON

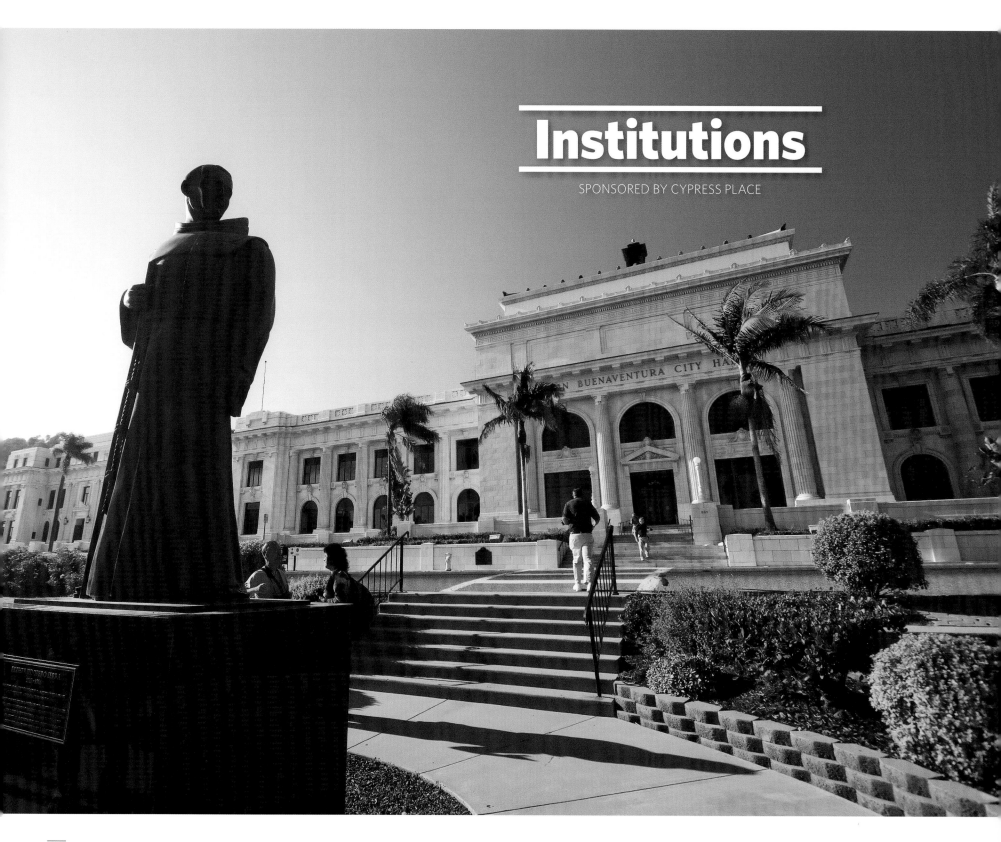

Institutions

SPONSORED BY CYPRESS PLACE

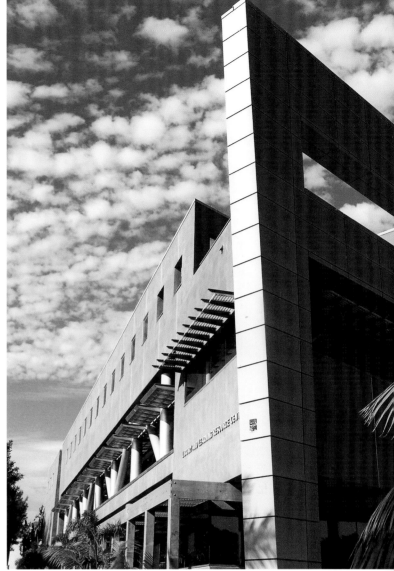

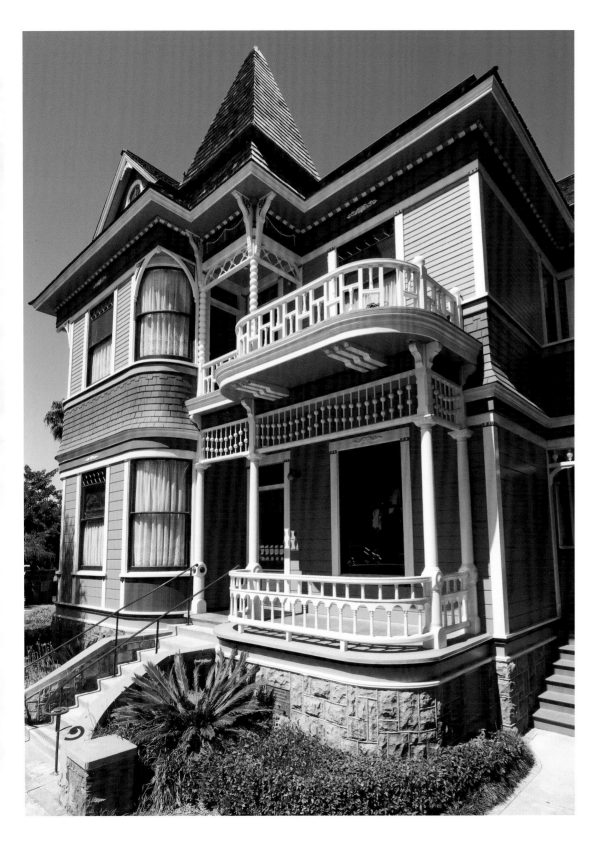

LEARNING WITH A VIEW *(above):* Ventura College's newest building, the Library & Learning Resource Center, is beautifully designed both inside and out. 📷 SUZY G

HERITAGE SQUARE PETIT HOUSE *(left):* The beautifully restored 1896 Justin Petit Ranch House is an outstanding example of Queen Anne architecture. Designed by architect Herman Anlauf, this residence was the first farmhouse in Ventura County to be electrified. 📷 STEPHEN SCHAFER

VENTURA CITY HALL *(opposite):* A statue of Father Junipero Serra looks on as photographers gathered in front of Ventura City Hall as the starting point for a Ventura photowalk, a social photography outing, that took place as part of a world wide event held in various locations around the globe on Aug. 23, 2008. 📷 EILEEN DESCALLAR

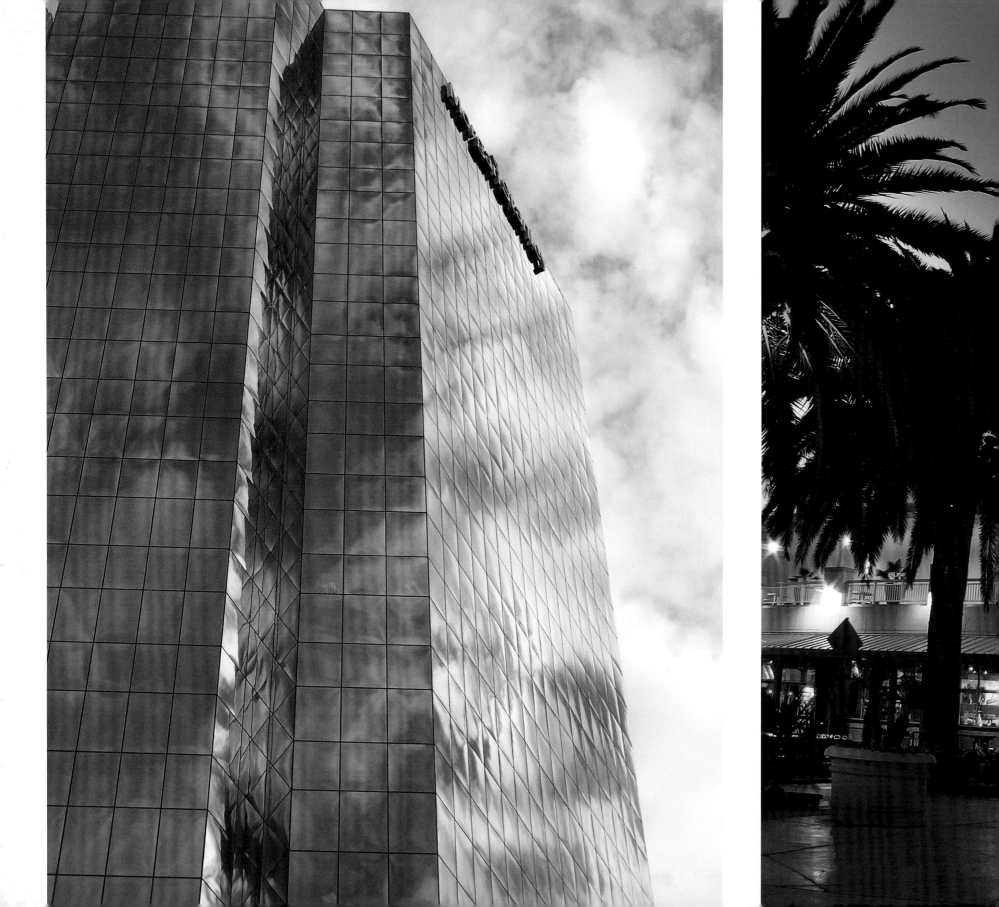

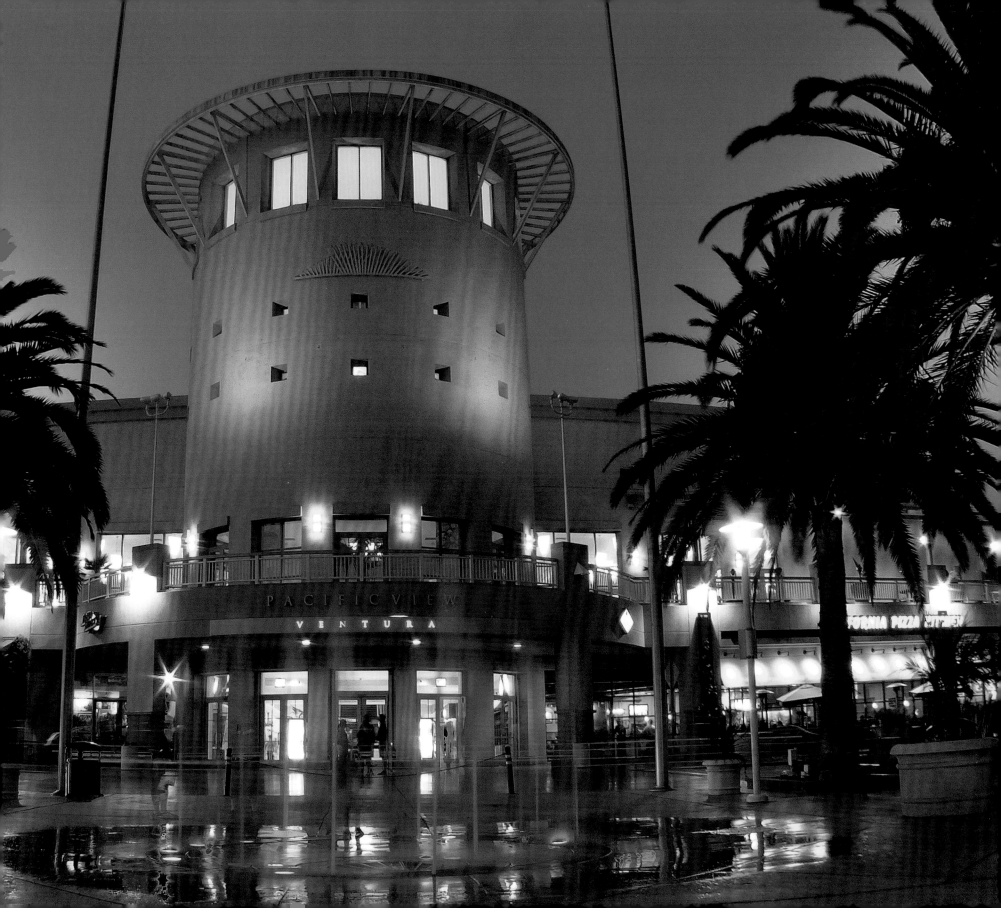

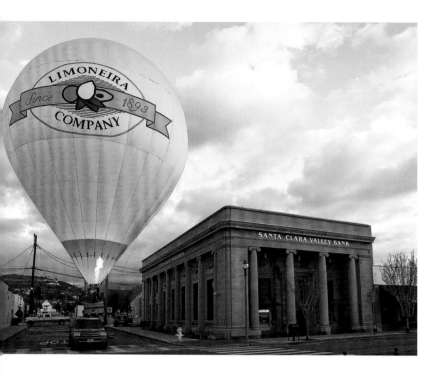

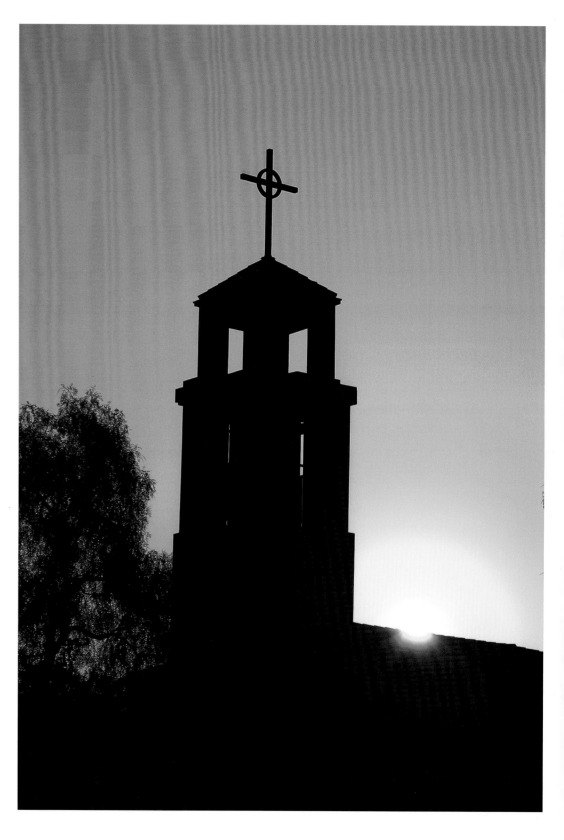

BALLOON AND BANK *(above)*: Inflating a hot air balloon for a shot on Main Street in Santa Paula. 📷 JOHN NICHOLS

RISING SUNDAY SUN *(right)*: Sun rising over the church early Sunday morning. 📷 PAUL POWERS

IN & OUT AND IN MY BELLY *(opposite)*: This place IS an institution. I remember back before this one it was the old style In & Out where you ate... OUTside. But this one is nice too. I just got lucky with the sunset in the background and not a whole lot of people or cars in the parking lot. Photo taken on July 29, 2008. 📷 JOHN MUELLER

GLIMPSE OF HEAVEN *(previous left)*: The Financial Tower in Oxnard provided wonderful cloud reflections in the early afternoon light. 📷 SUZY G

COME ON IN *(previous right)*: Pacific View mall fountains at dusk - three blended exposures. 📷 WENDELL WARD

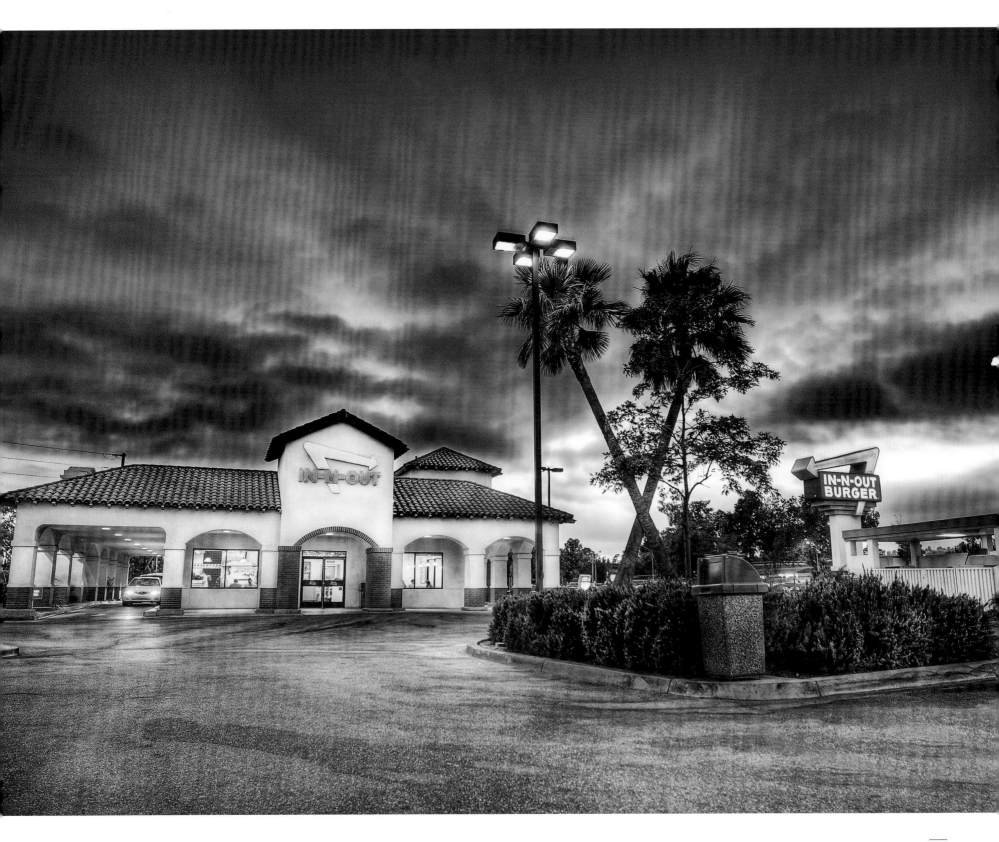

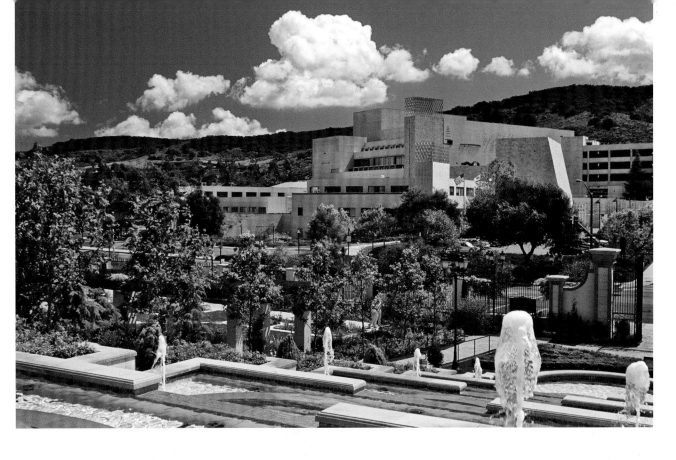

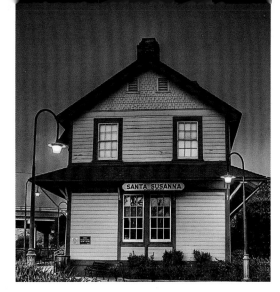

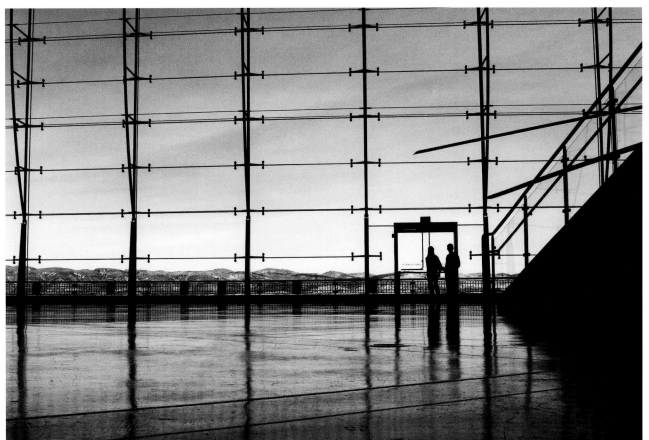

★ **SANTA SUSANA TRAIN STATION** (above): Santa Susana Train Station captured in the evening light of a long summer. 📷 STEVE WHITE

THOUSAND OAKS CIVIC ARTS PLAZA (left top): A lot goes on at the Thousand Oaks Civic Arts Plaza...from the running of the city to a venue of concerts. 📷 JOE VIRNIG

★ **RONALD REAGAN PRESIDENTIAL LIBRARY** (left bottom): Can we talk? 📷 CHARLES MCPADDEN

★ **SHOPPING IN WONDERLAND** (opposite): Old town Ventura shopping and eating. 📷 WENDELL WARD

SANTA PAULA TRAIN STATION (following): This photo of the train station is set off by the sculpture commemorating the motorcyclists who warned so many people about the St. Francis Dam disaster. You'll also notice that the train station was the campaign headquarters for Alan Alda's character on the popular TV drama "West Wing." 📷 JOE VIRNIG

AN OJAI ICON (below): The Ojai Post Office Tower from Libbey Park. 📷 CHUCK THOMAS

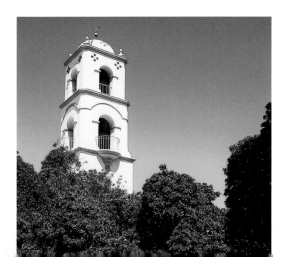

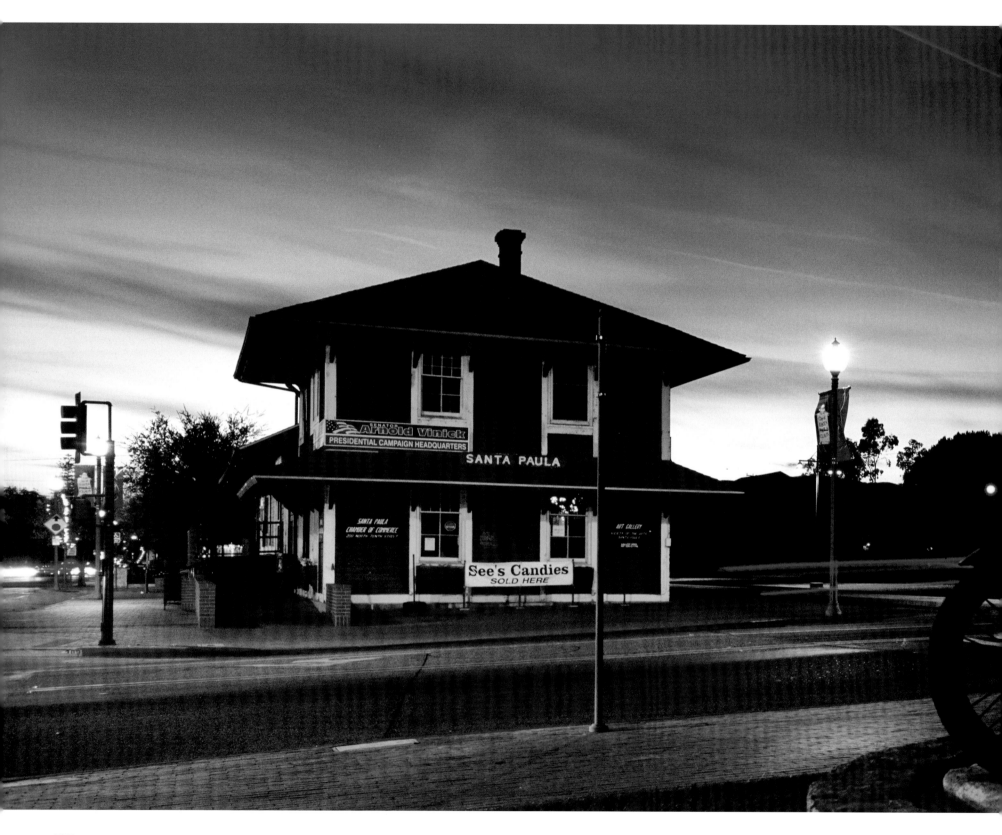

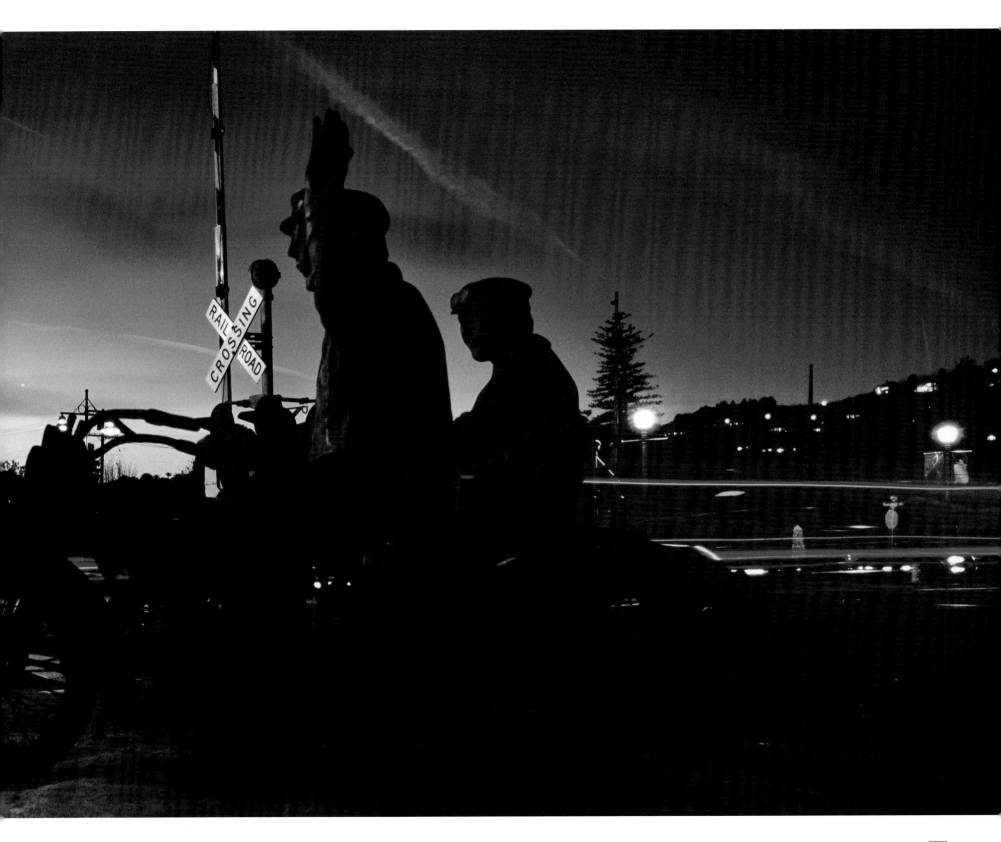

Pets

SPONSORED BY SAMY'S CAMERA

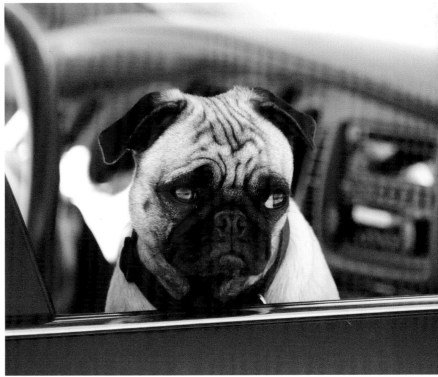

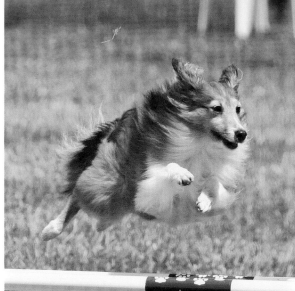

UNDERDOG IS HERE... *(above):* Shot during an agilities meet in Camarillo. First shot of the day. 📷 RAY ALBINO

GECKO *(right):* Out for an afternoon snack. 📷 ANDREW UVARI

ANNABELLE *(opposite):* Annabelle at 5 weeks old.
📷 STEPHANIE NEWTON

EMMA *(previous left):* Emma relaxing after a long day. 📷 SHELBY G

GROWING UP *(previous middle):* Photographed early evening. This photograph shows a young, longhaired kitten that has been the subject of my lens quite often in the recent weeks.
📷 THOMAS WOTKYNS

LOOKING FORWARD TO SPRING *(previous right top):* Felina, a quarter horse filly, enjoys the sunshine on a clear day during a break in the January rains. I didn't have to pose her for this shot, I had "help" from her herd. Baby, one of her herdmates, was being turned out into the pasture at the gate several hills below. Baby was calling out for the herd location (whinnying) and Felina was answering (whinnying in return). In this photograph, she is not quite 2 years old, still a filly. 📷 CRYSTAL MCABEE

★ **LEFT BEHIND** *(previous right bottom):* Pug I saw left in the car waiting for his owner. 📷 ANDREW UVARI

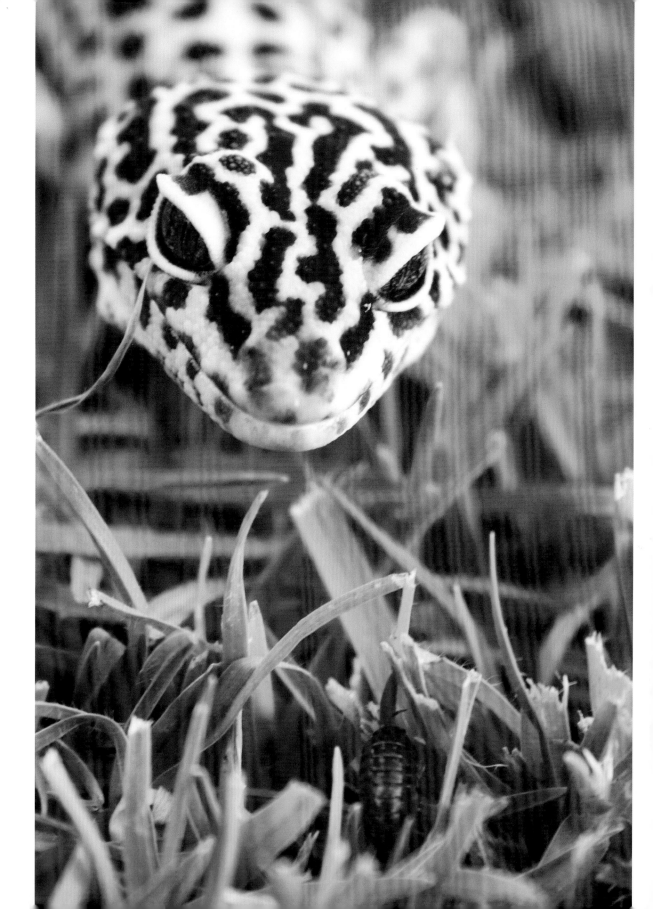

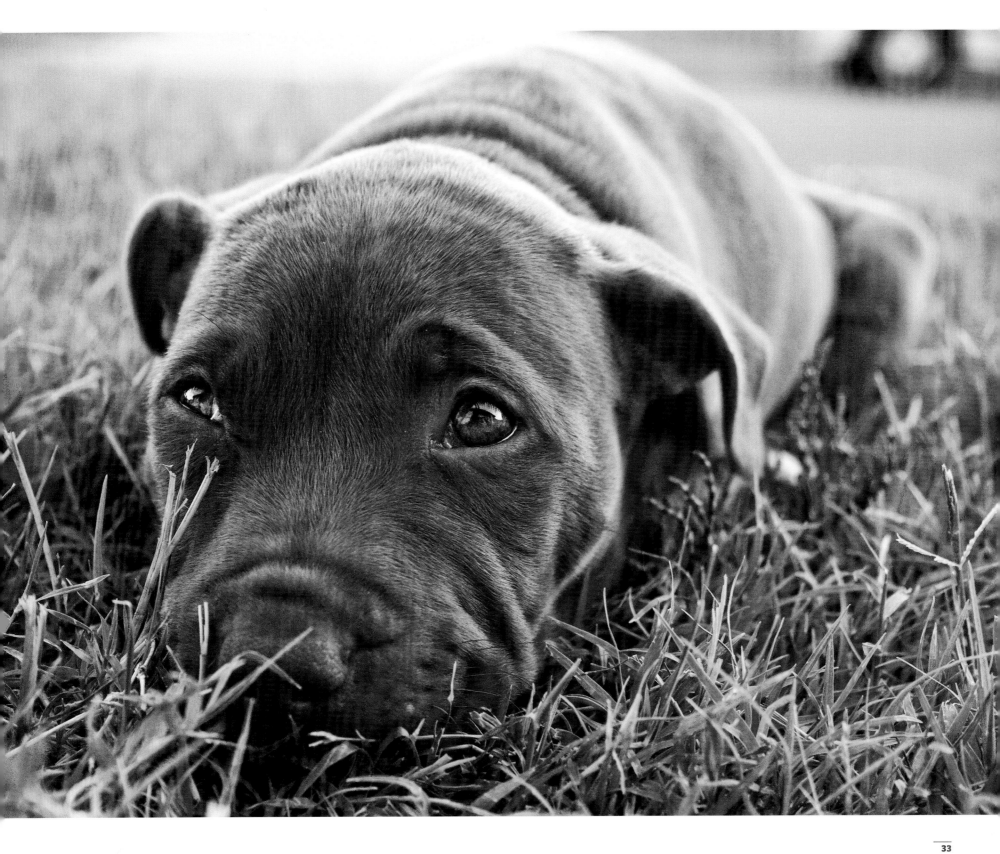

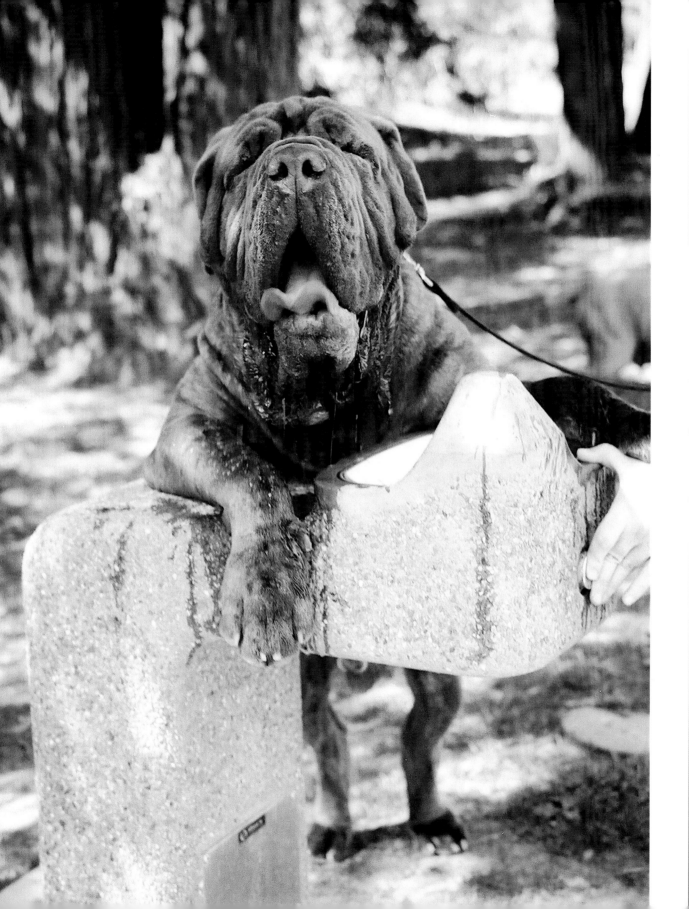

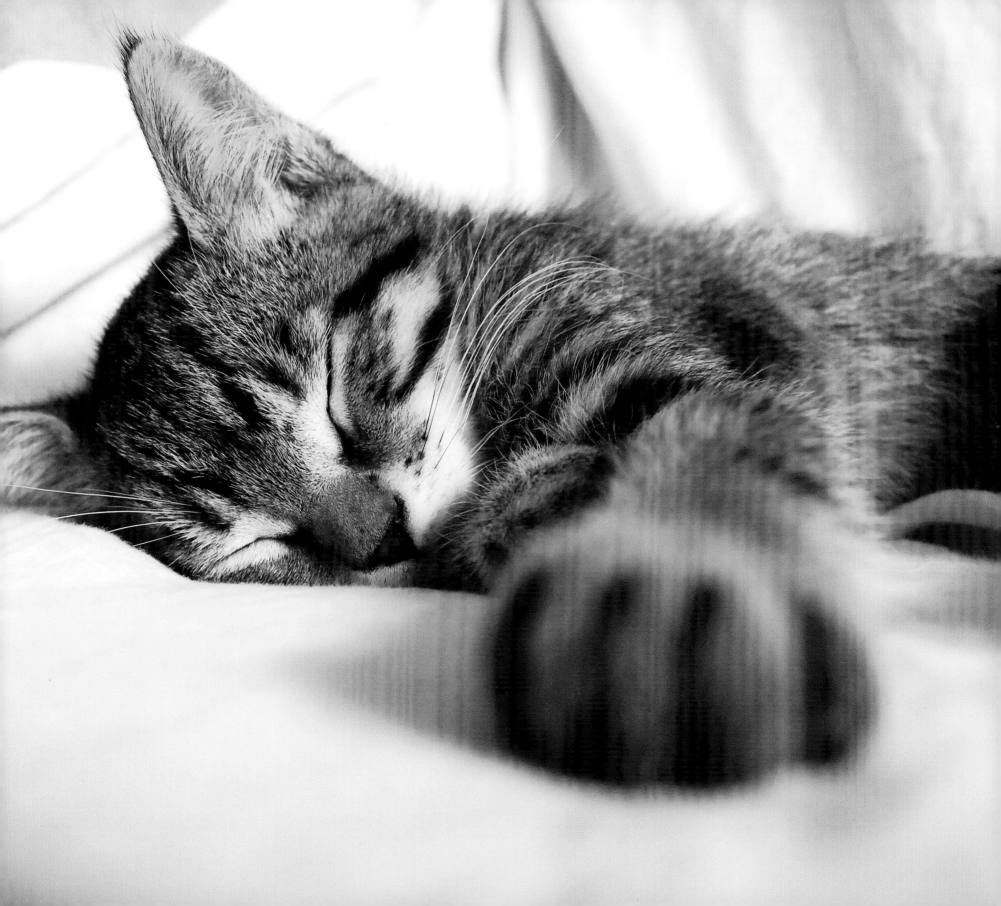

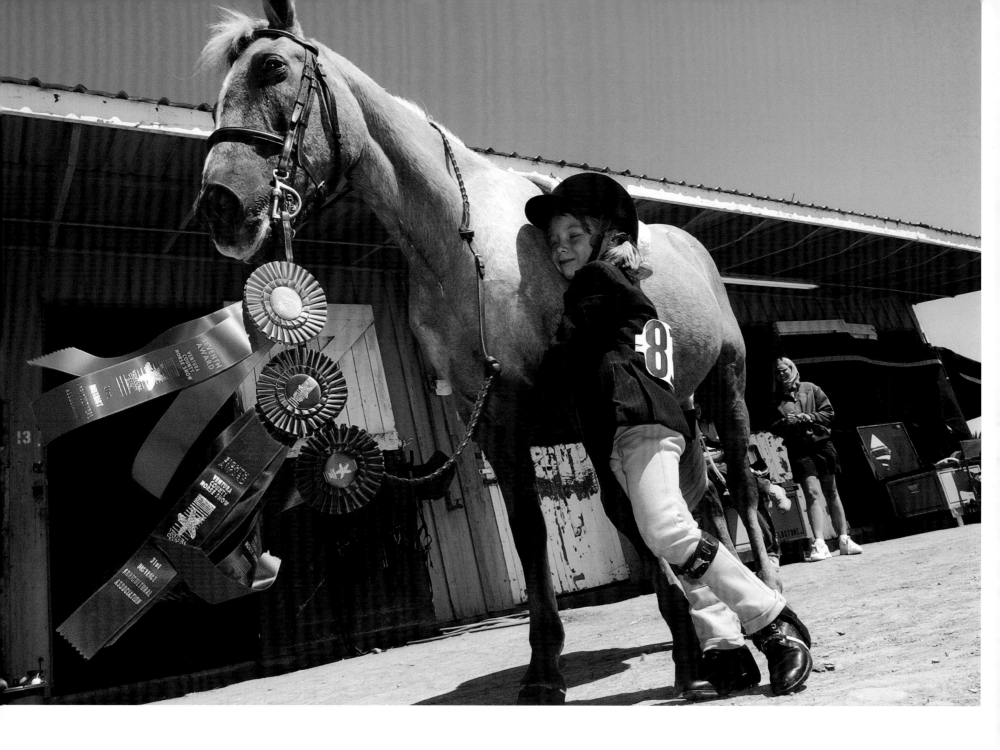

YOUNG RIDER & HER HORSE (above): Josie Hendry, 4, of Fieldstone Riding Club in Moorpark, leans up against her horse, Ozzy, happy with their performance in the English riding competition at the Ventura County Fair.
📷 KAREN QUINCY LOBERG/VENTURA COUNTY STAR

★ **UNTITLED** (opposite): In the eye of the beholder. 📷 SUSANNAH SOFAER KRAMER

THE WATERING HOLE (previous left): "After my dad and I take our morning run at Arroyo Verde Park in Ventura, I like to stop by my favorite watering hole for a quick drink! And yes, my paws are almost bigger than my dad's, but don't make fun of him — he's sensitive!"- Trojan. 📷 SARAH NICOLE SAITO

SLEEPY JACK (previous right): My kitty napping. 📷 TERI ESPINOSA

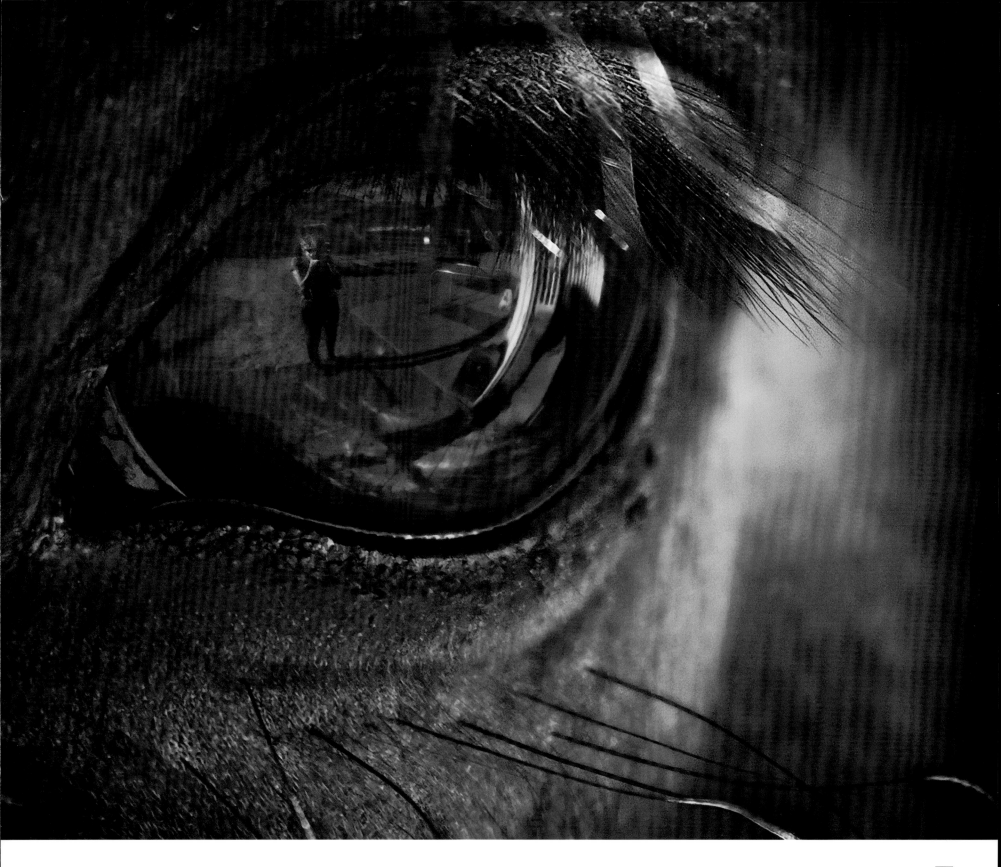

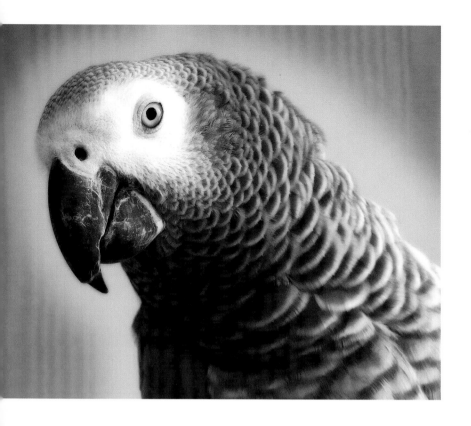

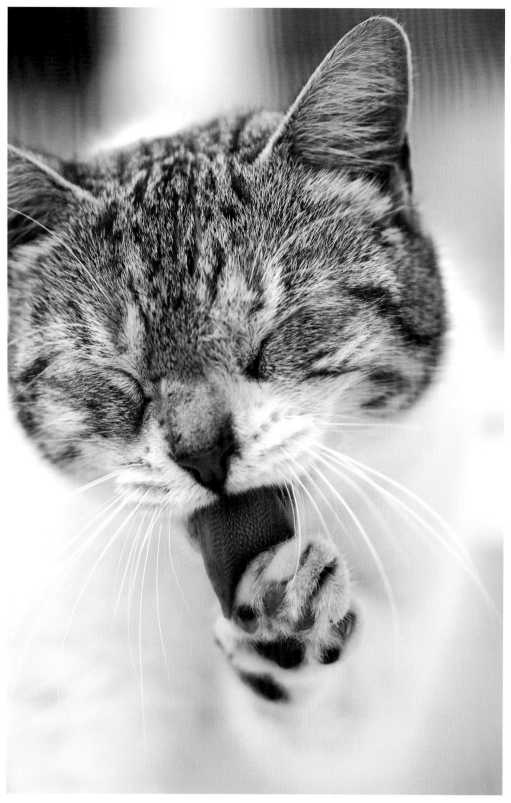

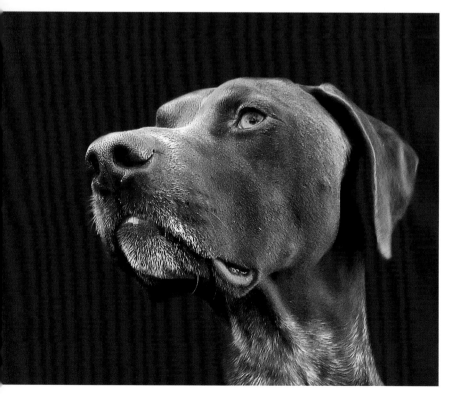

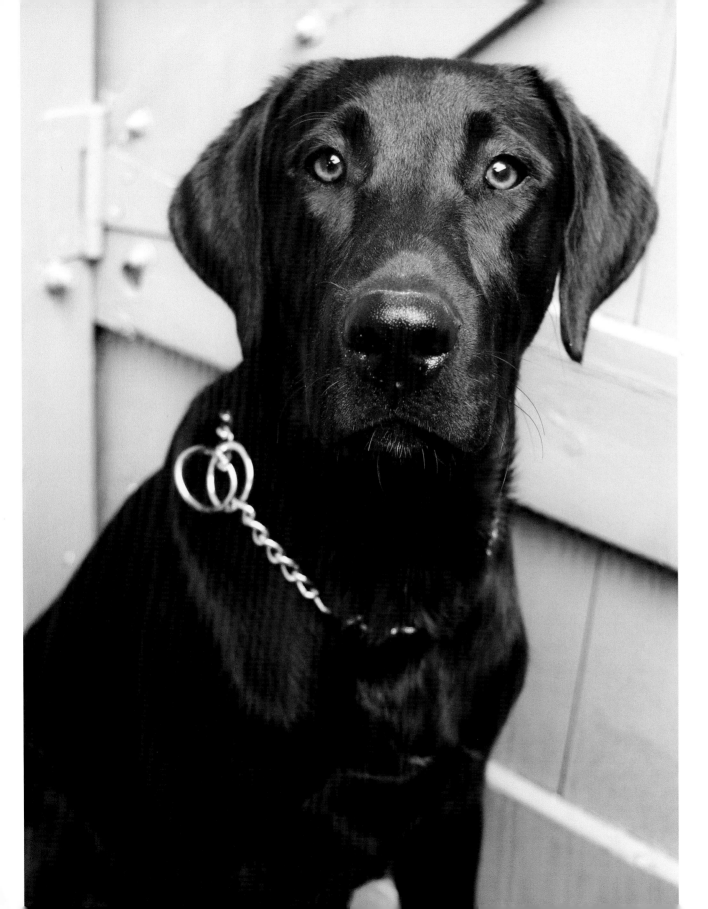

TOKI *(left):* This is Toki, my beautiful, spoiled little boy.
📷 KELLY MCGRAW

TULA! TULA! *(opposite top):* Say hi to Tula! She is one crazy African grey. You will often hear her calling your name once she learns it, imitating the sounds of the other birds outside or answering the phone when it rings. But watch out! She'll bite ya! 📷 KELLY MCGRAW

TOBY *(opposite bottom):* Toby, a German shorthaired pointer. 📷 HENRIK LEHNERER

AFTER LUNCH *(opposite right):* A stray that showed up on our doorstep. We gave her something to eat and as she licked her paw as this photo was captured. She found a wonderful home through the assistance of Grey Foot Cat Rescue. 📷 MARILYN GOULD

★ **MACAW EXTENDED** *(following):* Macaw in all its length on a bench by the beach. 📷 HENRIK LEHNERER

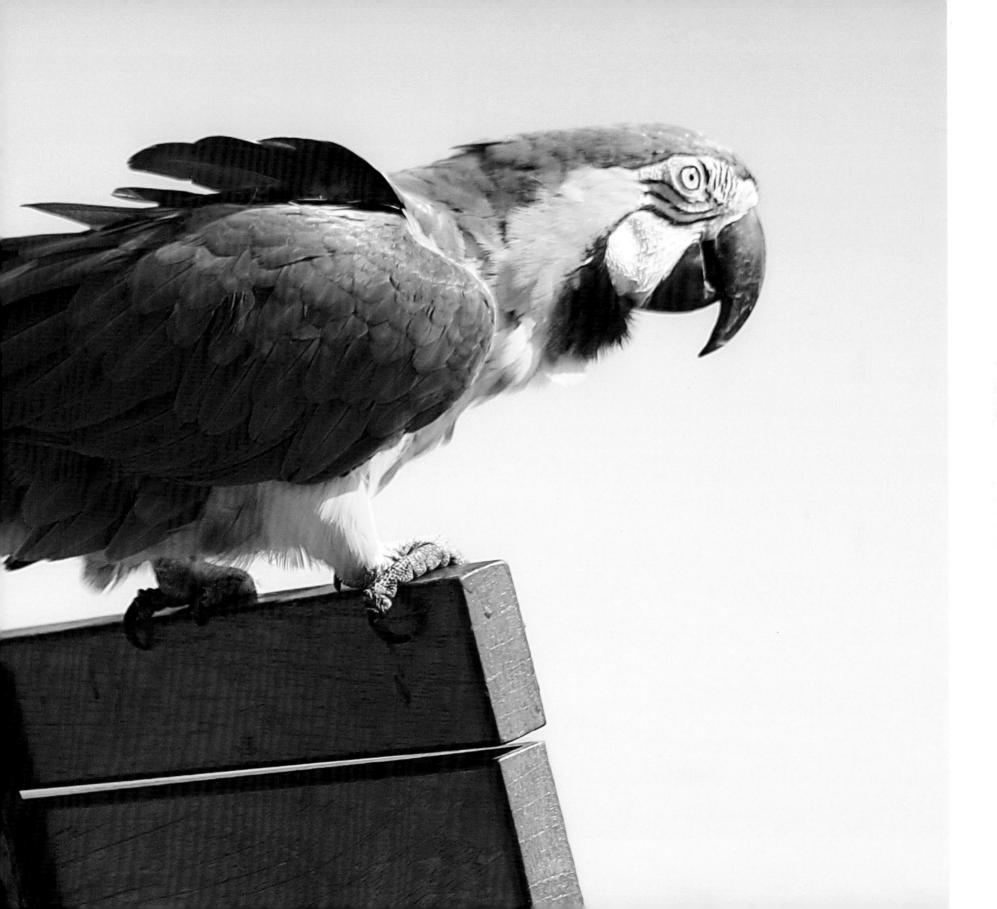

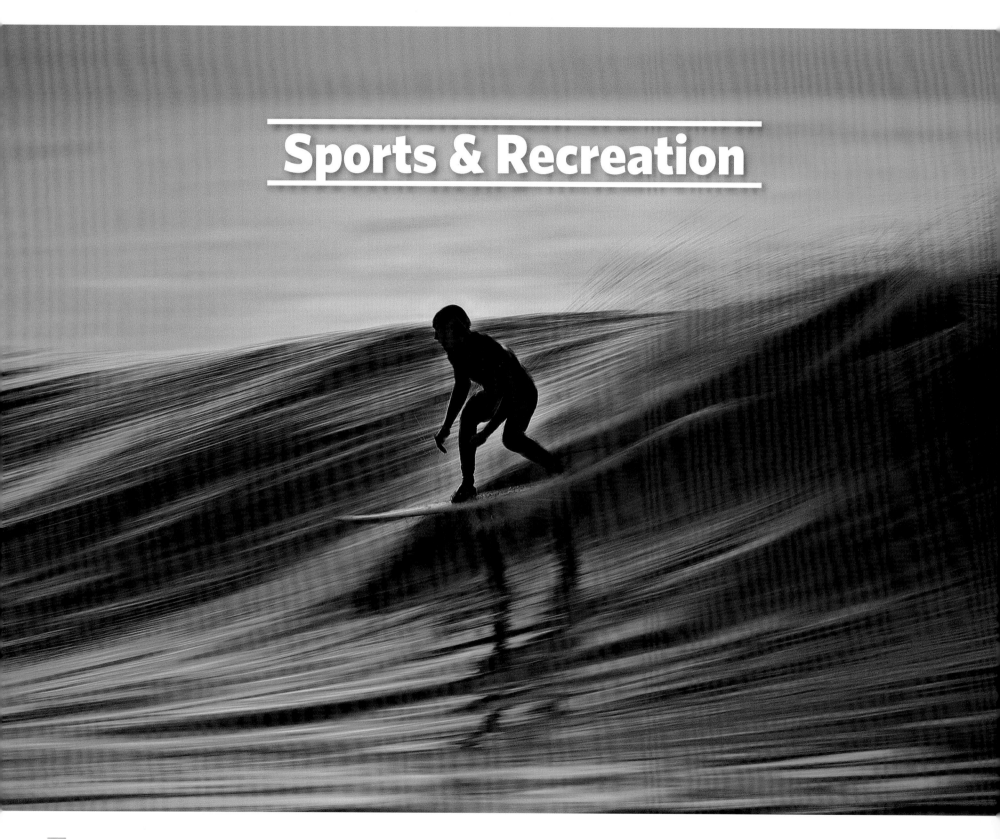

Sports & Recreation

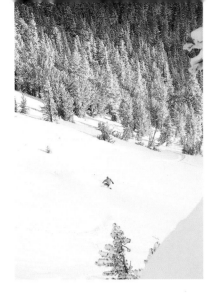

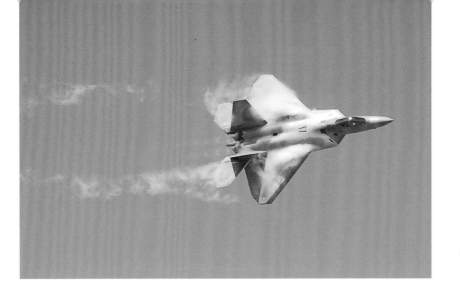

A MOST AWESOME FLIGHT DISPLAY *(left):* The F-22 flight demonstration at the Point Mugu Air Show out shown all the others. It was truly awesome. 📷 JACQUES GIROD

WHITE LINES *(far left):* It is rare to get this great of snow in these parts, but when we do, it is so good! This is my friend tracking out a powder field we found hiking in the backcountry of Ojai. 📷 PAUL POWERS

SURFING LIQUID COPPER *(opposite):* High clouds pick up the colors of the rising sun and reflect off the water in this predawn photo of a young surfer at Rincon. 📷 DAVID ORIAS

TALL SHIP LEAVING VENTURA HARBOR *(below):* A tall ship leaves the Ventura Harbor with the two trees in the background. 📷 STEPHEN SCHAFER

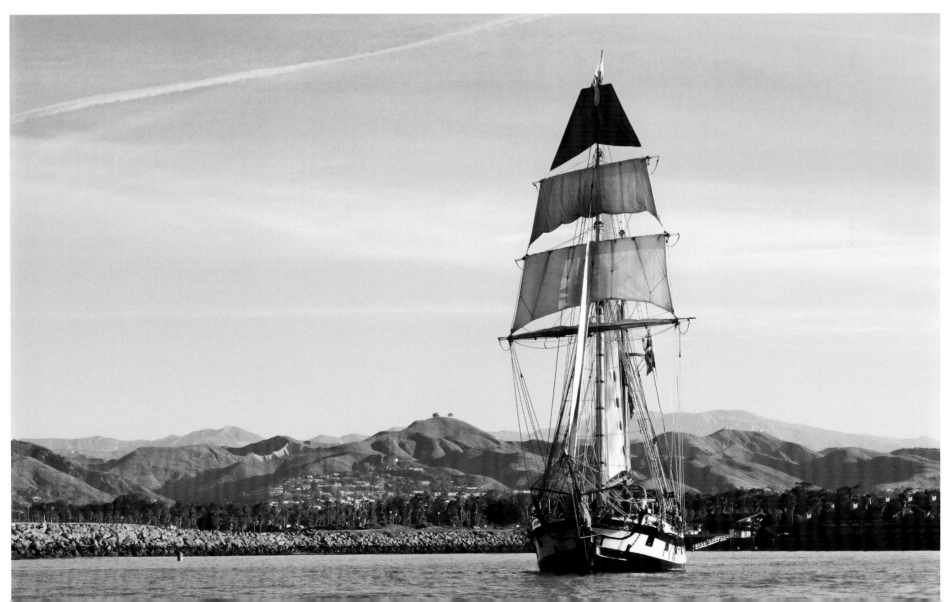

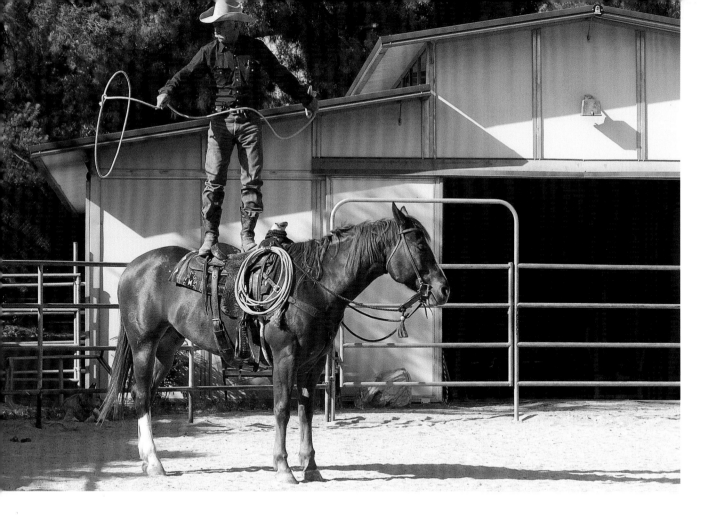

ORIGINAL COWBOY (*above*): Dave Thornbury, 60, practices his trick roping with his new horse Pistol on his property. Thornbury, longtime resident of Agoura, comes from generations of trick ropers, Roman riding, and riding broncs. For over 30 years, Thornbury has been repairing saddles and making custom chaps by hand. "It was like I was born riding," Thornbury said.
📷 DANA RENE BOWLER/VENTURA COUNTY STAR

WHEN PIGS FLY (*right*): Who can resist the Alaskan Pig Races at the Ventura County Fair? 📷 KATHRYN SALMON

SKY RIDER (*far right*): Getting some fresh air at the local trails.
📷 PAUL POWERS

LITTLE LEAGUE OPENING DAY (*following left*): Little League baseball is a very good thing because it keeps the parents off the streets.
📷 RAY ALBINO

LISTEN UP KIDS! (*following right*): Sophia Paden, 13, left, Neil Van Splinter, 11, and Grace Van Splinter, 8, listen to officials as they prepare to show pygmy goats for the Santa Rosa Valley 4H Club at the Ventura County Fair.
📷 KAREN QUINCY LOBERG/VENTURA COUNTY STAR

RAPID DESCENT (*following bottom left*): Natalie Boonstra, center, and Naomi Boonstra, right, from Simi Valley, and an unknown girl enjoy a rapid descent at the Ventura County Fair. 📷 GERRY CHUDLEIGH

SMALL FRIGHT (*following bottom middle*): Naomi Boonstra, from Simi Valley, enjoys a scary slide at the Ventura County Fair. 📷 GERRY CHUDLEIGH

TRIO (*following bottom right*): Fireworks dwarf oak trees in Thousand Oaks on the Fourth of July. 📷 DARREL PRIEBE

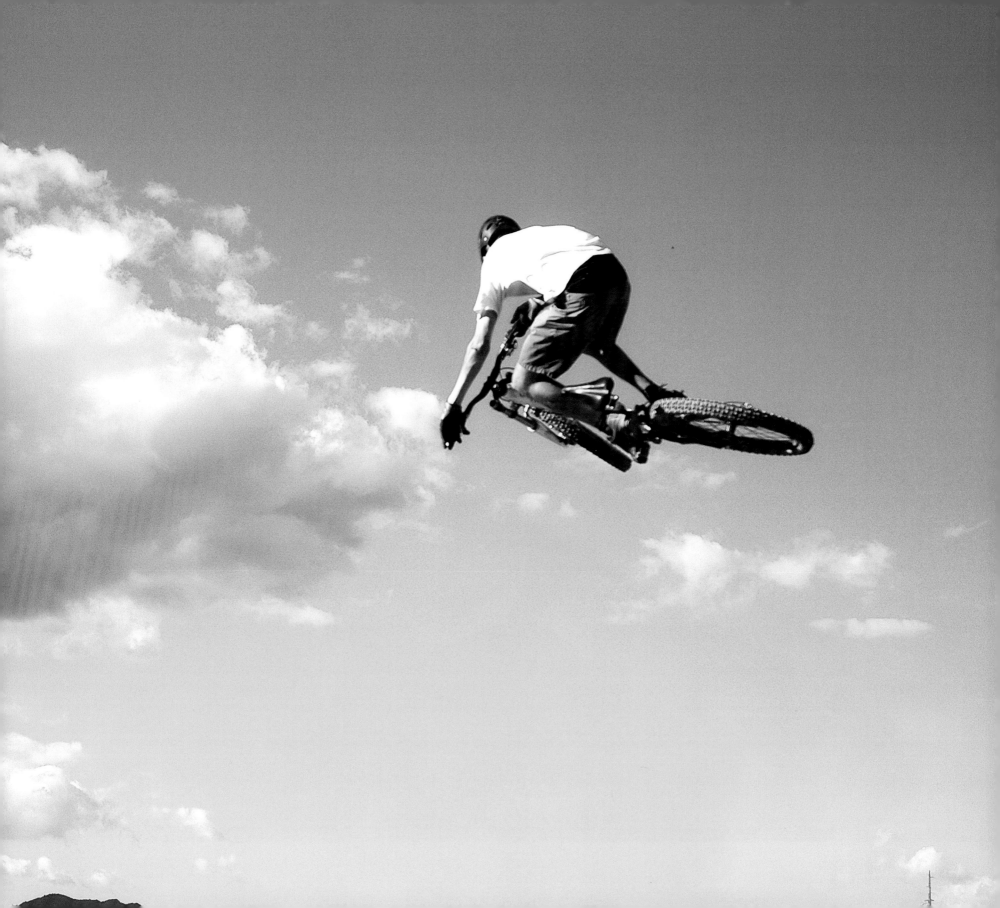

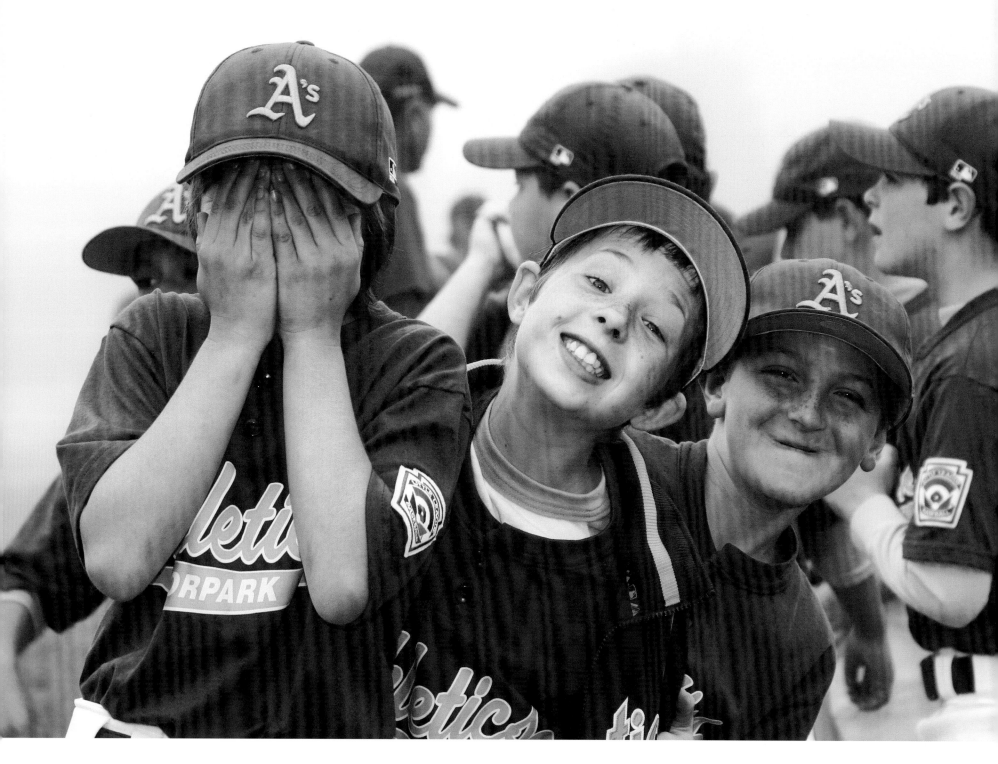

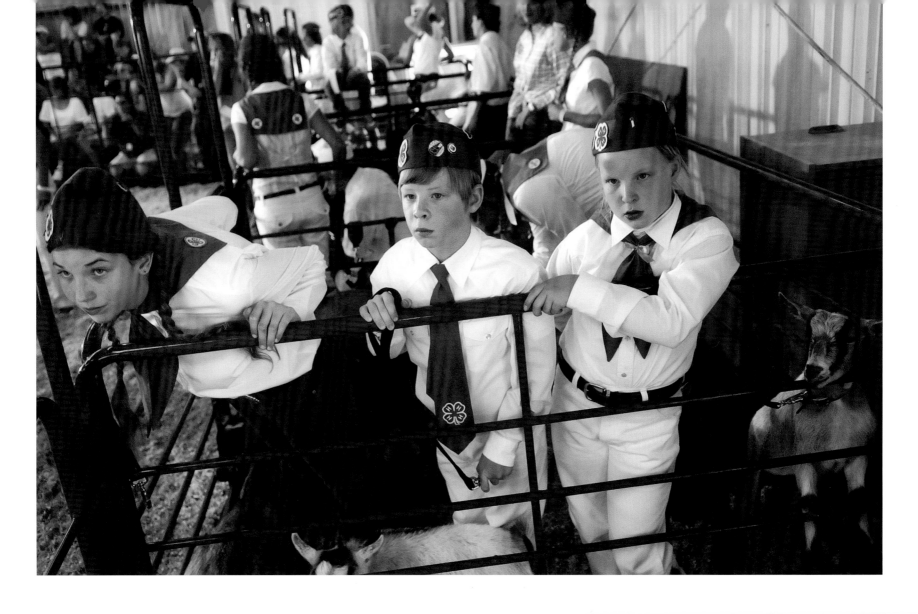

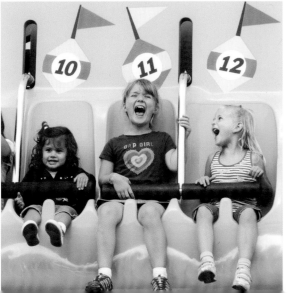

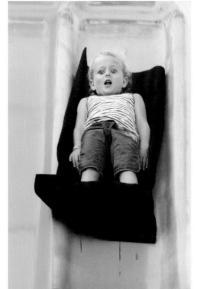

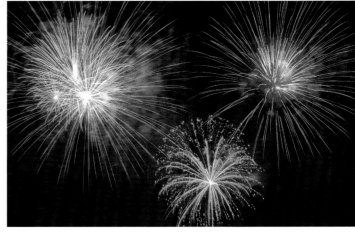

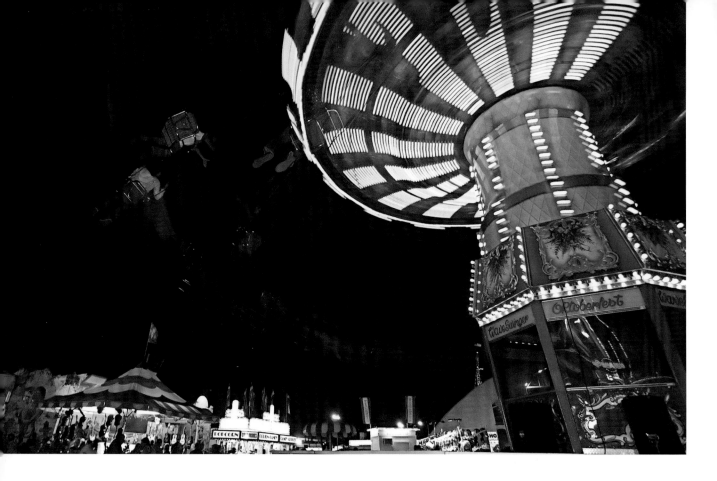

NIGHT SWINGING (*above*): This was one of my favorite spots at the fair — and I wanted to capture the best of both worlds — the vibrant color of the ride as it whirls around coupled with the people having fun being spun about.
📷 JESSICA REINHARDT

OCEAN FIREWORKS (*right*): Fireworks are shot over the ocean at Surfer's Point in Ventura. 📷 TOM BAKER

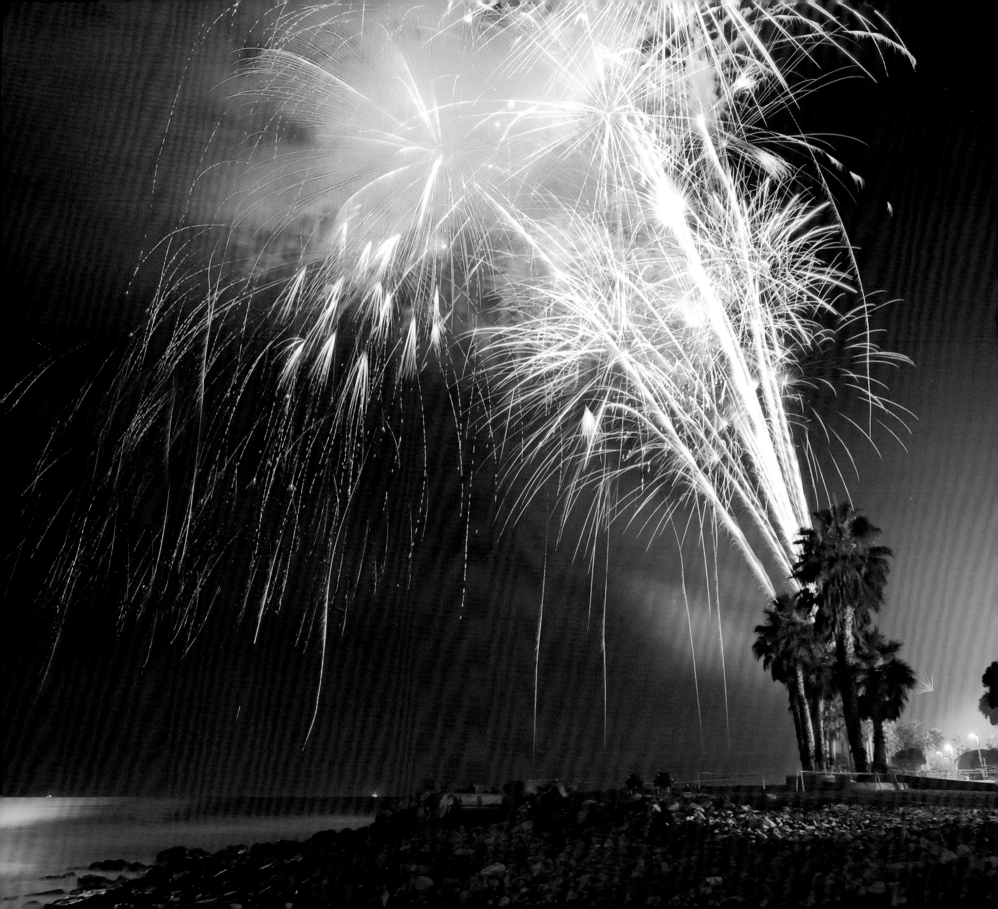

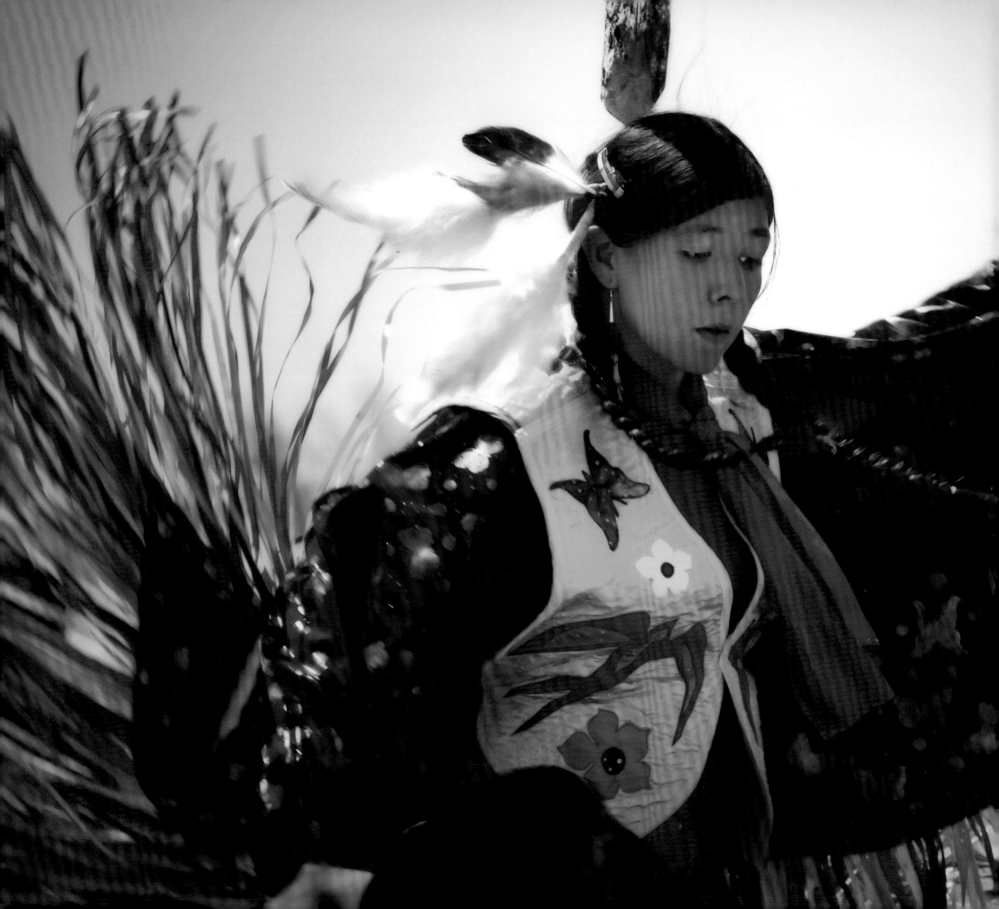

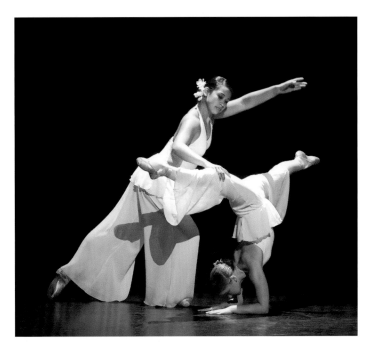

PURE BEAUTY *(left):* One of the images from the July 12-13, 2008 Camarillo Academy of Performing Arts Celebration of Dance. 📷 AL UNGAR

DANCING GIRL *(far left):* A Native American dancer deep in concentration and wearing a brilliantly colored costume performs at the Native American Powwow held at Moorpark College on July 21, 2007. 📷 DARREL PRIEBE

CHINESE NEW YEAR CELEBRATION *(below):* 2007 Chinese New Year Celebration 📷 MARC LANGSAM

TAKING THE PLUNGE *(following left):* Katie Windsor, goalie for California Lutheran University women's water polo team, is a step ahead of her teammates into the school's swimming pool in Thousand Oaks.
📷 KAREN QUINCY LOBERG/VENTURA COUNTY STAR

NUMBER *(following right):* USA vs. Aussie Water Polo at CLU. First Place, B&W, Other, Ventura County Fair 2008.
📷 AL UNGAR

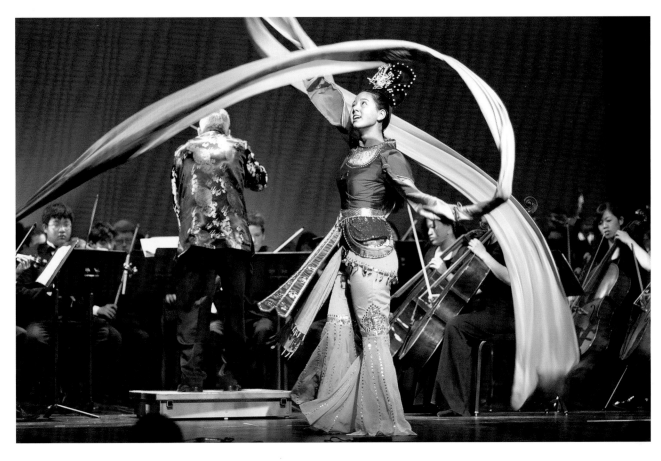

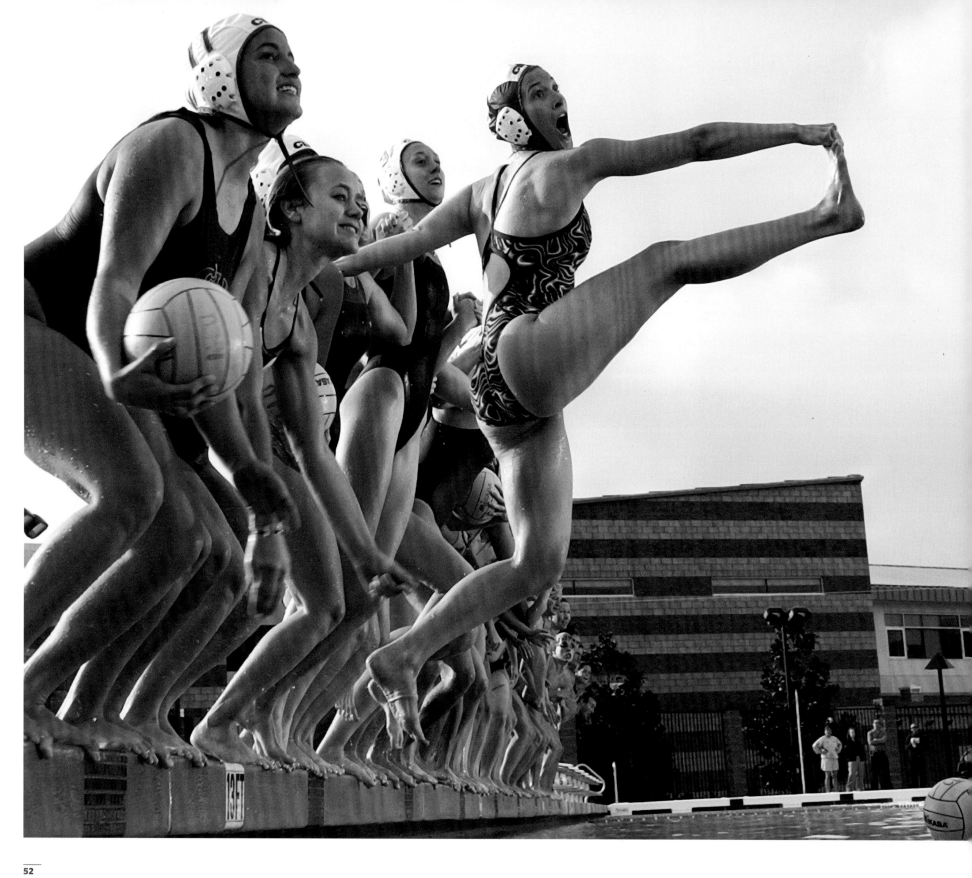

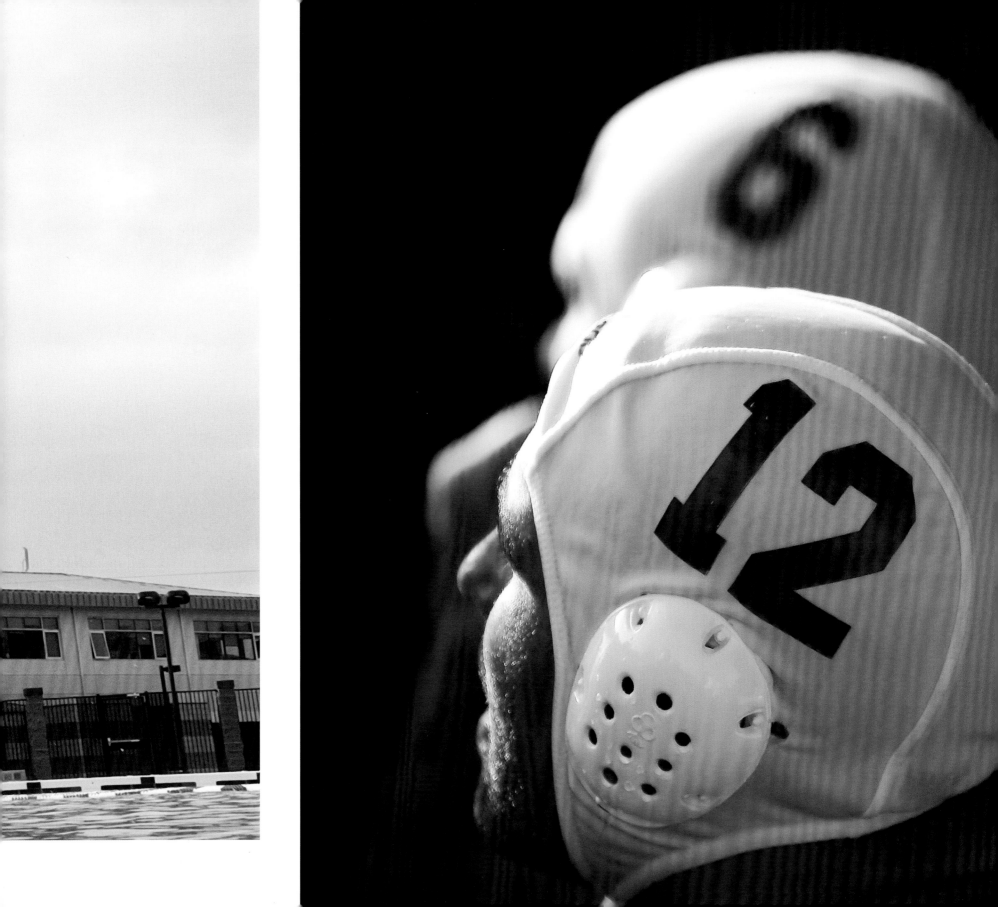

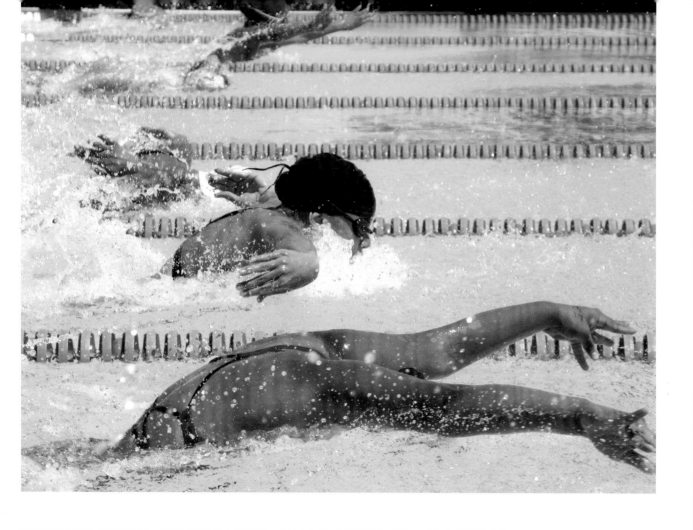

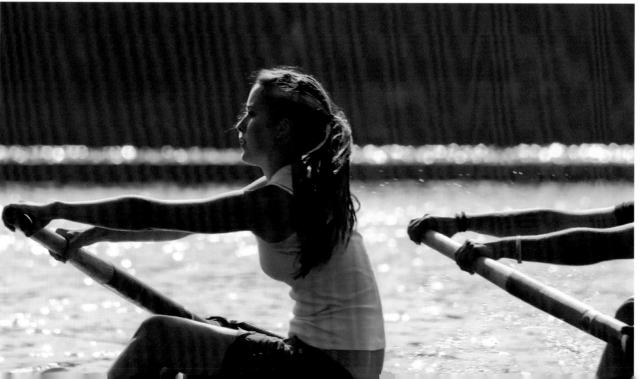

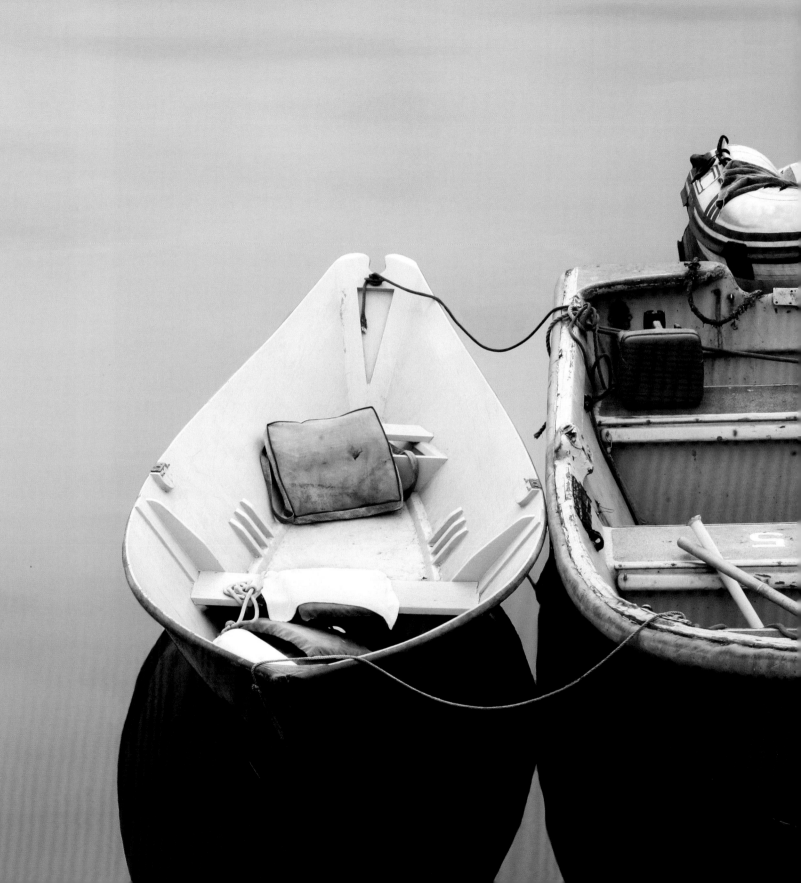

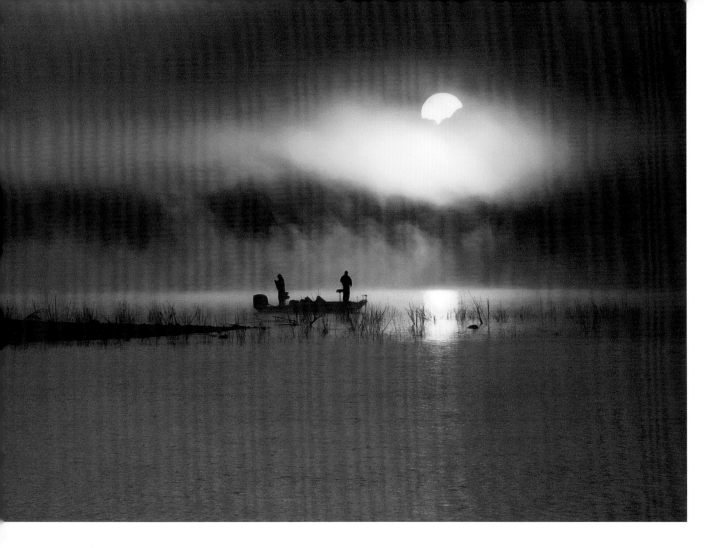

★ **LAKE CASITAS SUNRISE** *(above)*: An early morning of fishing. With the sun rising in our face and the fog lifting off the lake, it was the perfect morning. 📷 SHANE MARTIN

DAWN PATROL *(right)*: A surfer paddles out in the predawn to reap the rewards of Mother Nature at Rincon hoping to catch a wave. The artificial island off of Mussel Shoals is in the background. 📷 DAVID ORIAS

CALIFORNIA SUNSET *(far right)*: Perfect California sunset after huge surf on Dec. 5, 2007. 📷 ZACH BARKER

SWIM FAST! *(previous top)*: Girls in a close butterfly race during a swim meet at Ventura Aquatic Center. 📷 JULI CROMER

LAKE CASITAS AFTERNOON PRACTICE *(previous bottom)*: A member of the Lake Casitas Rowing Association Youth team practices at Lake Casitas with her teammates. Their dedication and enthusiasm for the sport is impressive. 📷 EILEEN DESCALLAR

MORNING STILLNESS *(previous right)*: Fishing boats at the harbor. 📷 GORDON SWANSON

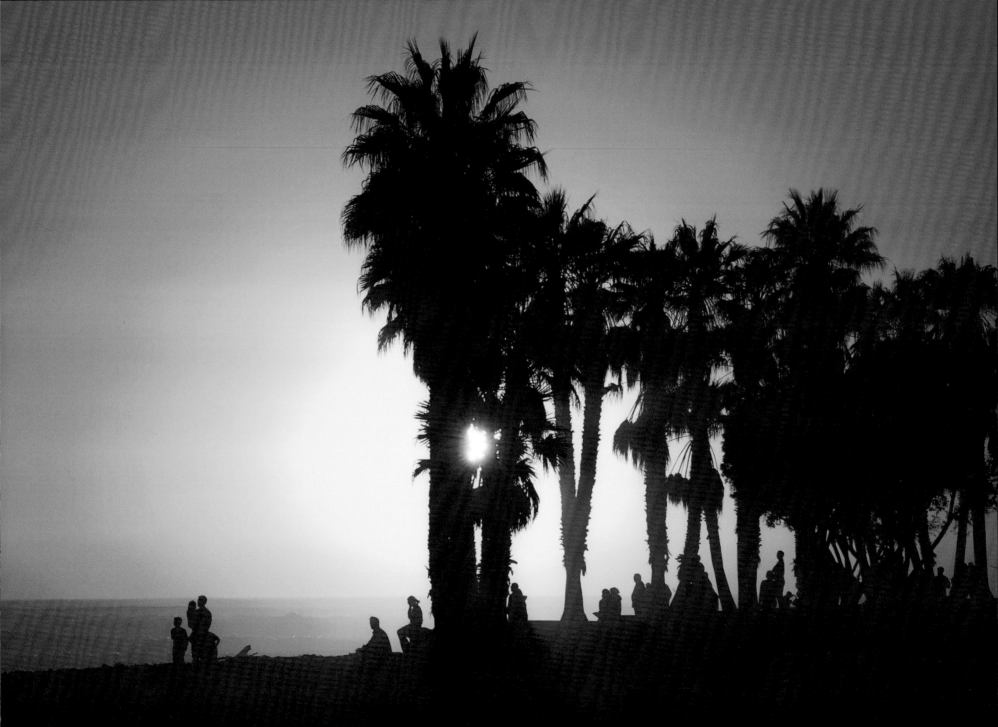

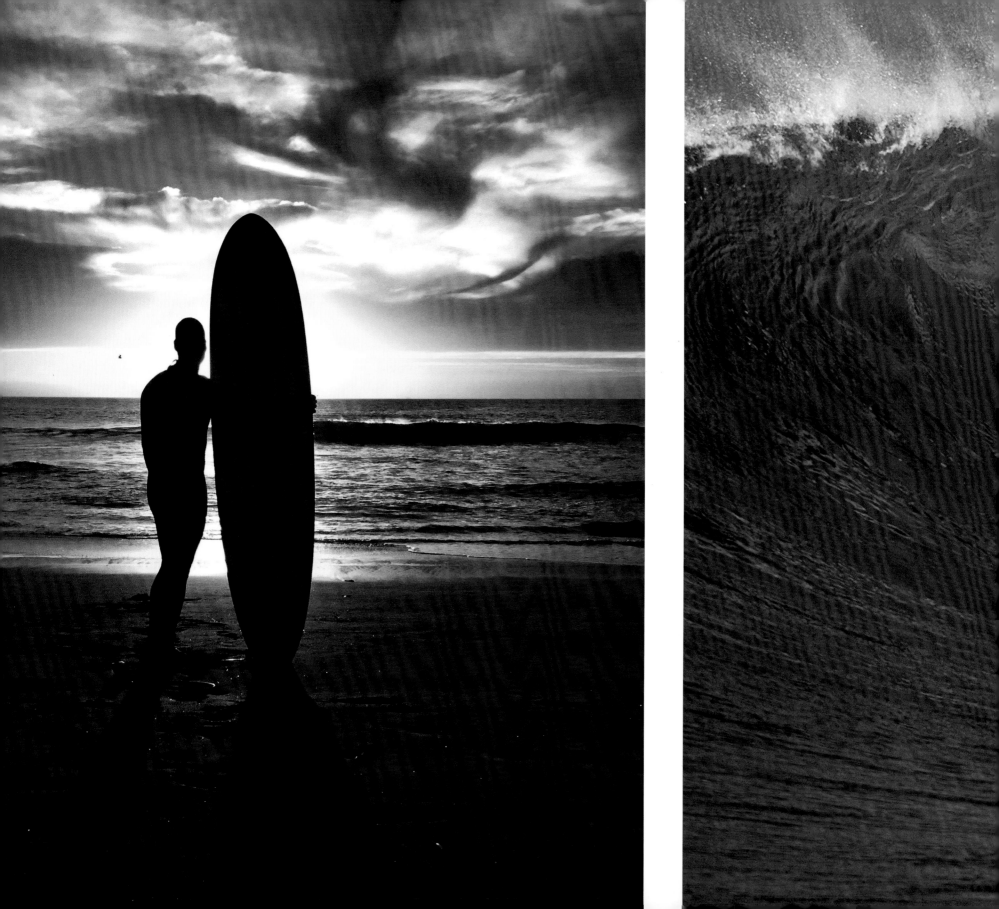

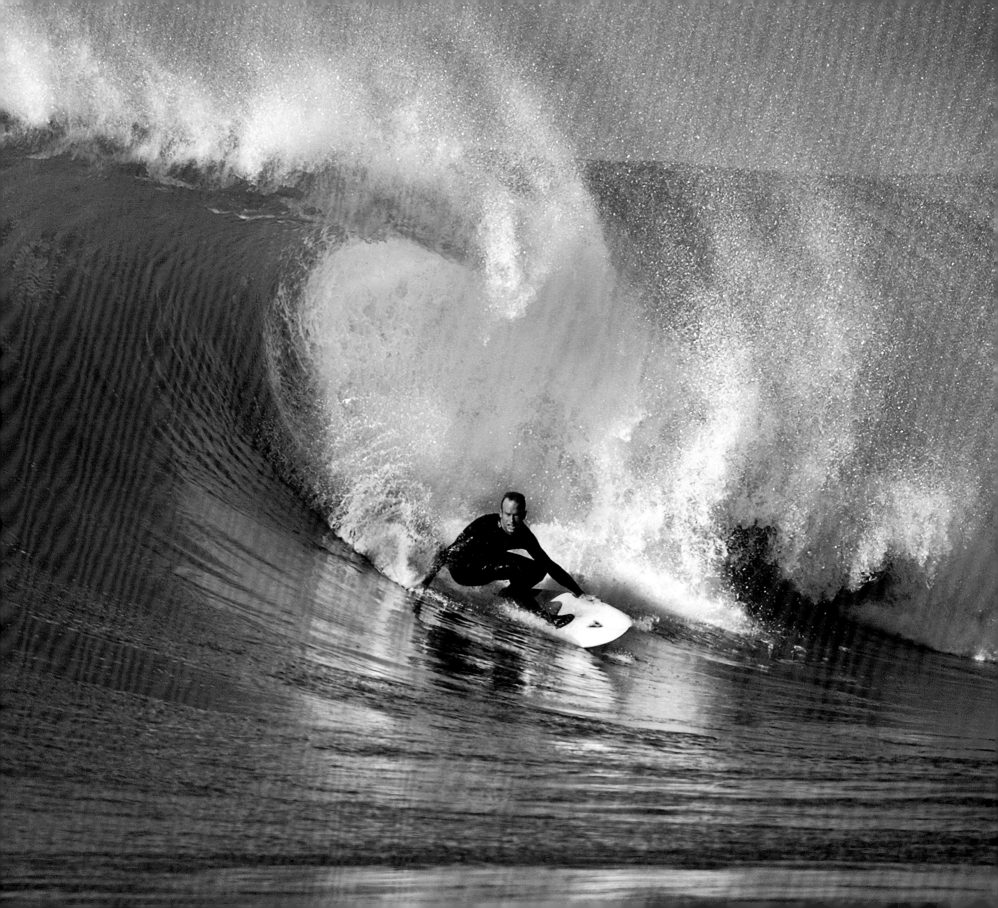

LONG BOARD (*previous left*): Early fall at Ventura's beaches, off Spinnaker Drive across from Ventura Harbor. A young man with a long board stopped to admire the sunset. He was from the East Coast, this being his first time to California and his last day before returning home. 📷 TZVIA GUERNSEY

★ **VENTURA COUNTY'S "BACKDOOR"** (*previous right*): During the winter, northwest swells bring hollow waves to this Oxnard surfing spot and the surfers who call this spot their own. Who needs to travel to the North Shore? 📷 DAVID ORIAS

TWO SURFERS AT SURFERS POINT (*right*): Two surfers mark an end to a perfect day. 📷 ROY ALLEN

ENTRY POINT (*far right*): A surfer waits to enter the water in Ventura. 📷 KEITH PYTLINSKI

SUNSET, SAND AND SURF (*below*): Sunset, sand and surf at Rincon Point. 📷 DANIELA FAILLA

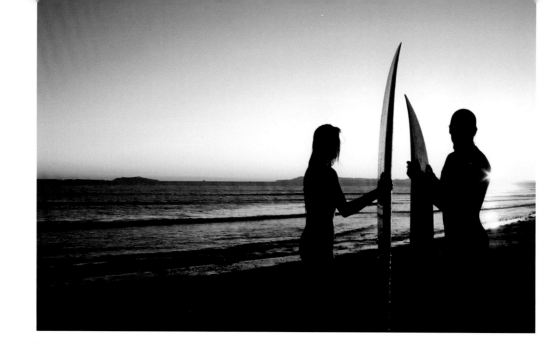

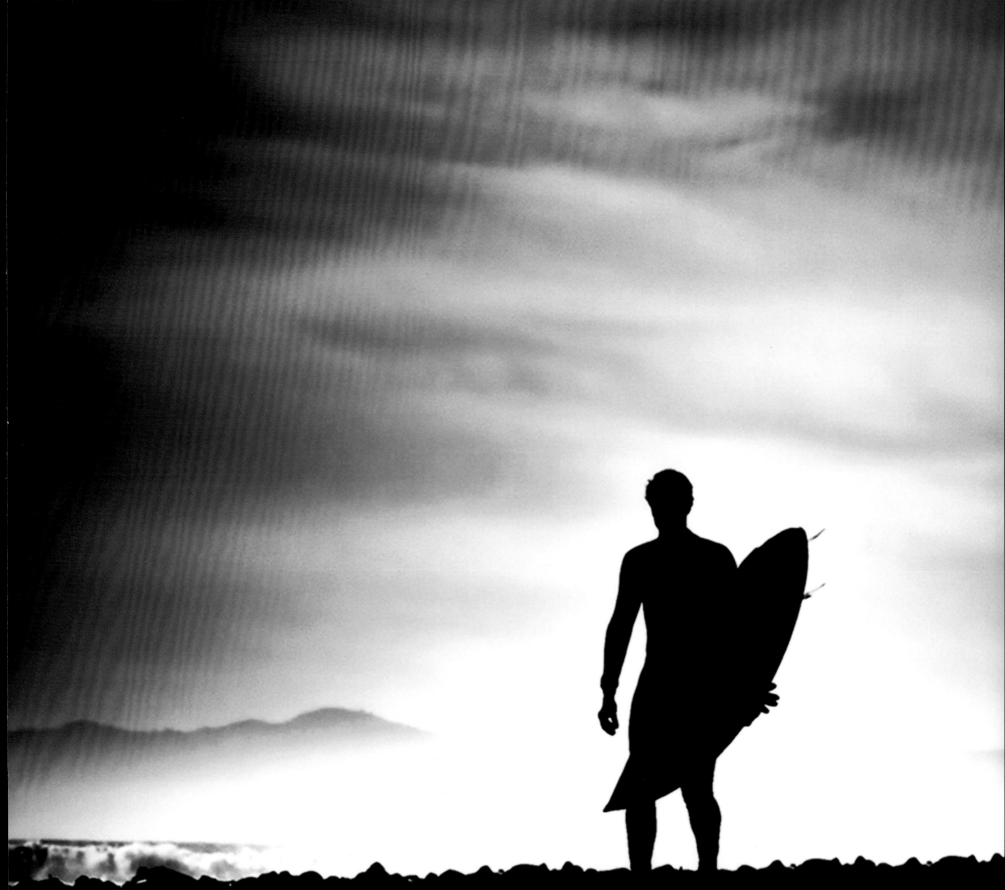

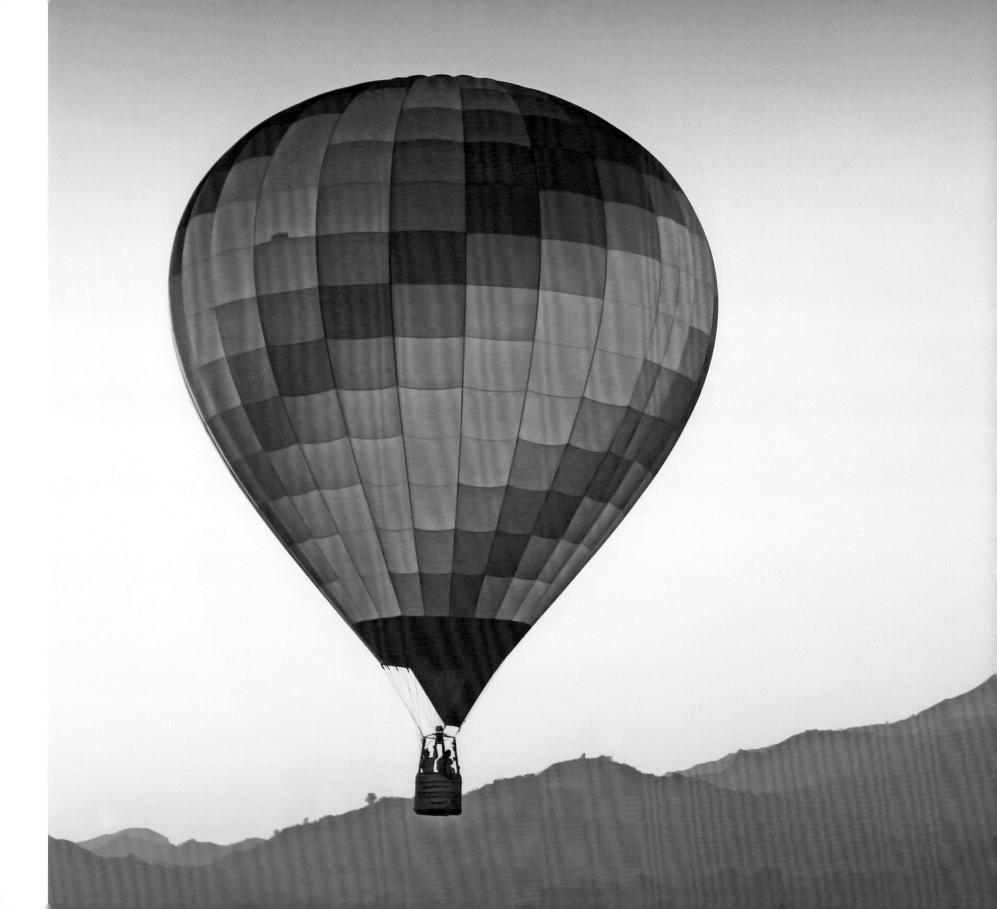

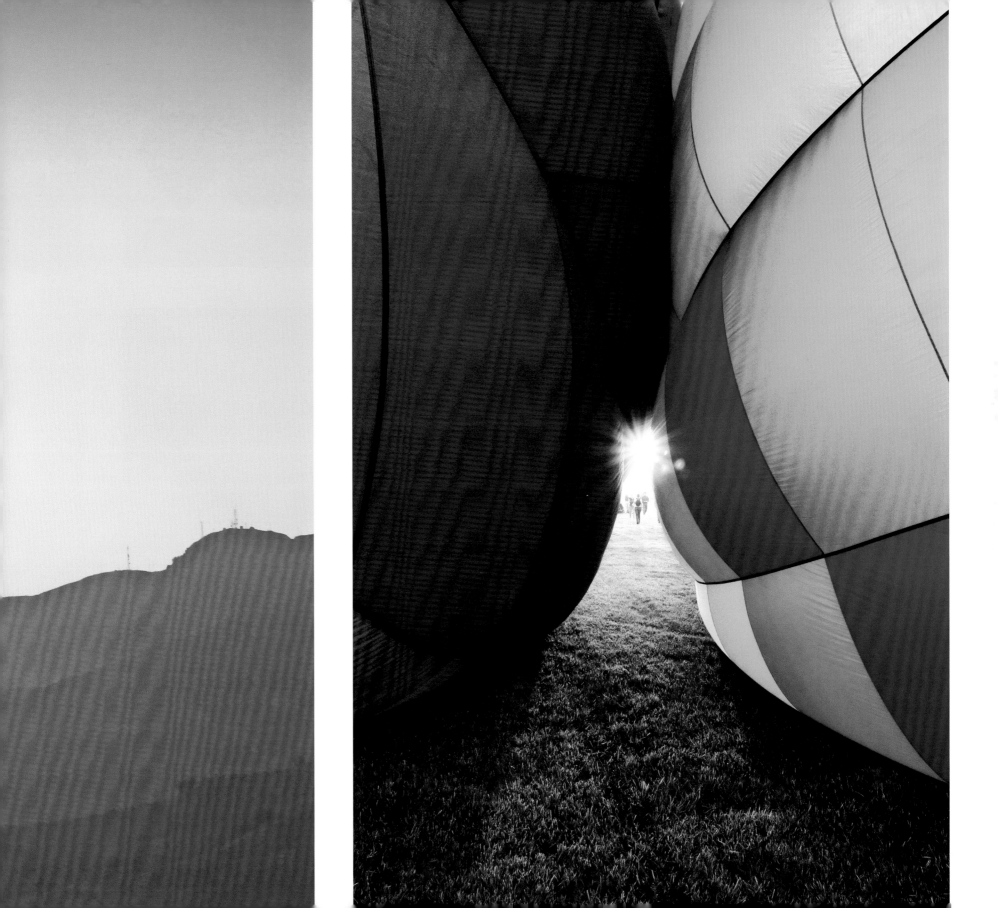

CELEBRATING SUNRISE IN SANTA PAULA
(previous left): A balloon takes flight at sunrise from Santa Paula Airport at the inaugural Citrus Classic Balloon Festival in Santa Paula.
📷 PATRICIA MARROQUIN

GOOD MORNING SUNSHINE
(previous right): Morning sun greets two Citrus Classic balloons preparing for flight.
📷 ROBERT MCCORD

SUNRISE PEEKING THROUGH THE BALLOONS
(right): Daybreak. The balloons are almost ready to launch. Shafts of sunlight start to penetrate between the colorful balloons as awestruck spectators gather to admire their beauty at Santa Paula's 2008 Citrus Classic Balloon Festival. 📷 RAY LASER

★ **BLAST OFF!** *(far right):* It was such a blast watching these balloons head out into the wild blue yonder. 📷 LARRY WHITE

FIRING UP *(below):* Citrus Classic Balloon Festival on July 25, 2008. 📷 KENT KANOUSE

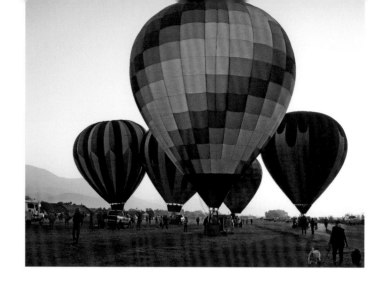

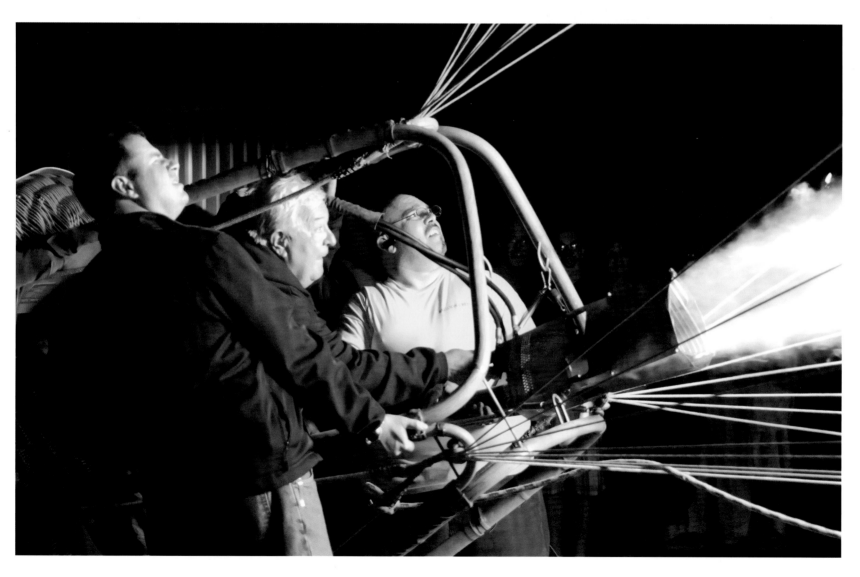

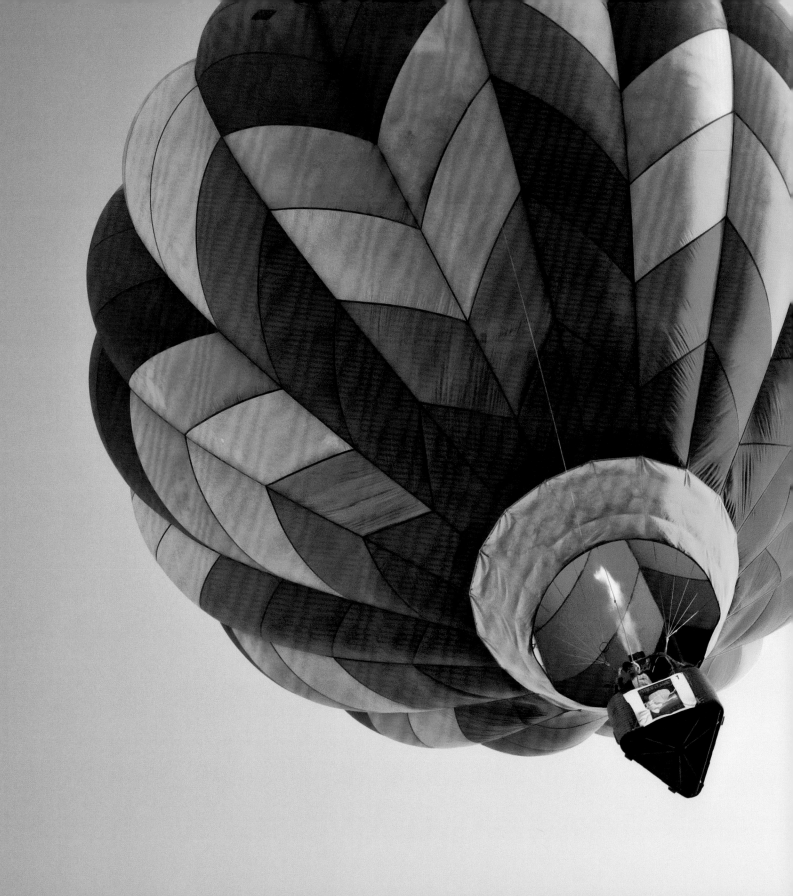

Scapes of All Sorts

SPONSORED BY HOOPER CAMERA & IMAGING

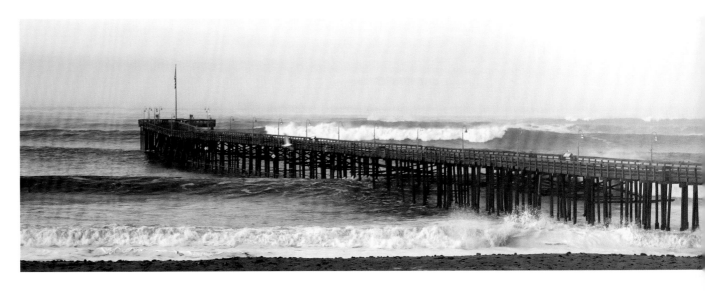

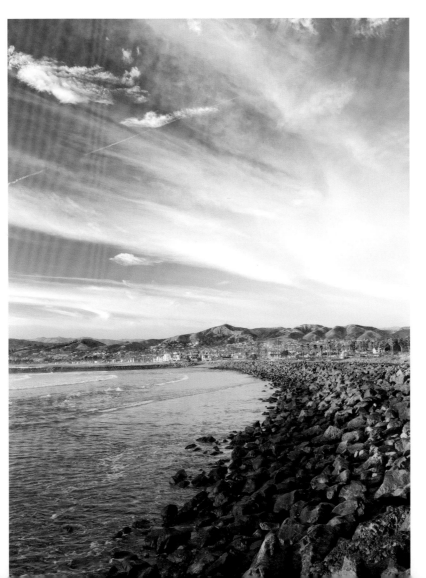

VENTURA OCEAN WAVES (*above*): Waves from the storm on Dec. 4, 2007, clashing against the Ventura Pier. 📷 HENRIK LEHNERER

UNTITLED (*left*): A warm late afternoon near Marina Park. 📷 AMERY CARLSON

SEAWEED AMONGST THE ROCKS (*far left*): Lucky to get some clearing in the clouds to show off some rays. The inlet on the lower right side is usually not visible during high tide. Photo taken in Point Mugu. 📷 ED JESALVA

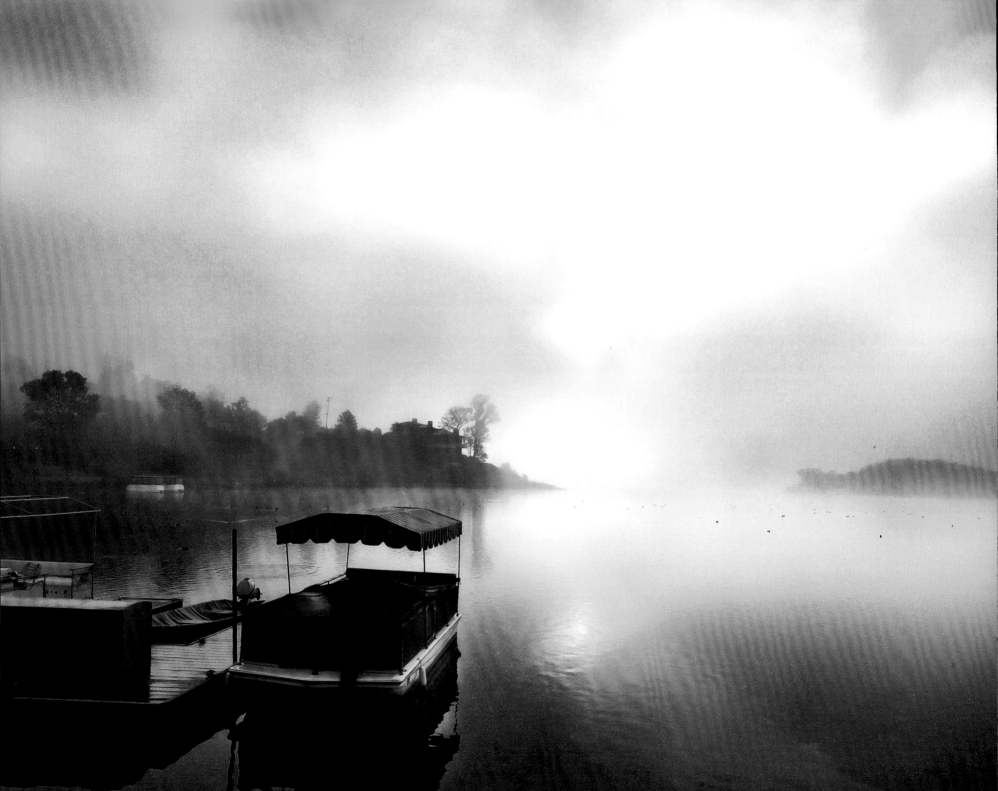

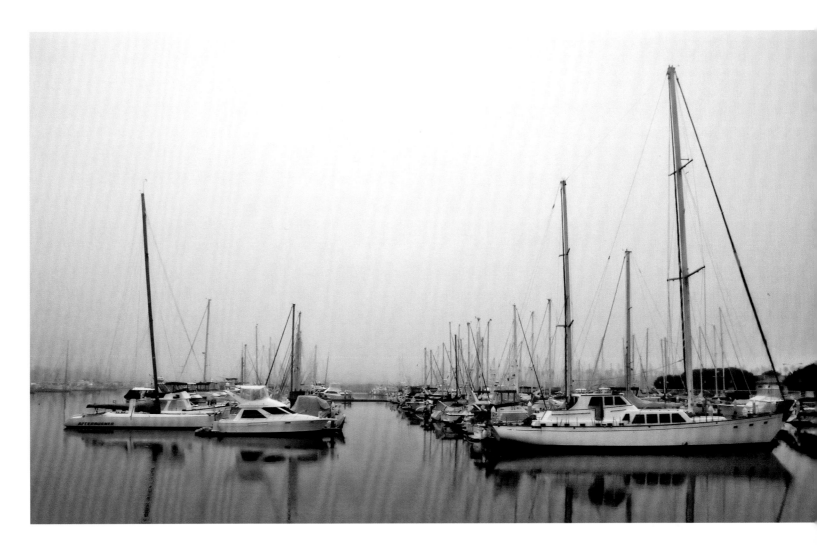

FOGGY HARBOR MORNING *(above)*: Taken at Ventura Harbor about 6:30 a.m. one foggy Sunday morning.
📷 CHUCK THOMAS

LAKE SHERWOOD SUNRISE *(left)*: Lake Sherwood is near Westlake Village. It's a man-made lake with upscale homes surrounding it. It's also next to the Lake Sherwood Country Club, where Tiger Woods and other noted celebrities play golf tournaments. 📷 ED JESALVA

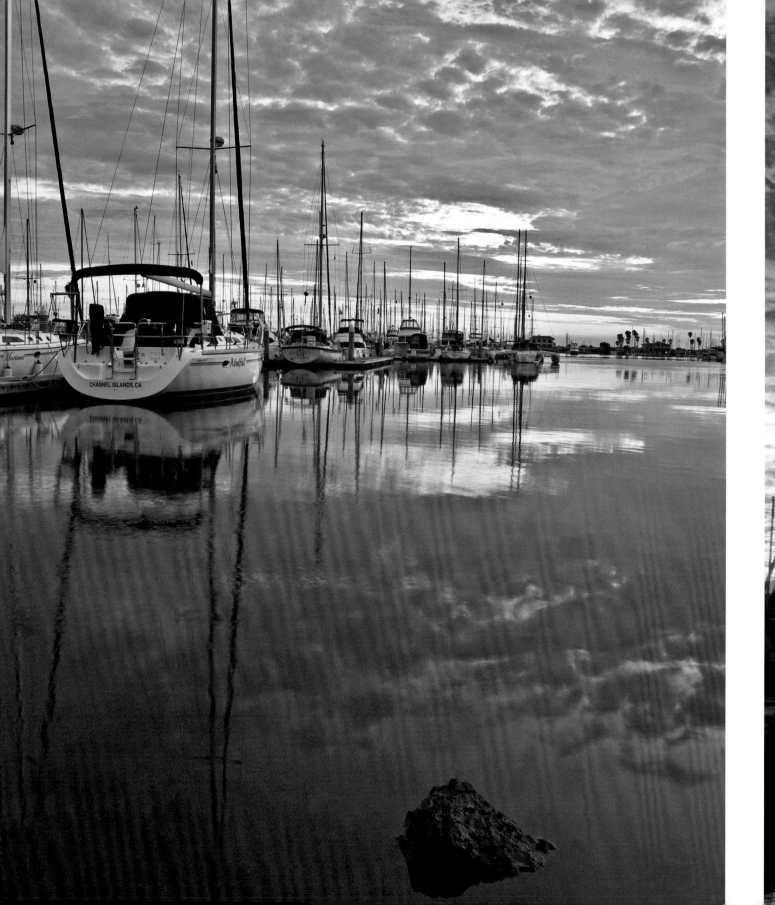

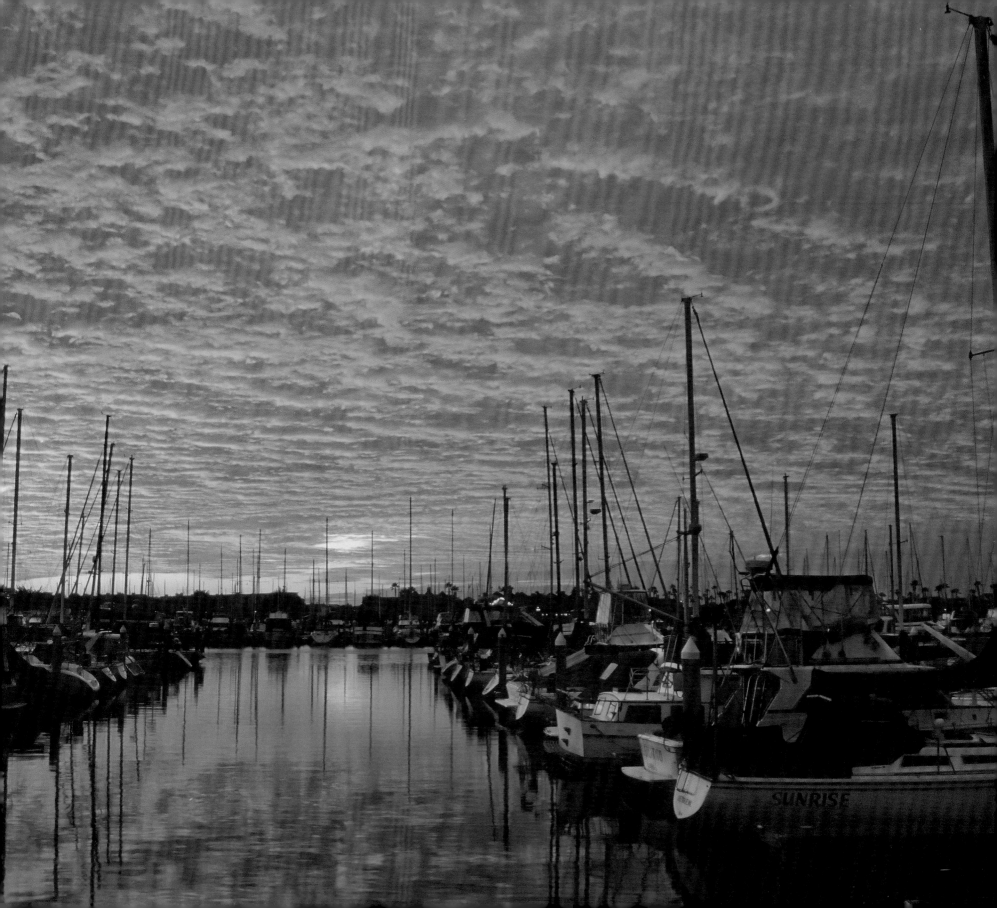

★ **VENTURA HARBOR** (*previous left*): Ventura Harbor after sunset. 📷 AMERY CARLSON

HARBOR SUNSET (*previous right*): Sometimes the clouds are just right when the sun sets. The sky just seems to pop with unimaginable hues and shapes. Even though this was sunset, the name of the boat in the foreground caught my eye as well: Sunrise! 📷 JIM PRETORIUS

TRANSCENDENTAL (*right*): I'm really getting into black and white lately. It's been raining the past few days with sporadic sunlight. This is a manual blend of two exposures, 35 seconds for the sky and 70 seconds for the foreground. 📷 TED RIVERA

★ **MUGU ARCH** (*below*): I saw photos of this arch before, but could never figure out where it was. I found it, but to get down there, you have to navigate down a very rocky hillside down to the ocean itself. It was windy, getting dark, but I still managed to clean my lens and get this 14-second exposure at f/13. 📷 JOHN MUELLER

THE VIEW (*following left*): Inside the barrel. 📷 CHRIS ALLEN

★ **MCGRATH BEACH** (*following top*): Sea gulls hanging out on the beach at high tide. 📷 BRIAN MCSTOTTS

SEA FOAM (*following bottom*): Sea foam creeping up the beach. 📷 ZACH BARKER

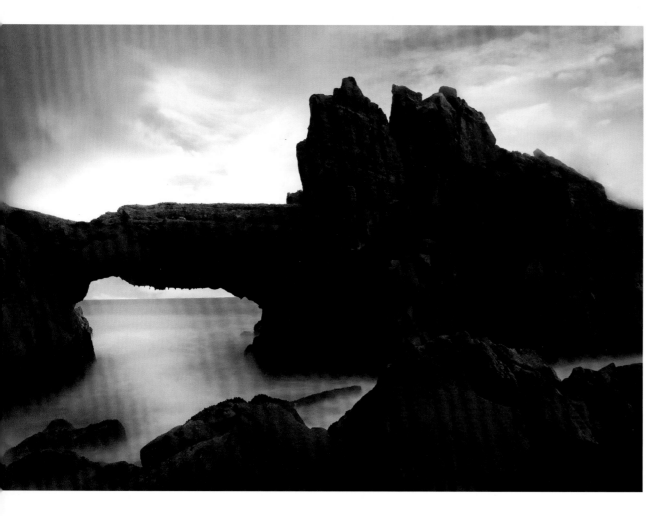

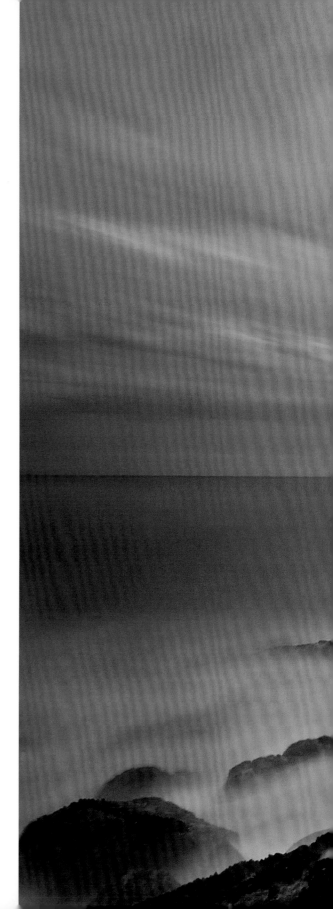

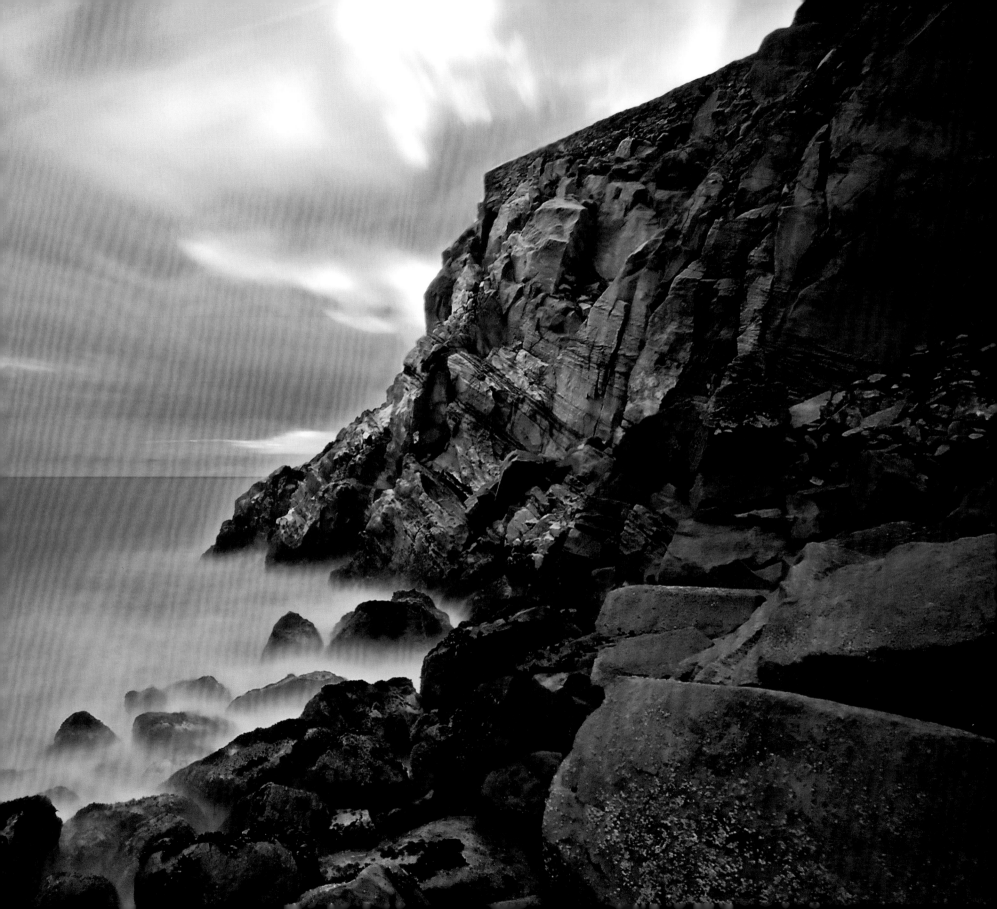

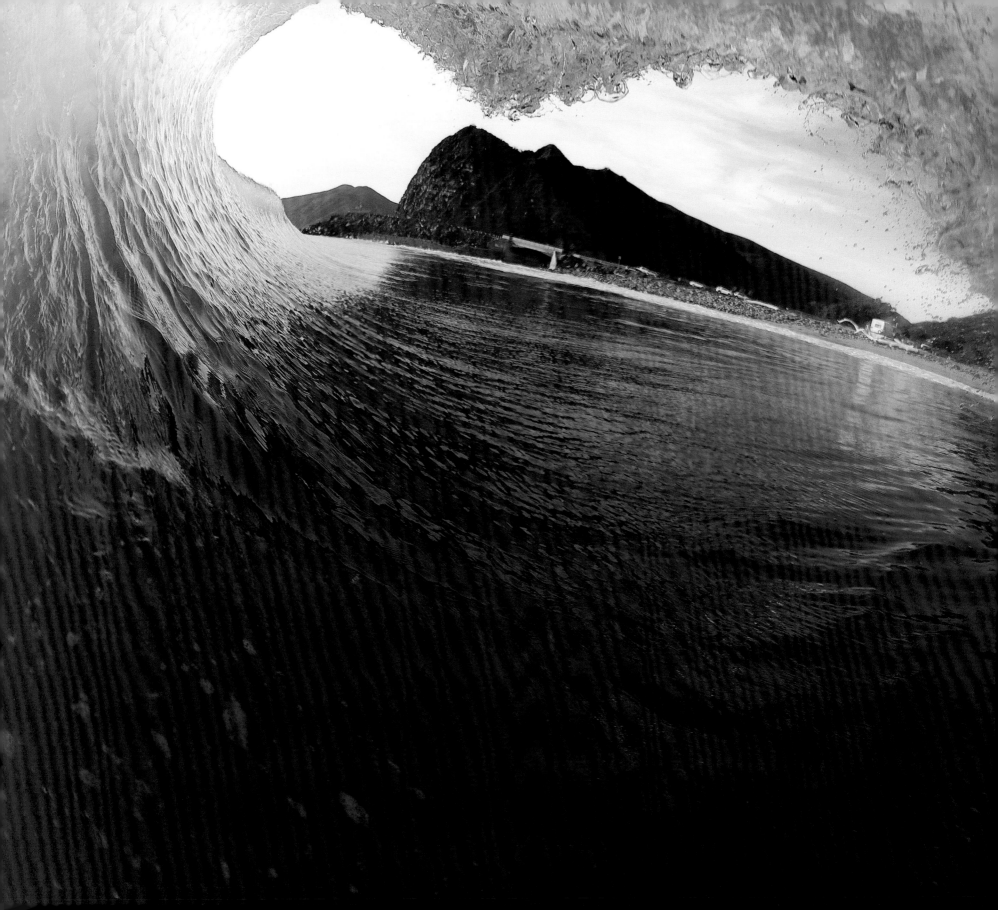

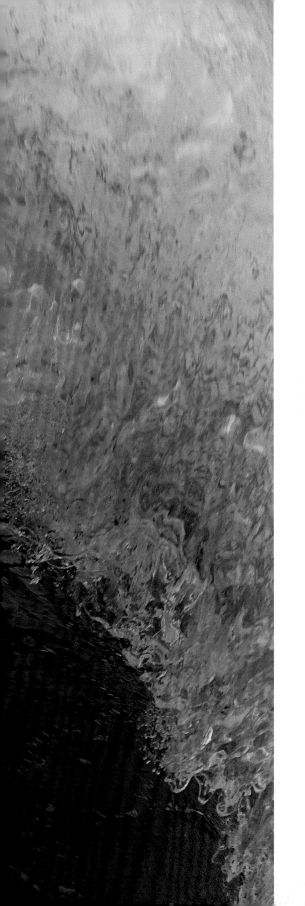

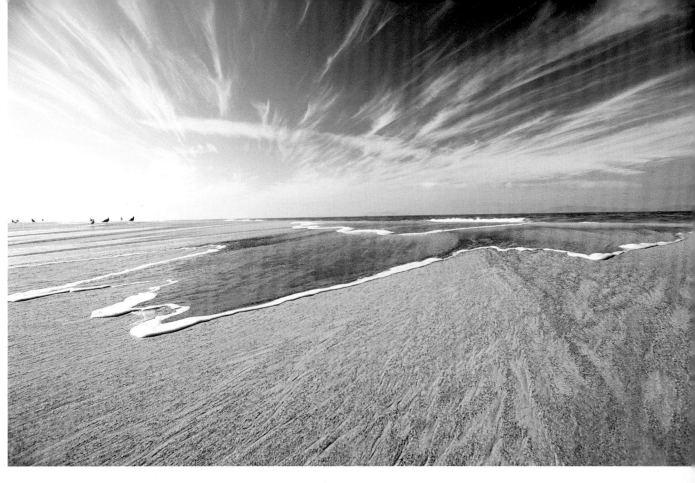

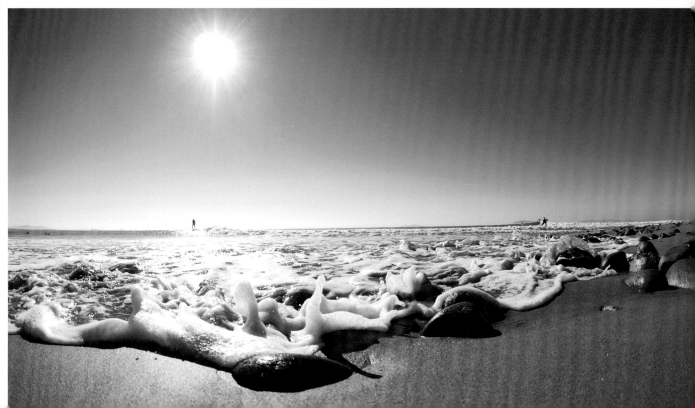

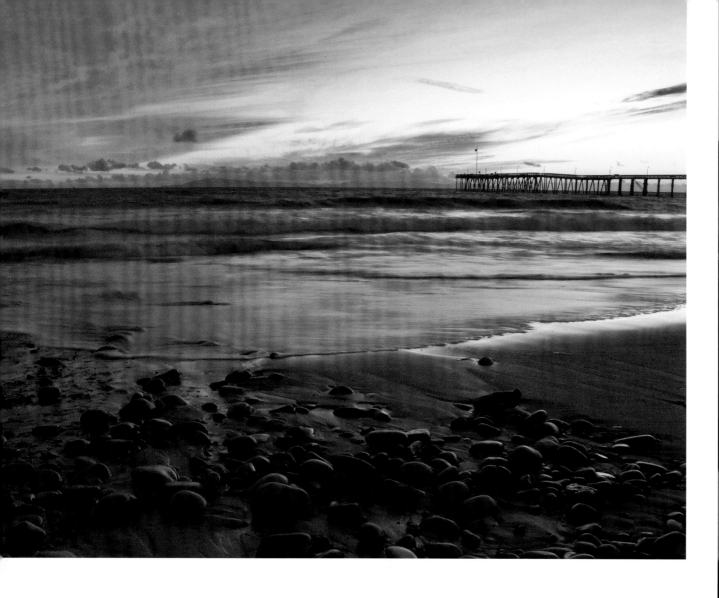

SAN BUENAVENTURA STATE BEACH *(above)*: A view of San Buenaventura State Beach at sunset. 📷 AMERY CARLSON

PURPLE PIER *(right)*: The Ventura Pier during an awesome sunset. 📷 TOM BAKER

VENTURA SUNSET FROM A HILLTOP *(following left)*: One of numerous sunsets we have in Ventura each year. This one is more dramatic because of the massive thunderhead. 📷 KURT PREISSLER

TALL SHIP AND ANACAPA *(following top)*: I saw this ship while driving down the 101 freeway and just had to stop and take some pictures. 📷 DEREK GULDEN

ANACAPA LIGHTHOUSE AFTER THE STORM *(following bottom)*: Anacapa Lighthouse after the storm. 📷 KURT PREISSLER

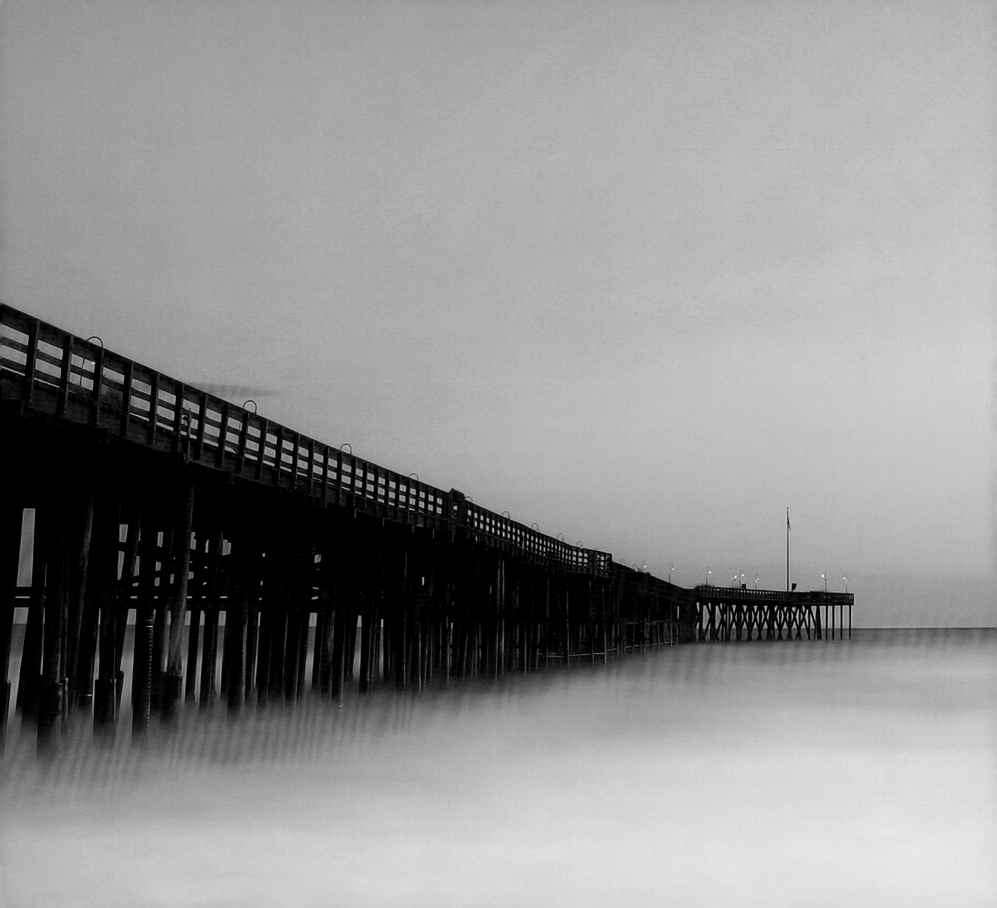

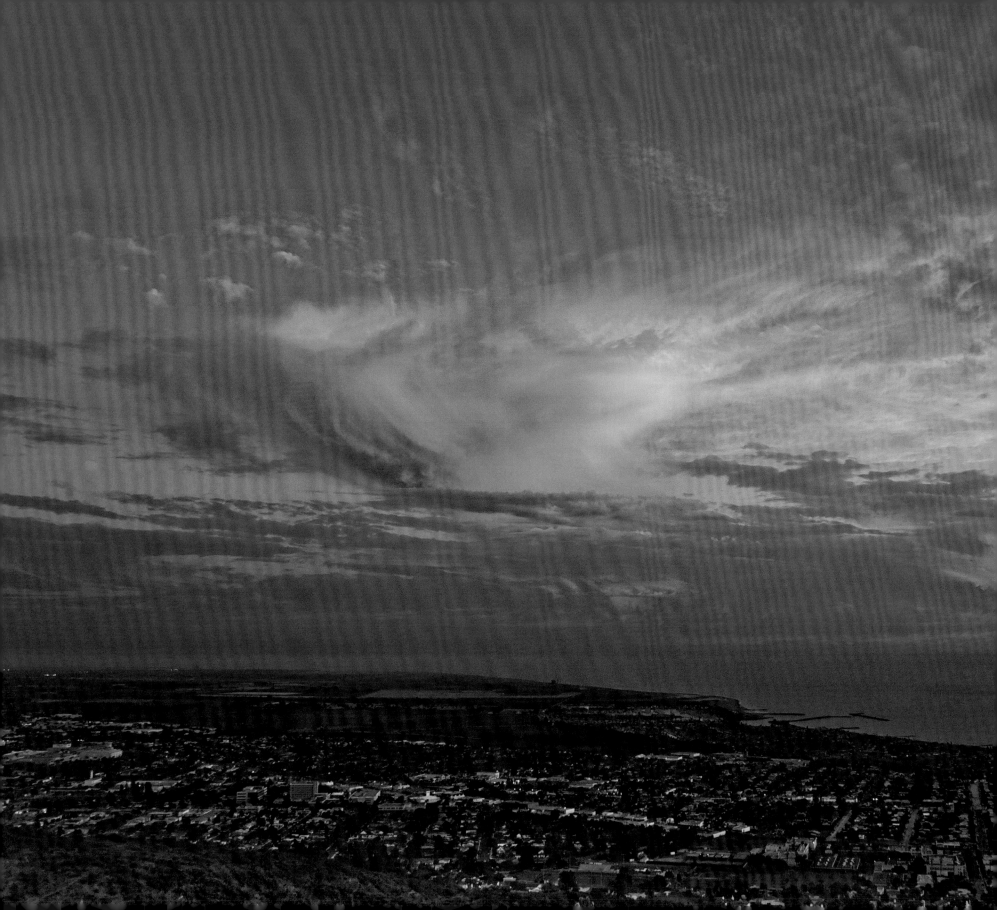

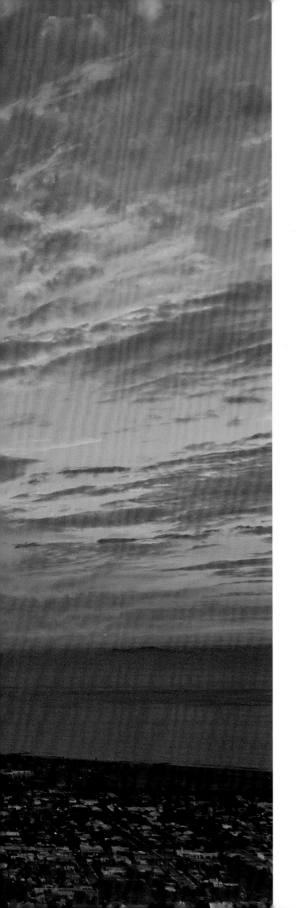

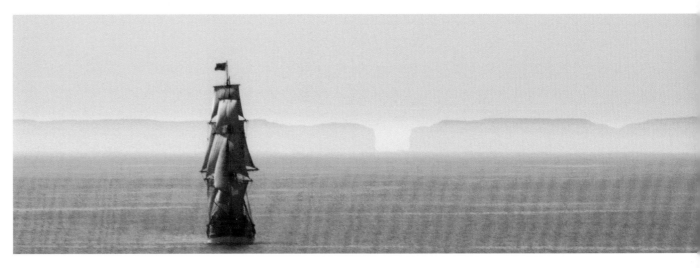

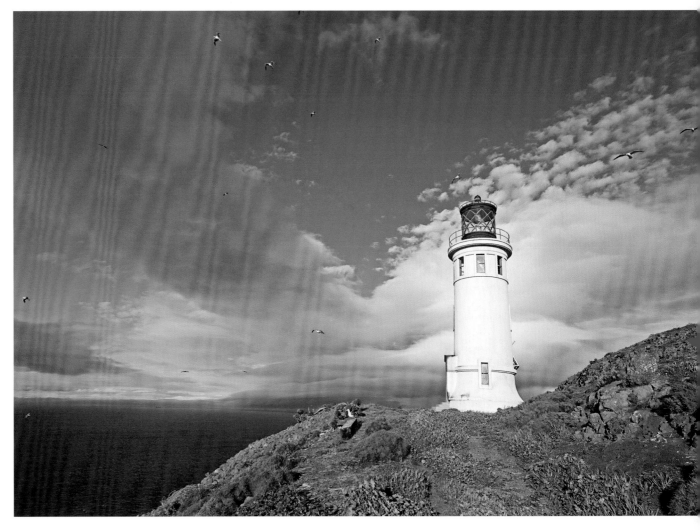

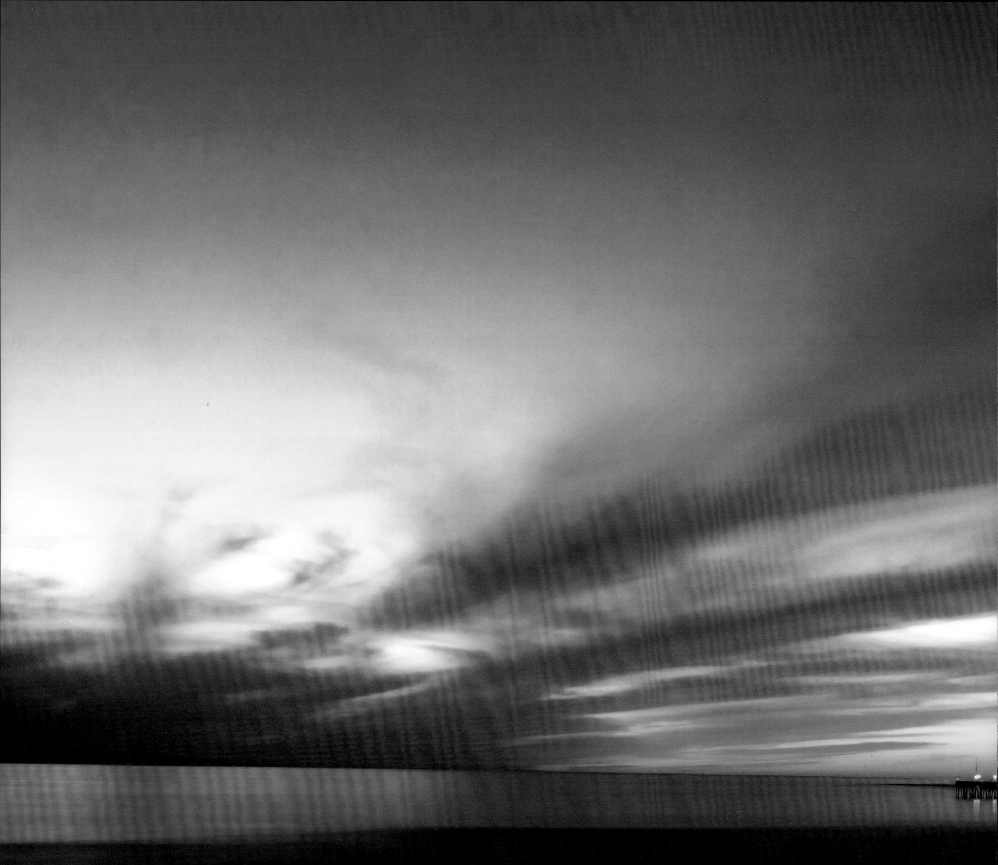

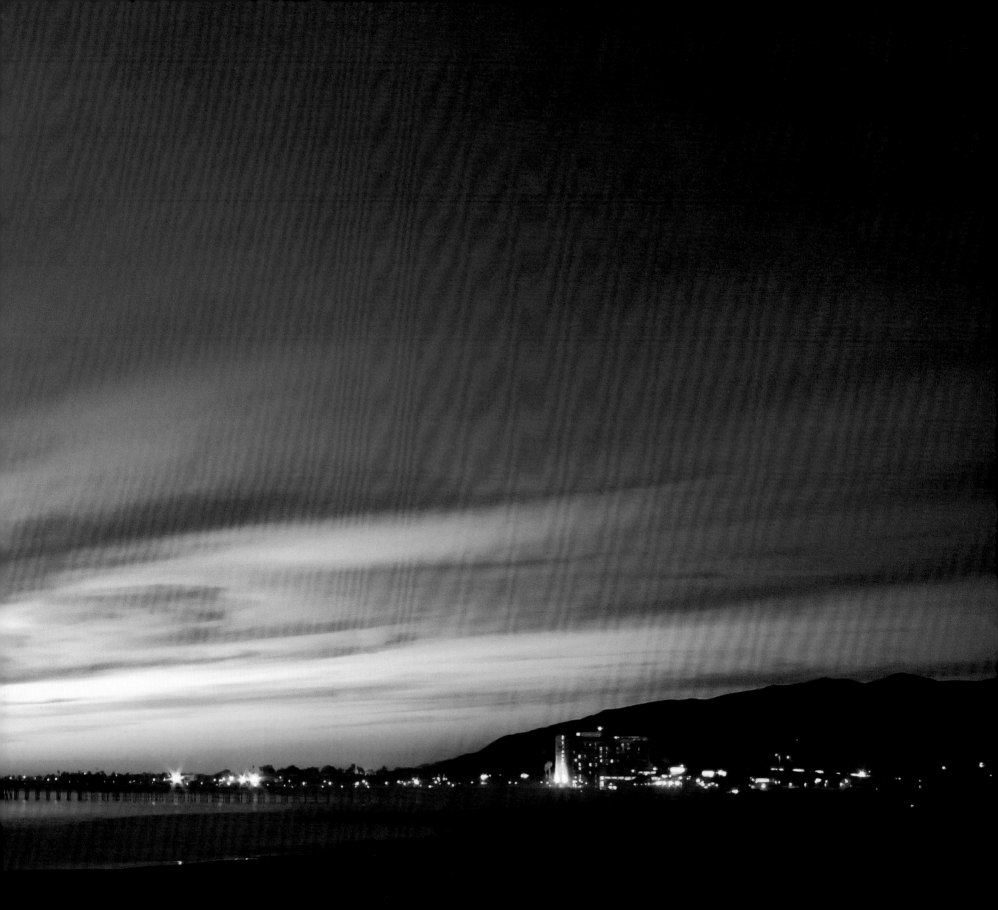

VENTURA PIER : WINTER SKY
(previous): Taken January 2007, this long exposure captures the last light on a winter day in Ventura. The clouds in the sky are prelude to an approaching storm. 📷 PATRICK KENNEDY

FLYING NORTH DURING A CALIFORNIA SUNSET
(right): Taken between Emma Wood and Solimar Beach. This stretch of beach, in my opinion, is one of the most beautiful beaches in the state of California. It's where the ocean meets the mountains with a little bit of sand in between.
📷 JASON MEDINA

FINAL LIGHT ON THE PROMENADE *(far right):* An early summer sunset at Surfer's Point.
📷 PATRICK KENNEDY

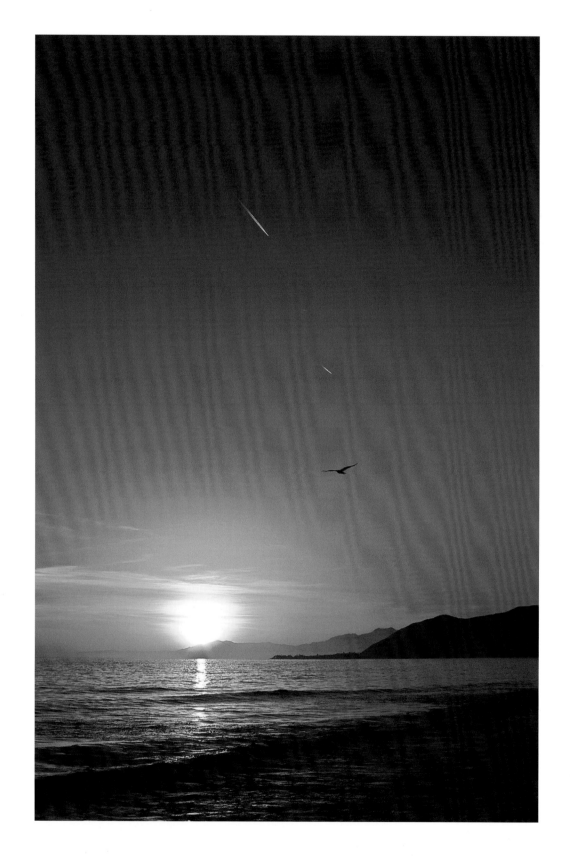

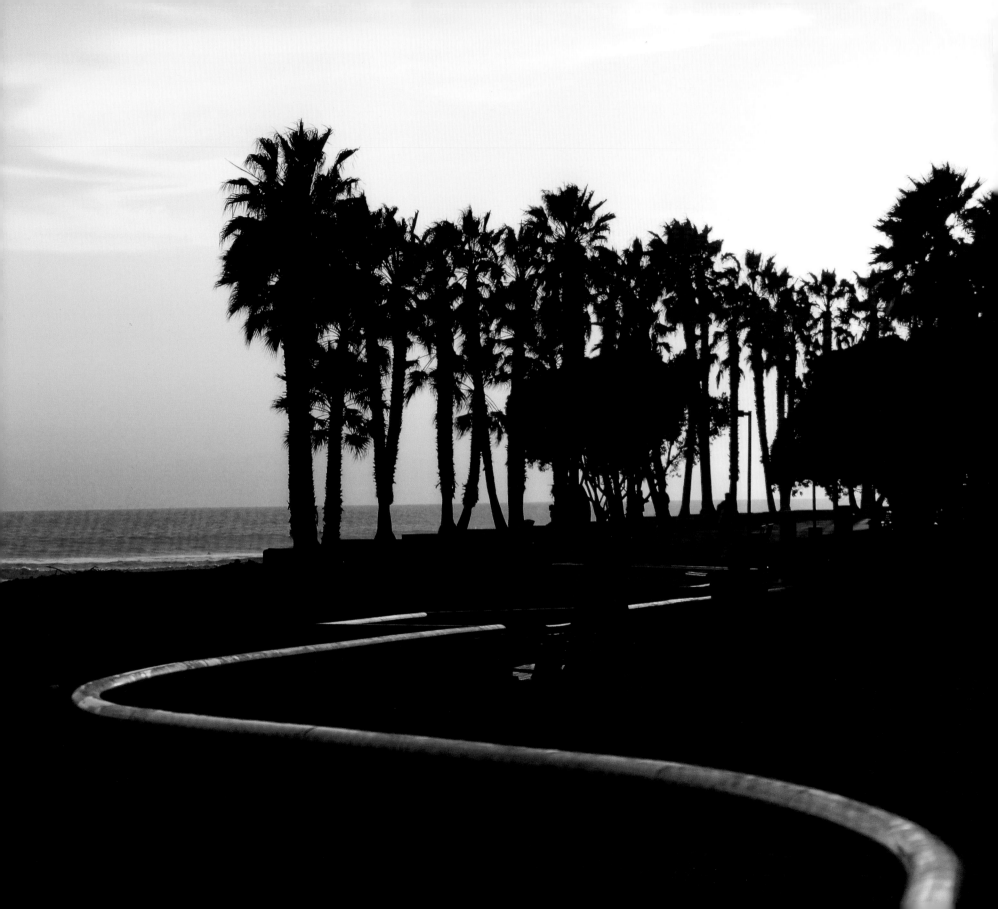

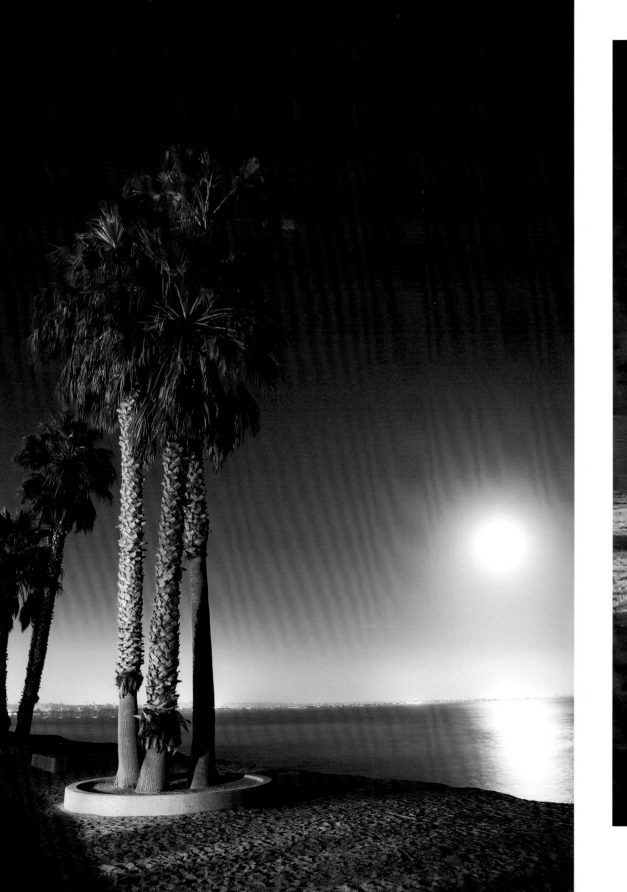

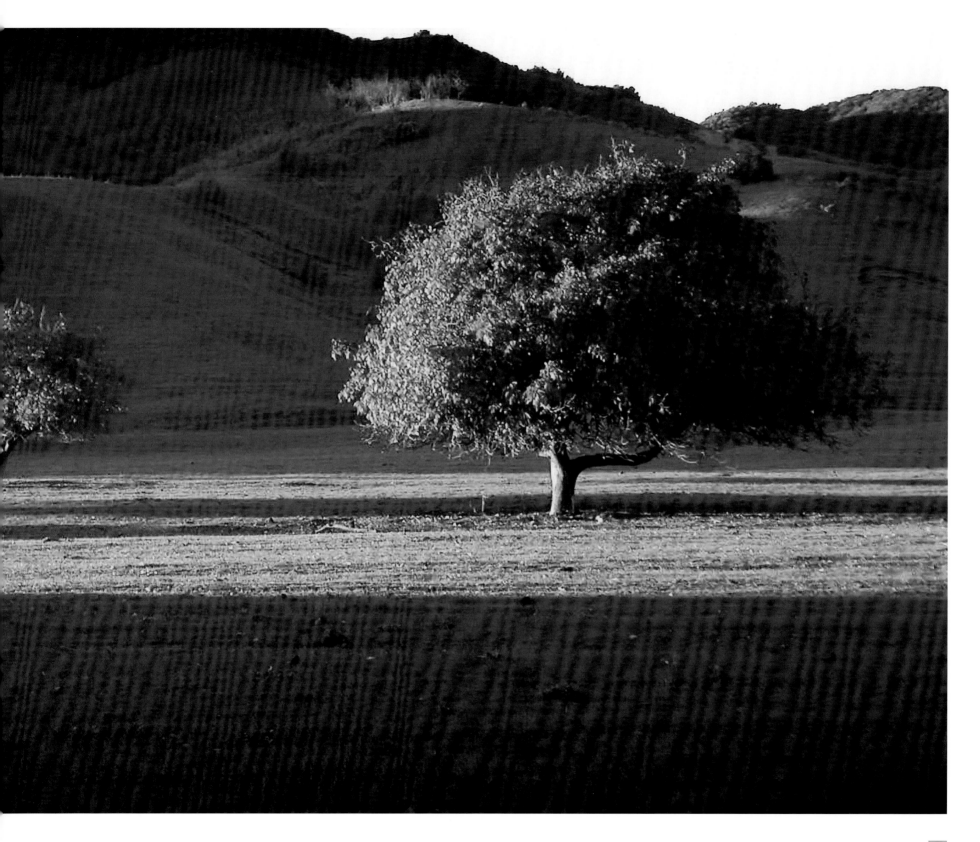

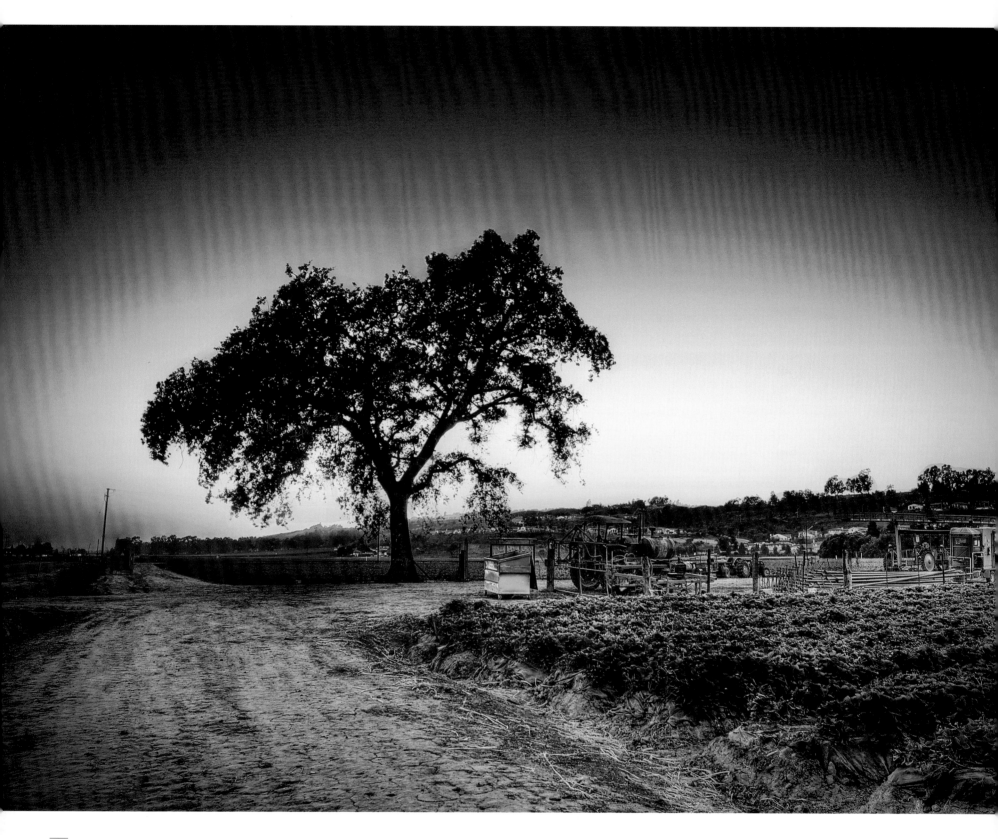

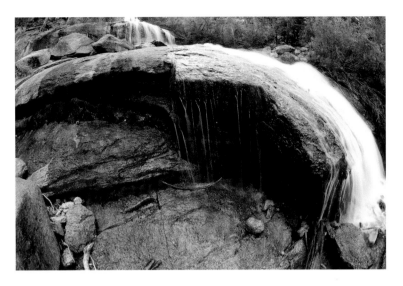

WATER'S RHYTHM (left): Spring runoff in Ojai backcountry. I shot this with a 16 mm fisheye. I thought it complimented the round shape of the rock well. 📷 PAUL POWERS

VENTURA HIGHWAY (far left): Drive north on the 101 and you'll see this oak tree, all by itself, on the side of the freeway. There isn't another oak tree for thousands of miles (ok, feet) so this one just sticks out. It makes me think how this landscape looked hundreds of years ago, with the golden grass, rolling hills and untouched nature. Maybe there'd be a trail made by animals, and then Native Americans, then cowboys, then cars... and now the 10-lane 101 Freeway. 📷 JOHN MUELLER

VENTURA EVENING (previous left): Palm trees are lit up by the moon at night near Surfer's Point in Ventura. 📷 TOM BAKER

TREES (previous right): Late afternoon sun paints hills and a pair of trees in the Cañada Larga Valley north of Ventura. 📷 THOMAS GAPEN

FOGGY FARM (below): A foggy morning in the Casitas Valley shows a quiet farm enveloped in fog. 📷 BENJAMIN KUO

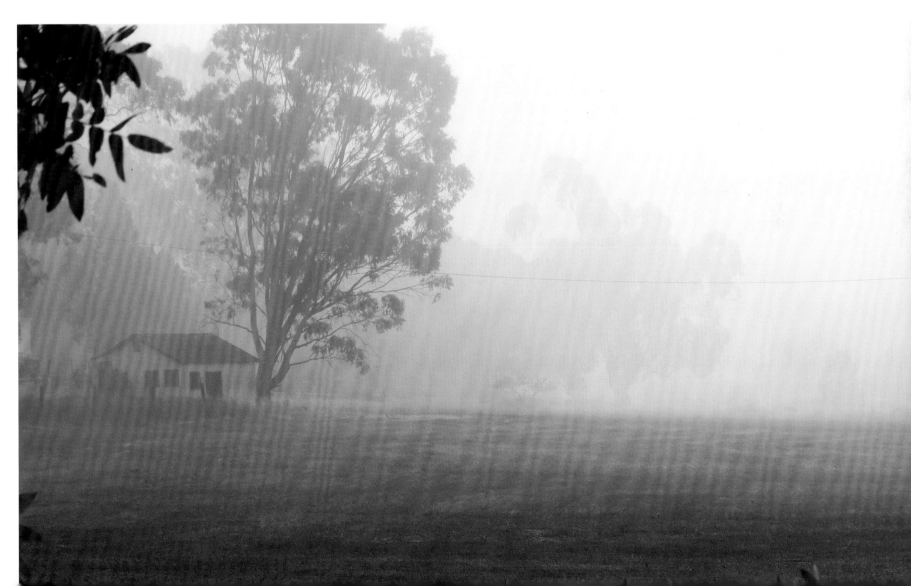

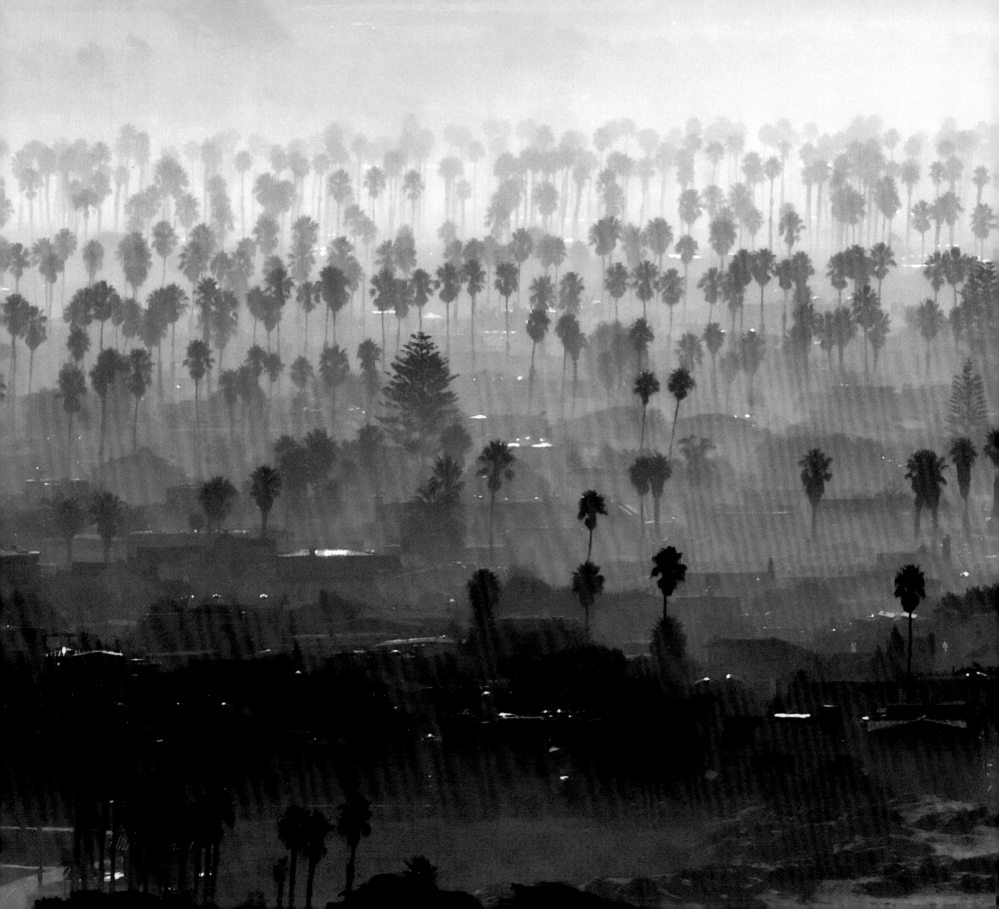

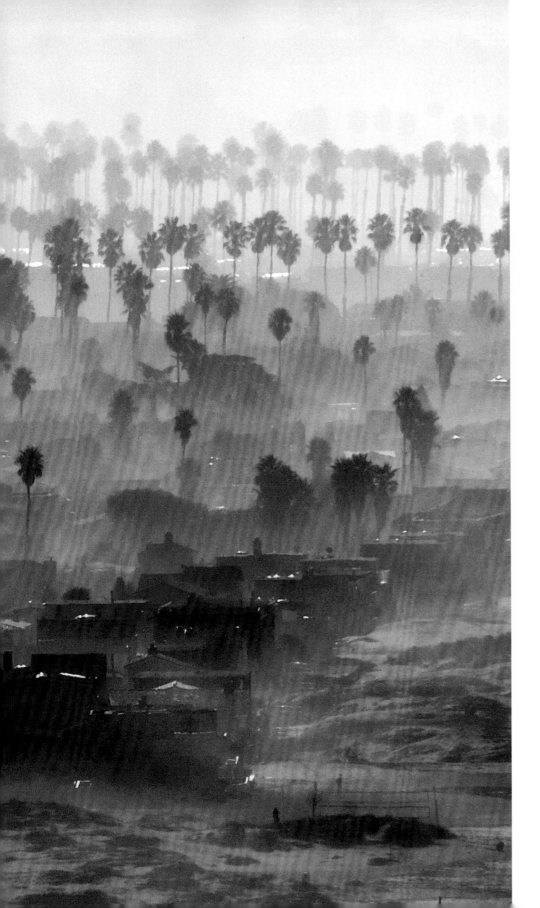
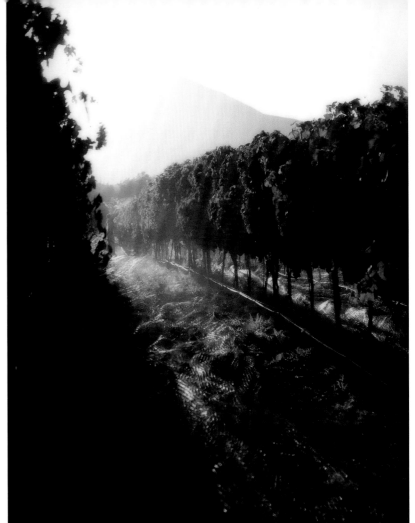
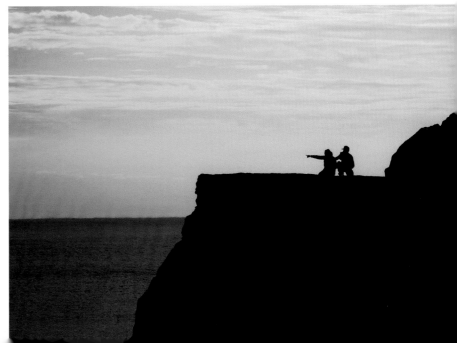

MARIGOLDS AND BARN (*right*): This picturesque barn in Santa Paula is set off a field of brilliant marigolds. 📷 JOE VIRNIG

PIERPONT (*previous left*): Palm trees are sihouetted in the Ventura fog overlooking the Pierpoint neighborhood in Ventura, as seen from Grant Park. 📷 DANA RENE BOWLER/VENTURA COUNTY STAR

SUN BETWEEN THE ROWS (*previous top*): Boccali's morning pick and crush. Working at sunrise was fun but challenging. Some people asked me what is on the ground. It is netting to keep the birds and critters from eating the grapes. The vines are Boccali's syrah. 📷 KRISTINE ELLISON

POINTING TOWARDS THE FUTURE (*previous bottom*): Mugu Rock still yields some of the best shots in California. I got lucky on this one. 📷 JOHN MUELLER

OXNARD GREENHOUSES (*following*): Late afternoon on a beautiful January day. Really captures the year-round agriculture here in Ventura County. 📷 JOE VIRNIG

CLOUDS, FIELDS AND SOUTH MOUNTAIN (*below*): Parsley field with clouds and South Mountain. 📷 JOHN NICHOLS

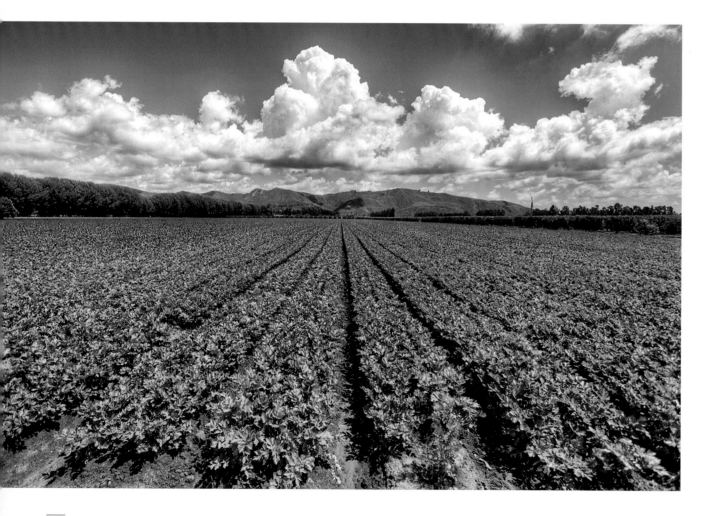

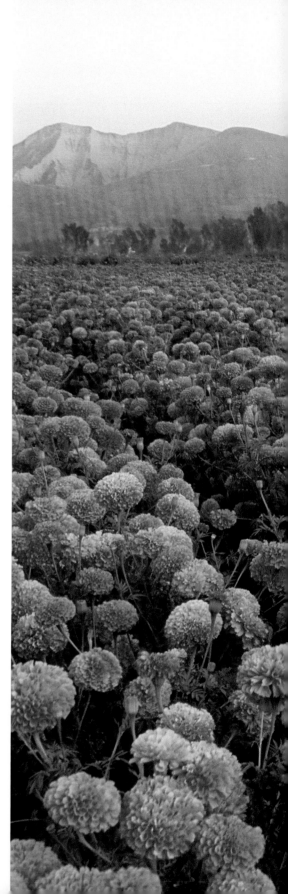

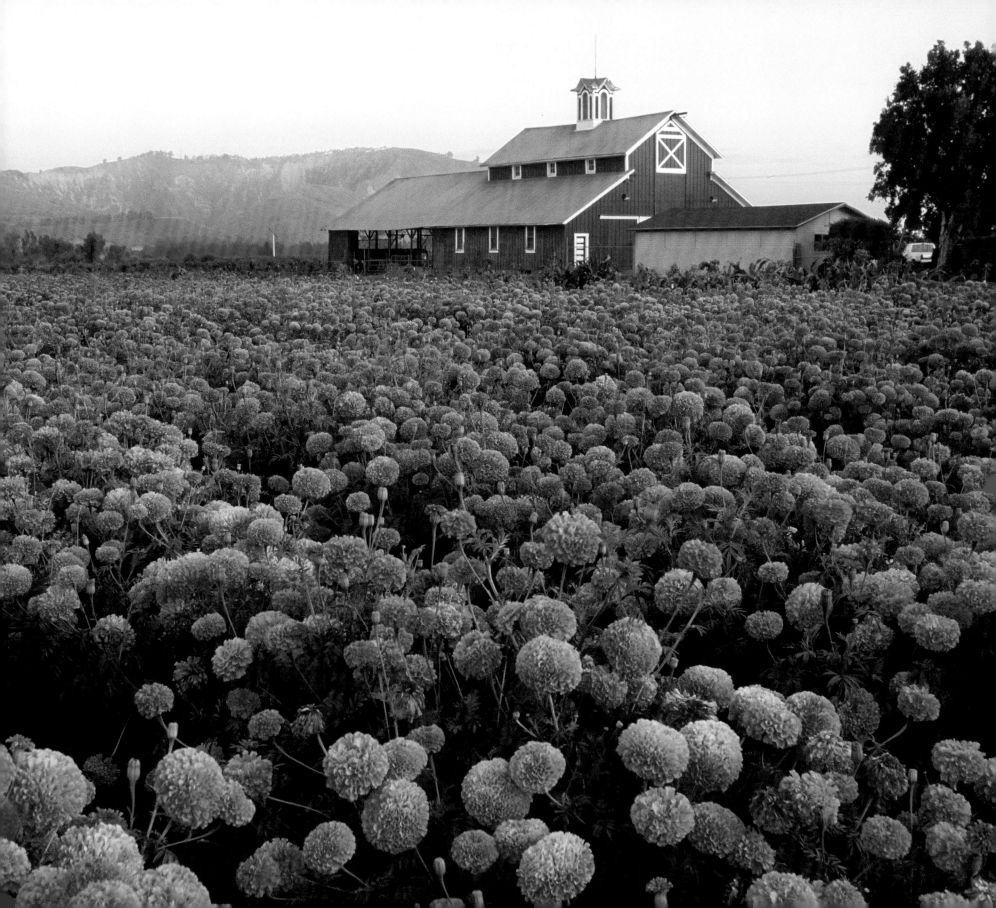

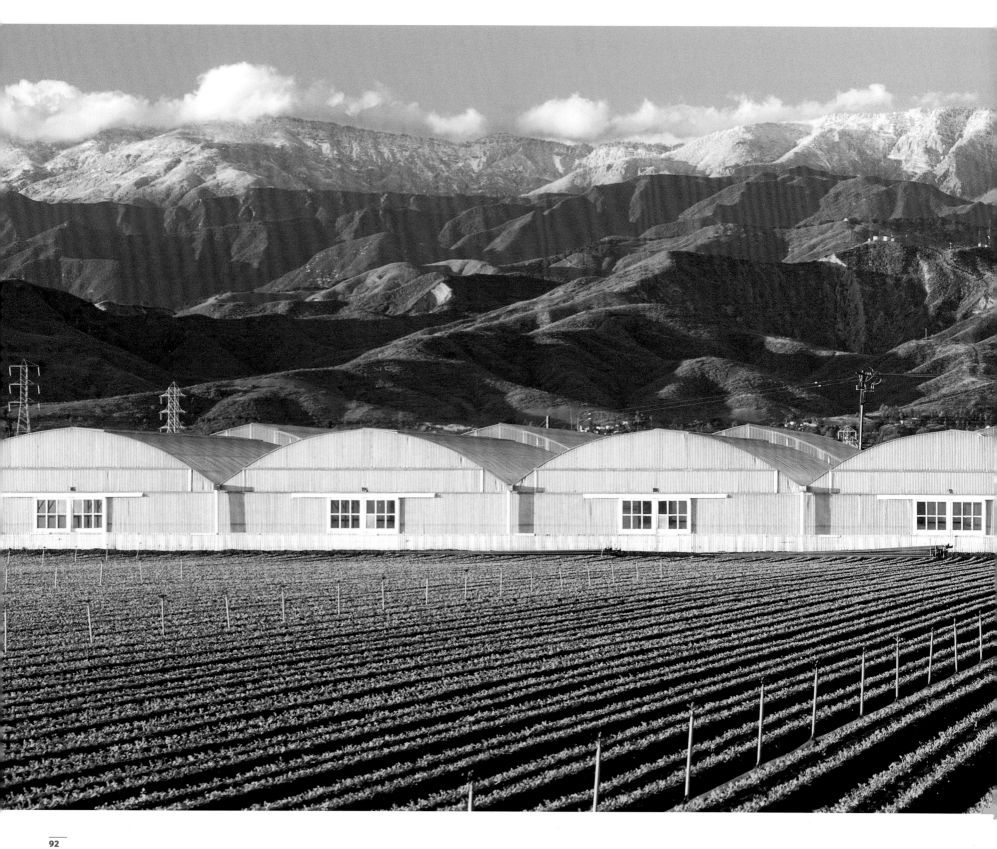

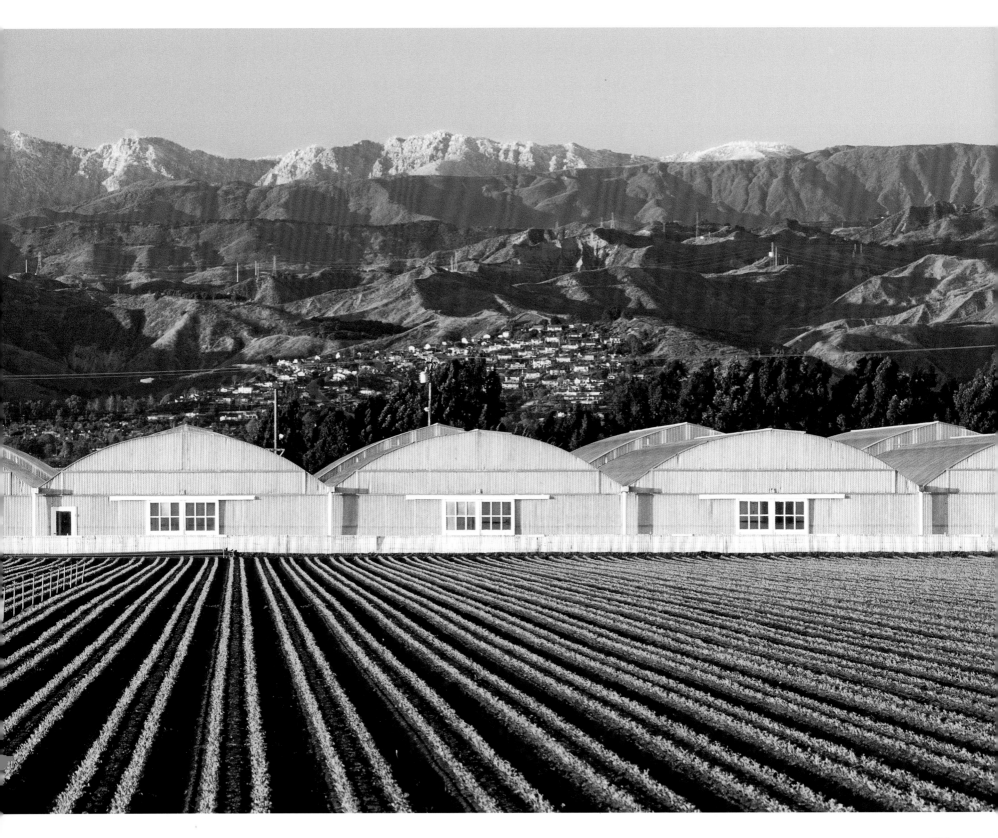

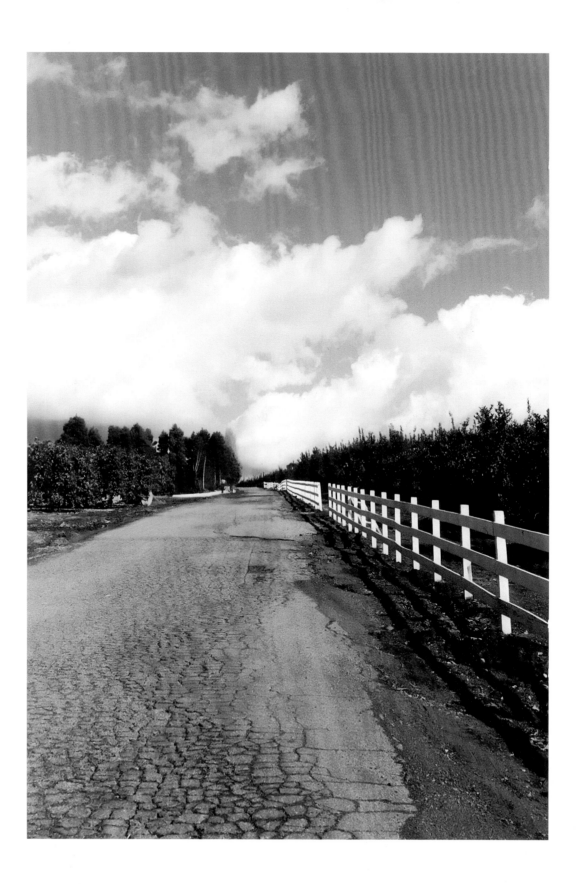

WORTH WAY *(right)*: Worth Way. Photo taken in Camarillo 📷 KRIS HASHIMOTO

RICH LAND - READY TO PLANT *(far right)*: I loved the lines and lighting. Early morning shot. 📷 SHARON GANSER

MORNING MUSTARD *(following left)*: The early riser is rewarded with this view of mustard during the spring in Upper Ojai 📷 JACK STAFFORD

VENTURA TRAIN TRACKS *(following right)*: The train bridge just as the sun was going down. It's a structure all Ventura residents are familiar with. 📷 ANDREW UVARI

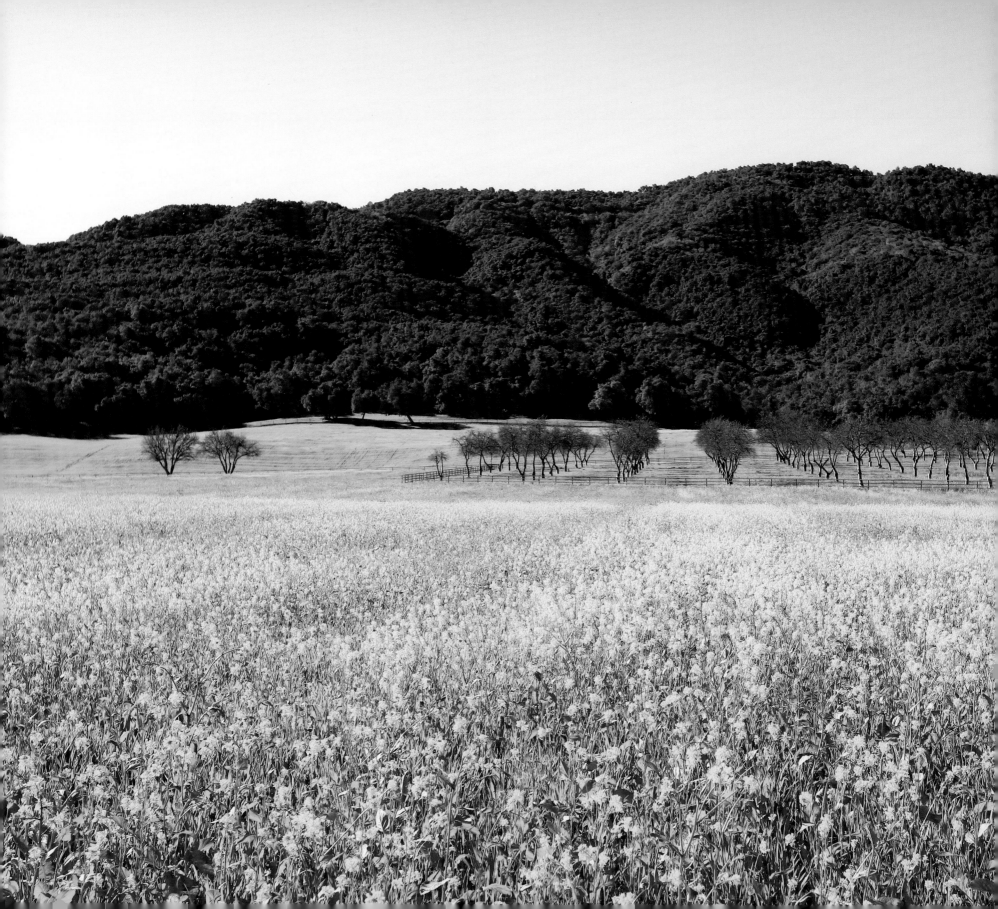

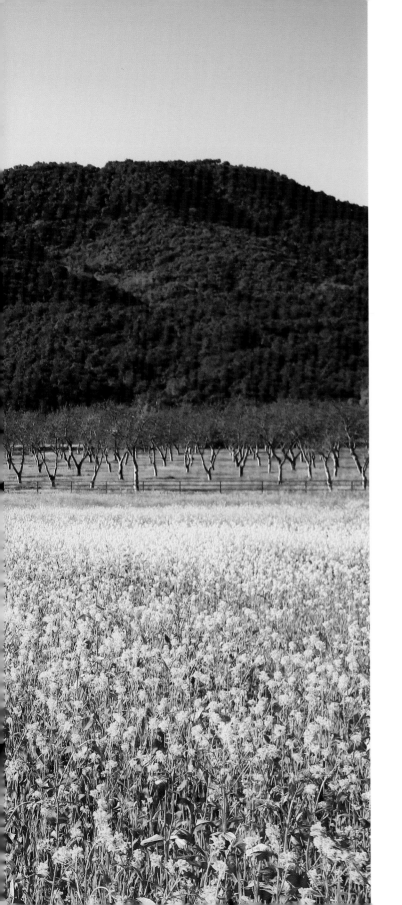
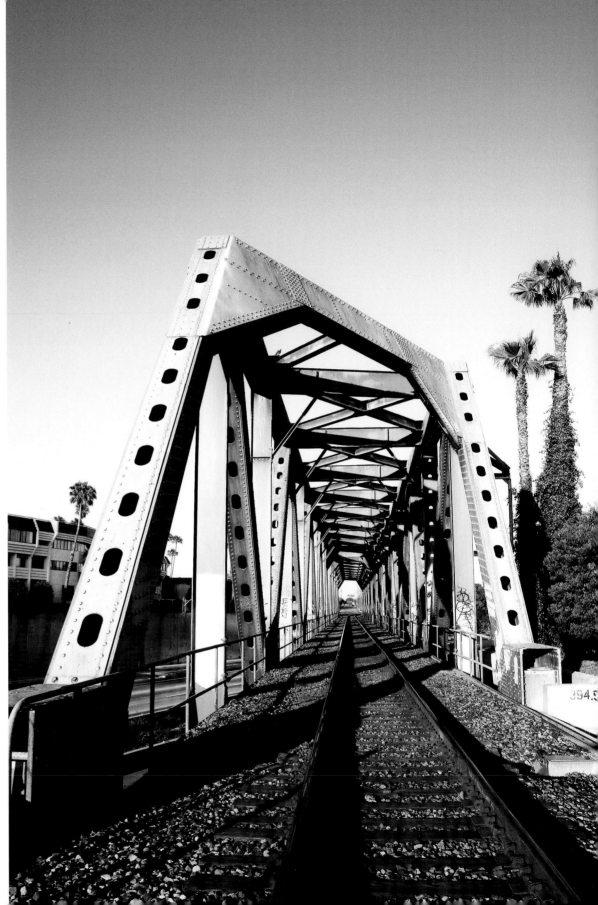

LOWER LAKE AT ROSE VALLEY (*right*): Ventura rarely shows any difference in the seasons. It's nice to enjoy the change. 📷 SHARON DEMELE

SLOW DOWN, IT'S HOT! (*opposite*): This is one of the very few "straight out of the camera" shots I'll ever submit. But, I couldn't find anything wrong with it. Sometimes, I get lucky. 📷 JOHN MUELLER

NIGHT AT VENTURA HARBOR VILLAGE (*below*): It was almost dark and I was done for the evening, but I had to get my camera out one last time when I saw the last golden light balanced perfectly with the reflected lights across the harbor. 📷 JOE VIRNIG

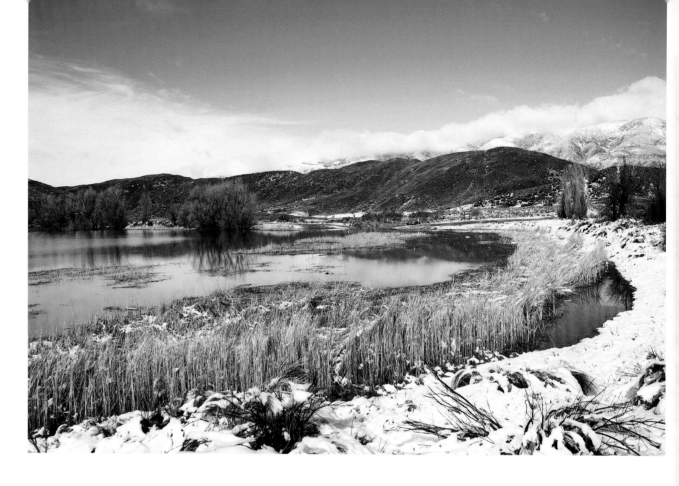

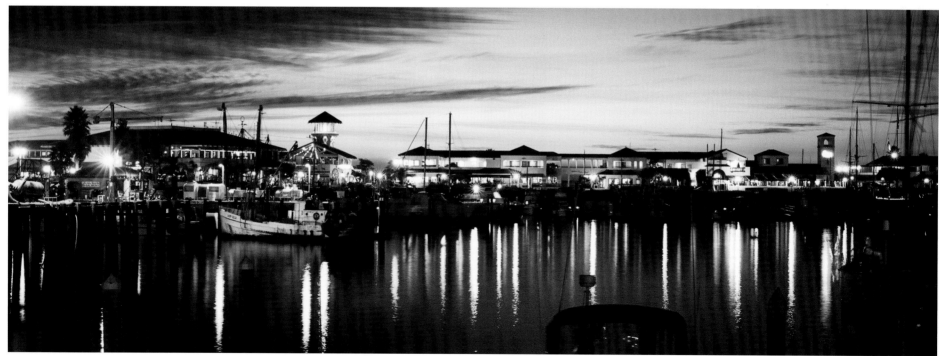

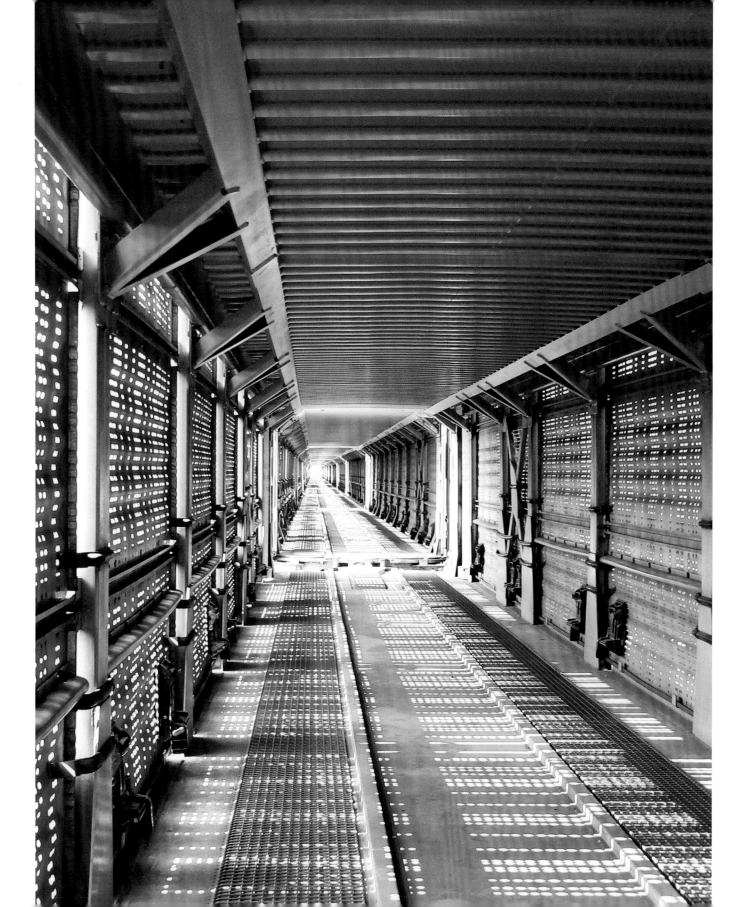

ENDLESS *(right)*: Train cars from inside at Port Hueneme.
📷 LAURA HORTON

CALIFORNIA STREET
(far right): View of California Street from the front of City Hall on Poli Street. I could hear the waves crashing that morning.
📷 JOE VIRNIG

HARBOR VILLAGE PANORAMA
(following): Ventura Harbor Village at sunset. Sometimes it all comes together, a good vantage point and interesting sunset.
📷 STEPHEN SCHAFER

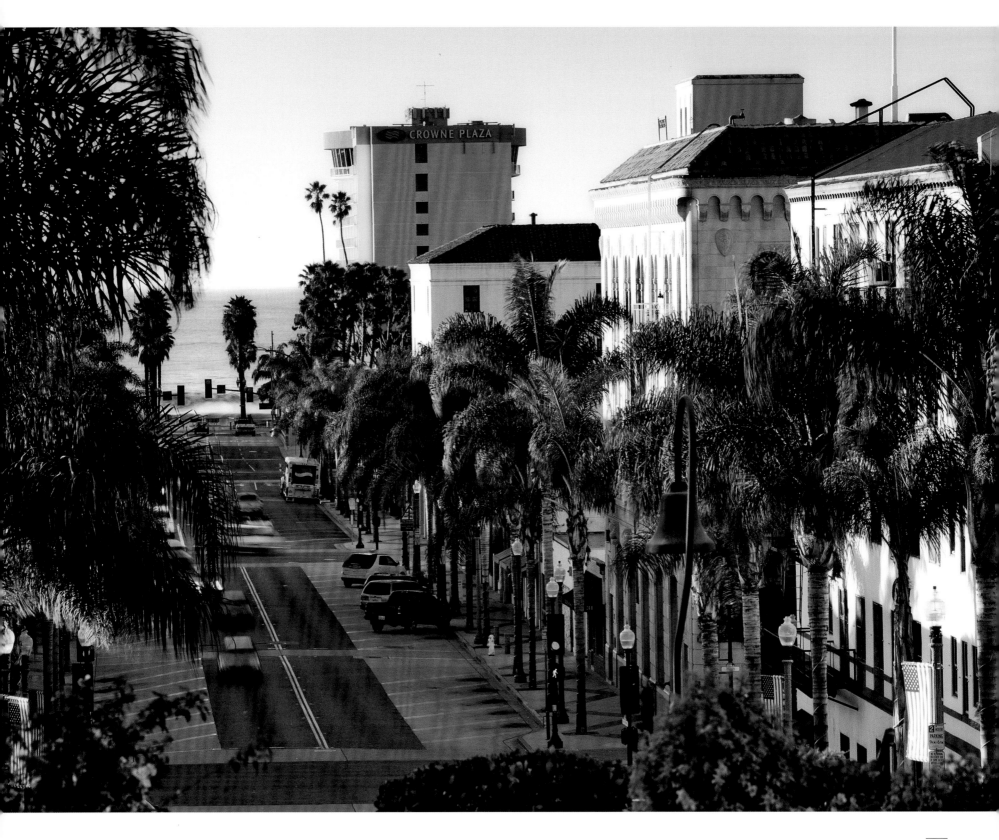

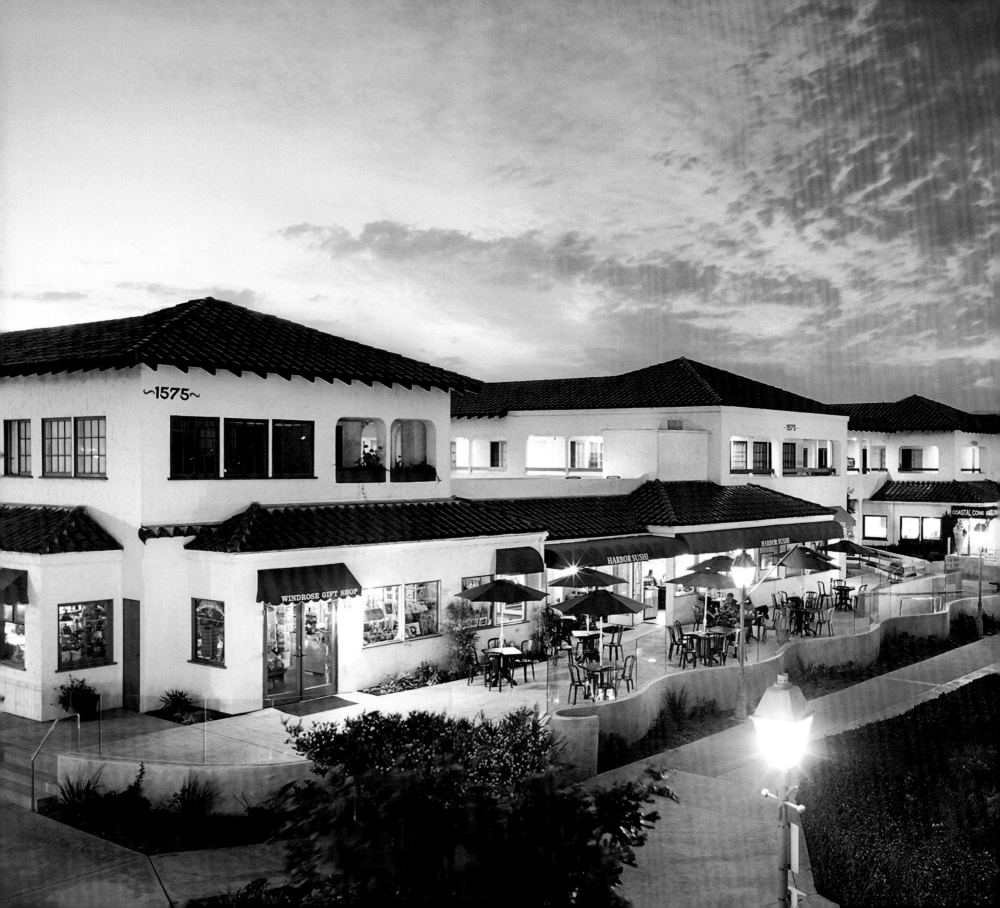

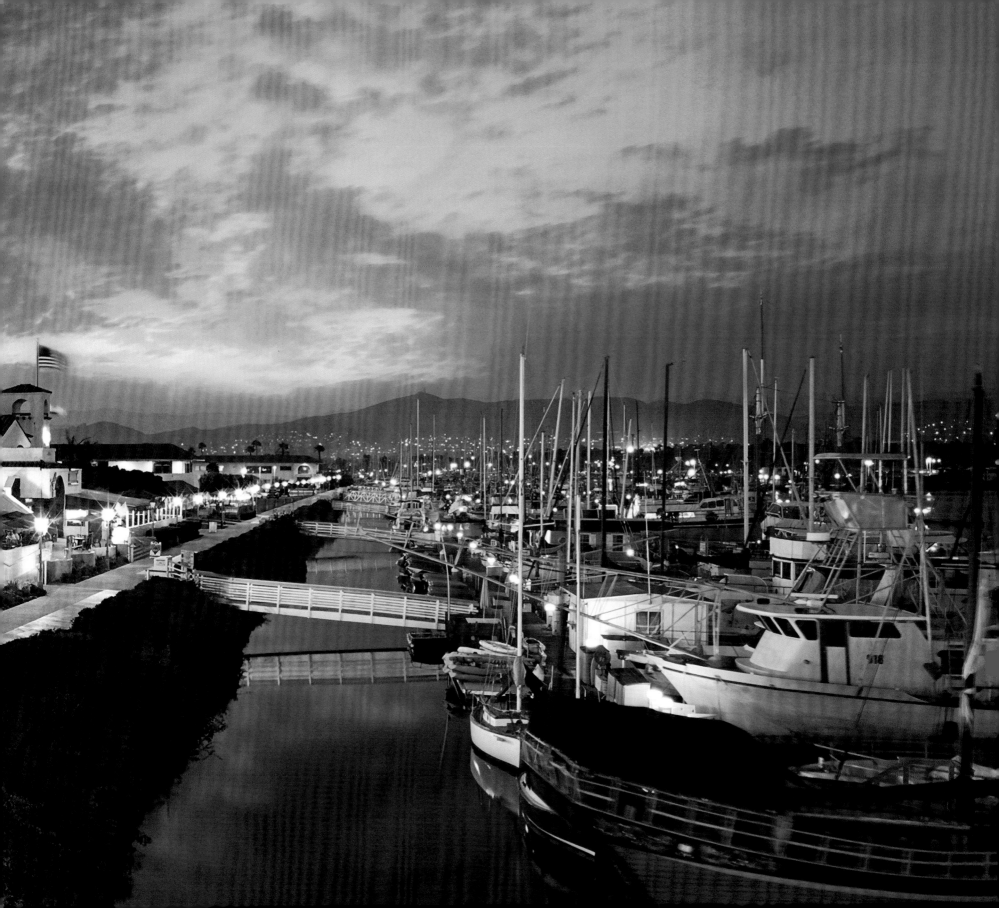

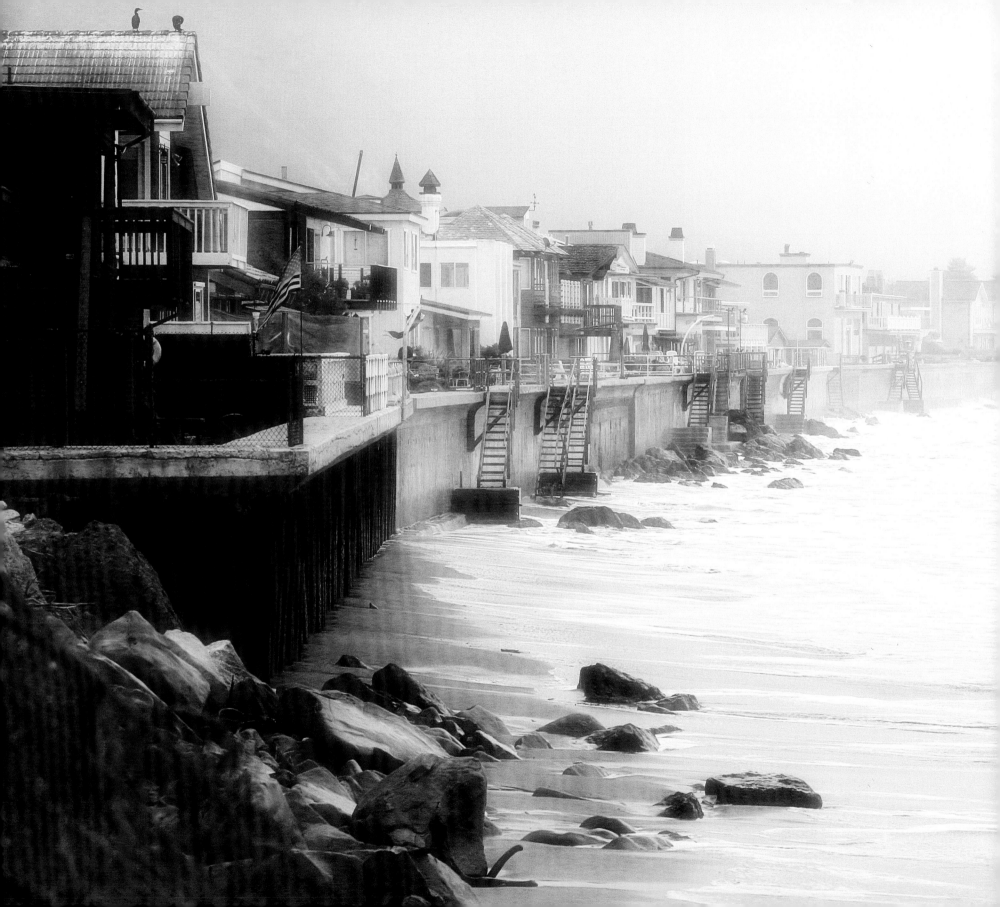

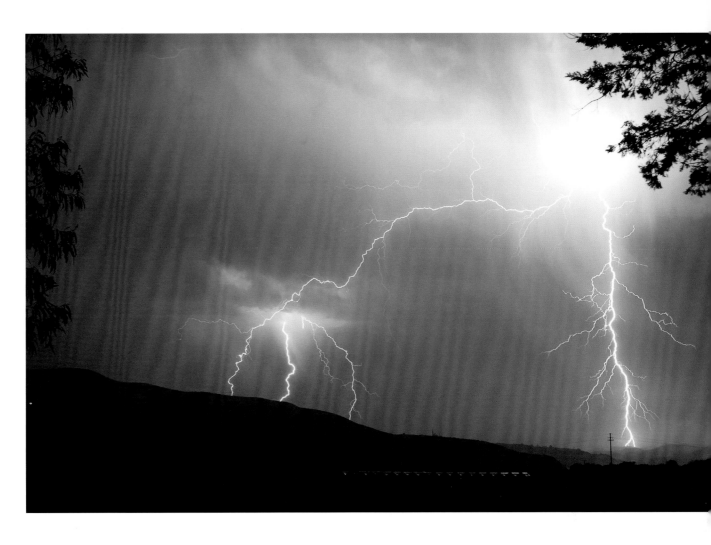

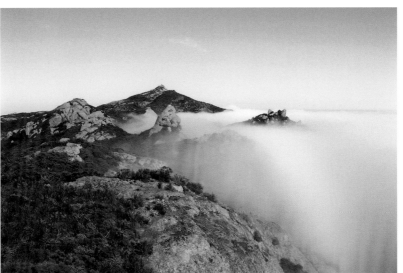

SUMMER STORM (*above*): It's not very often we have lightning in Southern California, and even more amazing when it's like it was this night. For over three hours, some of the most amazing bolts of lightning were streaking across the sky. 📷 ANDREW LIVINGSTON

HIKING ABOVE THE CLOUDS (*left*): When I left the car to hike up Sandstone Peak, the weather was damp and the marine layer was thick. My effort was rewarded when I emerged above the cloud layer into a crystal-clear morning. 📷 JIM PRETORIUS

INTO THE MIST (*far left*): The fog quickly moves in along the shore near Rincon Beach. 📷 TERRANCE DOBROSKY

Nature

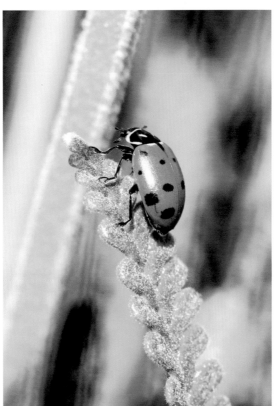

FLYING FREE (*previous left*): Red-tail hawk flying free. 📷 JULIE REITER

FIG LEAF (*previous top*): The lighting one day just caught my eye on one of our fig trees in my backyard. I loved the way this turned out. The figs are good, too! 📷 SHARON GANSER

LADYBUG (*previous middle*): Ladybug traveling up long leaf. 📷 MARILYN GOULD

A NEW BIRD LEAF (*previous right*): The sun was shining from the outside. This made the color pop! 📷 KRISTINE ELLISON

★ **CALIFORNIA BROWN PELICAN** (*top*): A California brown pelican glides above a mirror-like ocean in the Santa Barbara Channel. This pelican was catching drafts off the boat that gave it a free and seemingly effortless flight out of Ventura Harbor. 📷 ANTHONY LOMBARDI

AMERICAN AVOCET (*bottom*): This guy walked right up to me. Taken at Emma Wood State Beach, at the lagoon. 📷 ROBERT WETTERAU

GONE FISHING (*opposite left*): A snowy egret hunts for small fish along the shallows of the J Street estuary at Ormond Beach. 📷 ROB VARELA/VENTURA COUNTY STAR

FOCUSED PELICAN (*opposite right*): This is a humorous shot of a very "focused" California brown pelican that is about to catch a meal. 📷 ANTHONY LOMBARDI

★ **FIRST LIGHT** (*opposite bottom*): I awoke early on a Monday morning before the sun came up and decided to head to the beach to catch the sunrise. I ran into this family of birds on the shore. The sun was just creeping up through a little valley in the hills above, setting the perfect spotlight on my friends. 📷 PAUL POWERS

HUMMINGBIRD TONGUE (*following left*): Remaining watchful for intruders in its territory, a male Allen's hummingbird displays its tongue. 📷 PAT CHING

PELICAN IN FLIGHT (*following right*): I was lucky enough to run into about 100 pelicans hanging out in the channels between the homes in the Oxnard marina. They flew in straight lines right over my car and I had many chances to catch one in flight. 📷 JOE VIRNIG

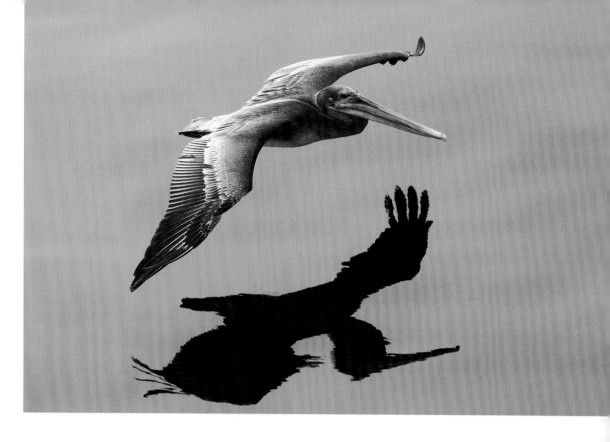

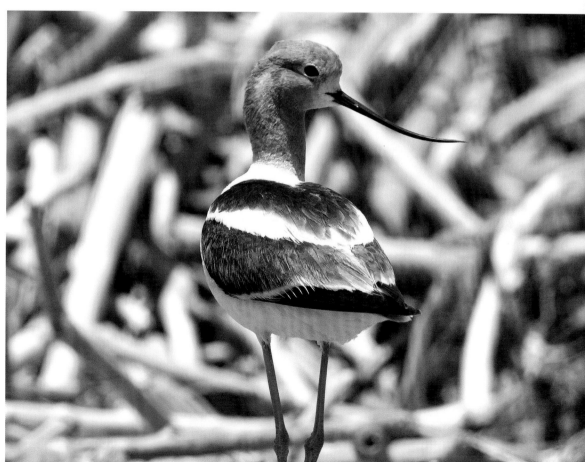

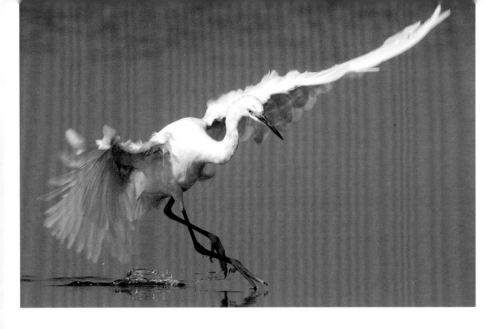

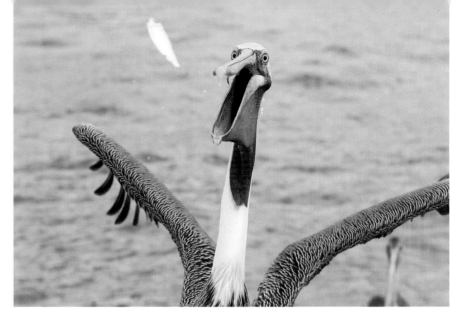

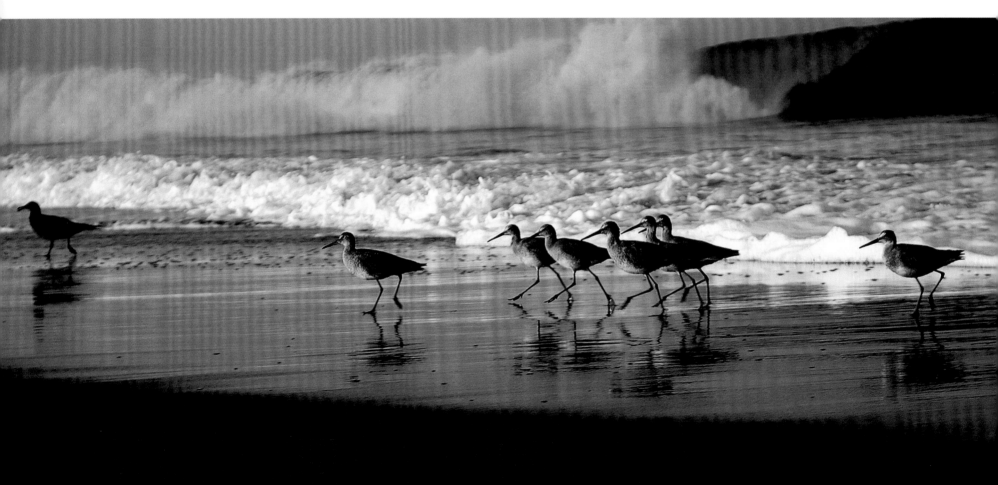

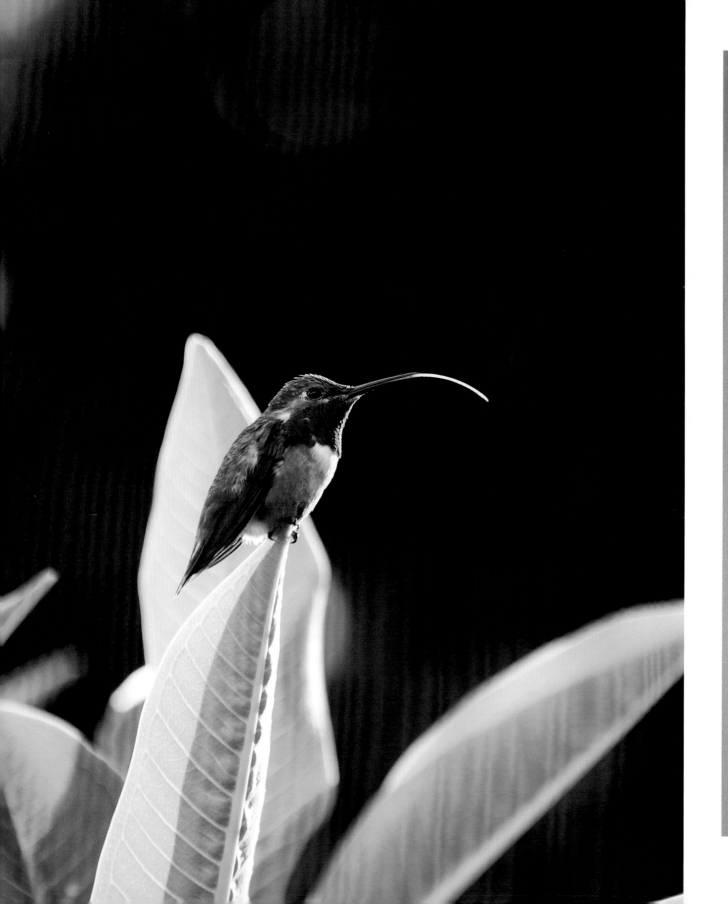

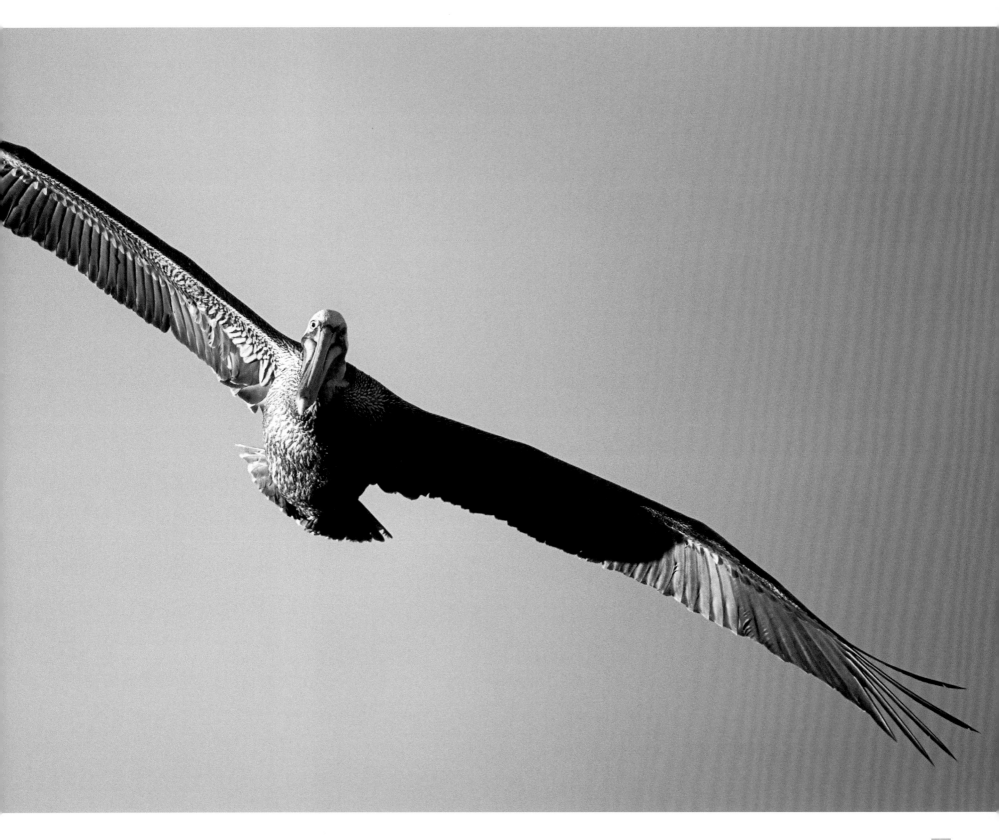

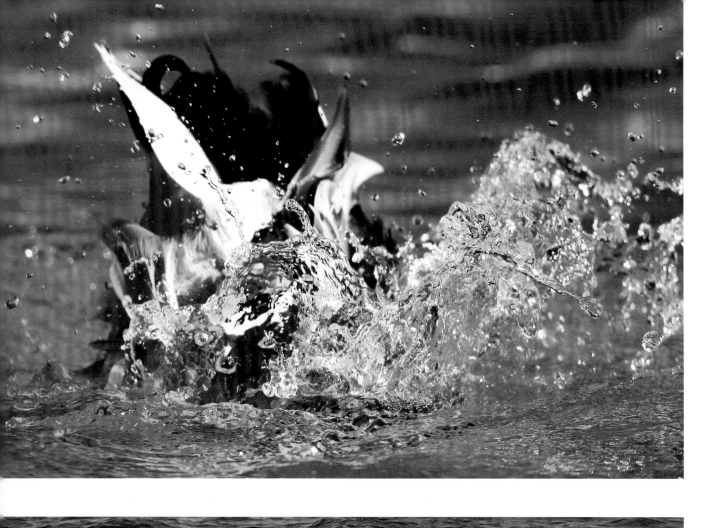

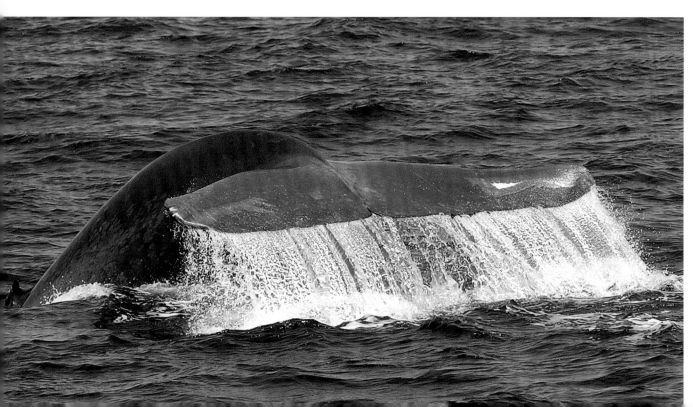

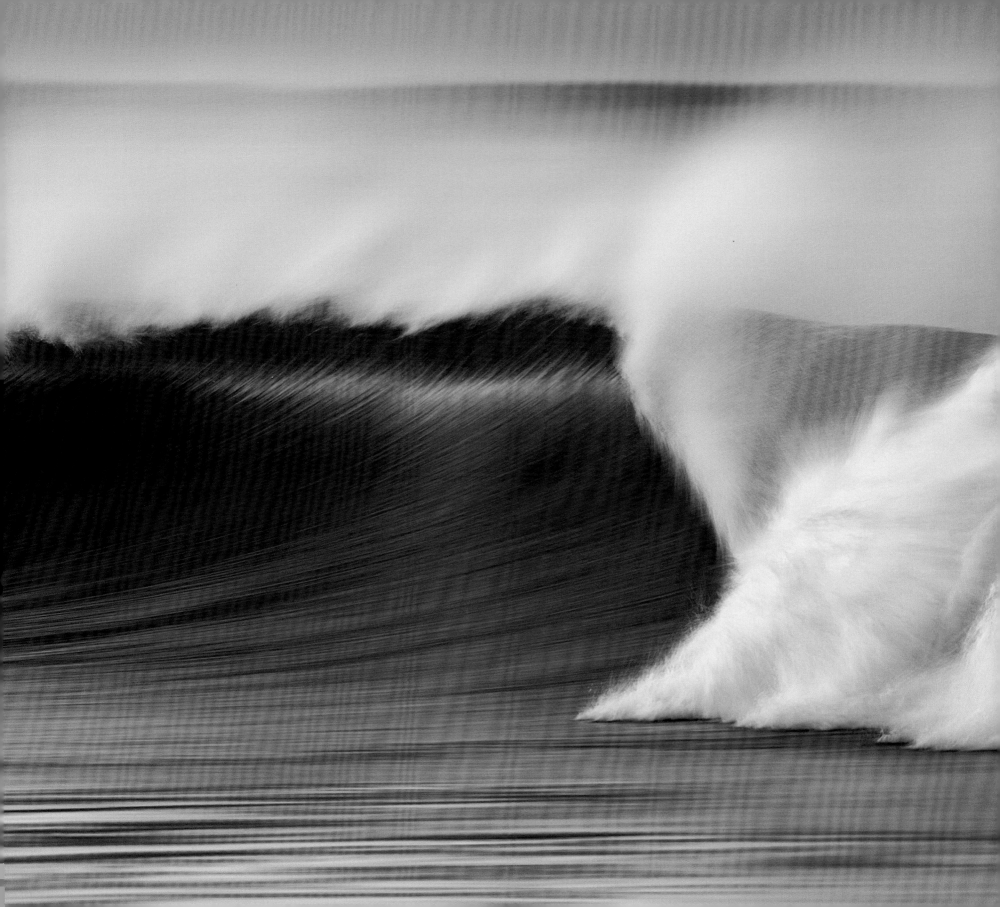

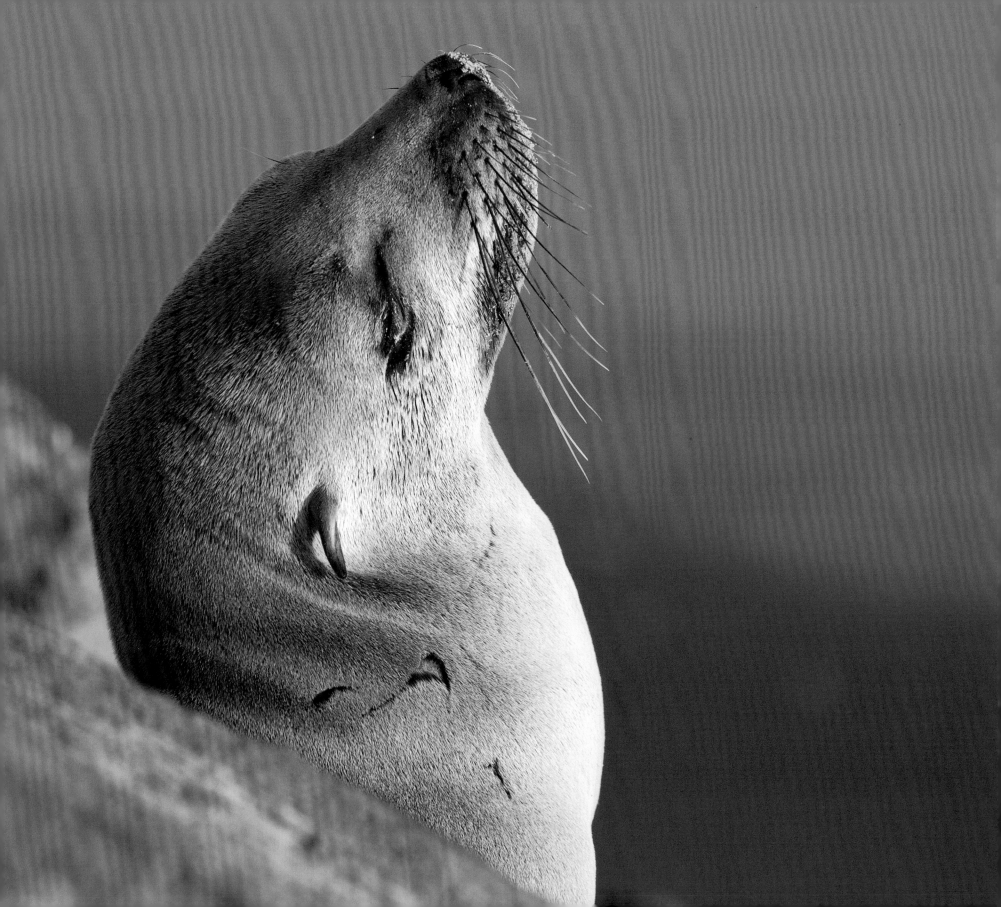

WHAT ARE YOU LOOKING AT? (*above*): Just received my new Nikon camera and wanted to take some shots, so I headed down to the beach to see what I could get. I found this shy little fella on the rocks at Mugu Rock. He kept going back in his cave every time I tried to get a close-up. I told him that he would soon be famous if he would let me take a photo. After hearing those words he crawled back out and gave me this! 📷 PAUL POWERS

SEA LION (*opposite*): A young sea lion on the rocks near Marina Park. He seems to be enjoying the warmth of the afternoon sun. 📷 JULI CROMER

DIVING DUCK (*previous top*): Caught this little duck having fun in the water. Testing a 300 mm F2.8 lens at the time. 📷 RAY ALBINO

WHALE'S TAIL (*previous bottom*): A blue whale makes a dive near Santa Cruz Island as seen from the Condor Express out of Sea Landing. 📷 CHUCK KIRMAN/VENTURA COUNTY STAR

RAINBOW WAVE (*previous right*): A wave approaches the shore near the Ventura River mouth. The early morning light reflects off the wall of the wave with a rainbow of colors. 📷 DAVID ORIAS

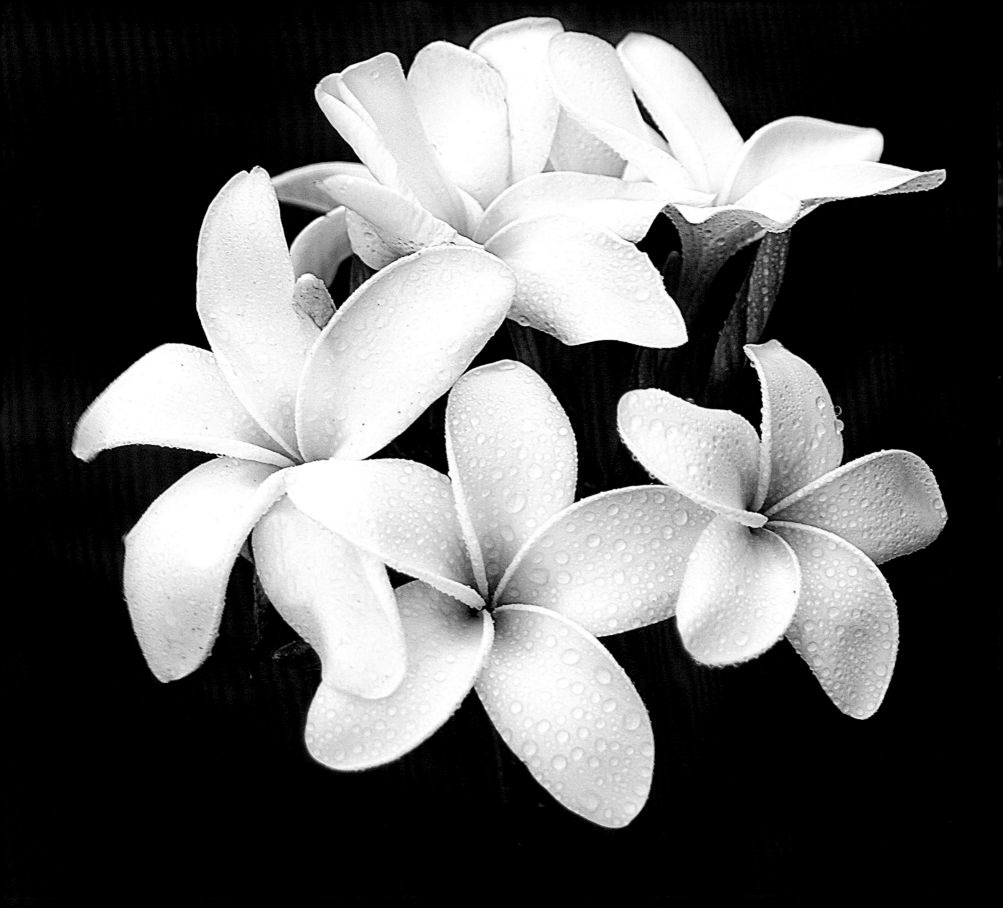

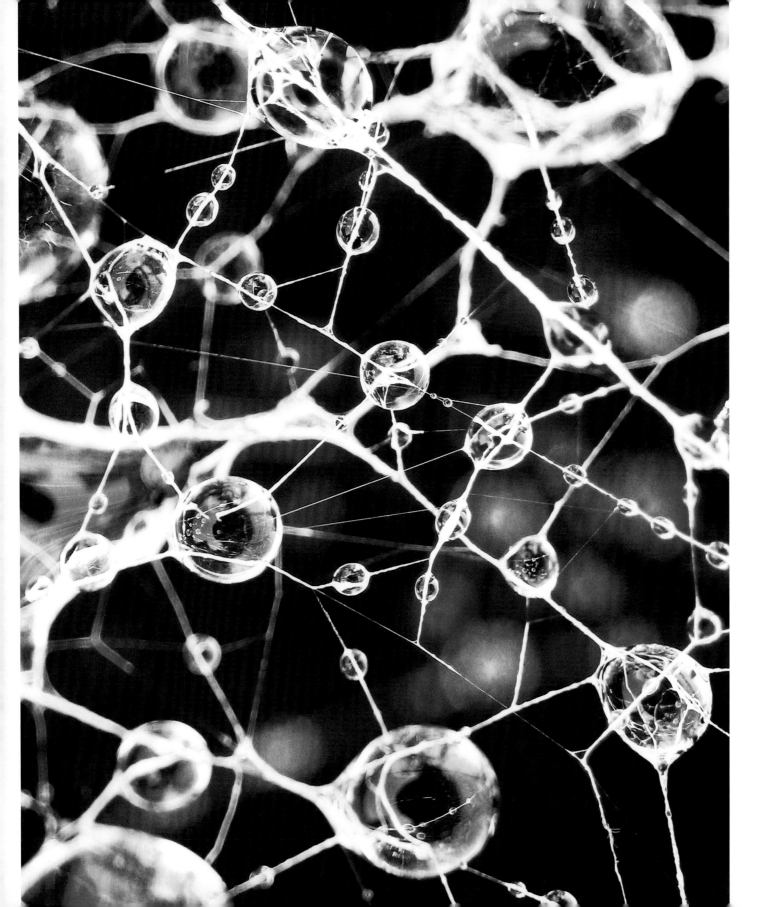

UNTITLED *(left):* Close-up shot of a spider web after a light rain. 📷 AMERY CARLSON

PLUMERIA *(opposite):* I grow a number of plumerias in my backyard. I've found that not only does the aroma permeate the air but the white petals also photograph like they're velvet. 📷 JAN CLOUGH

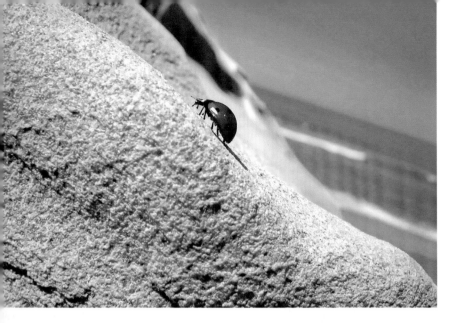

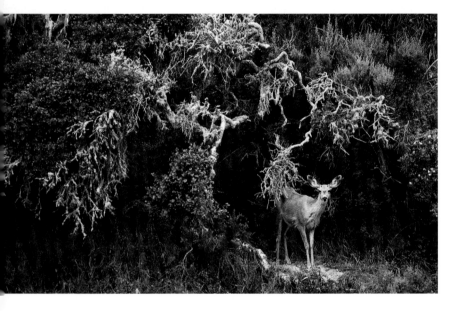

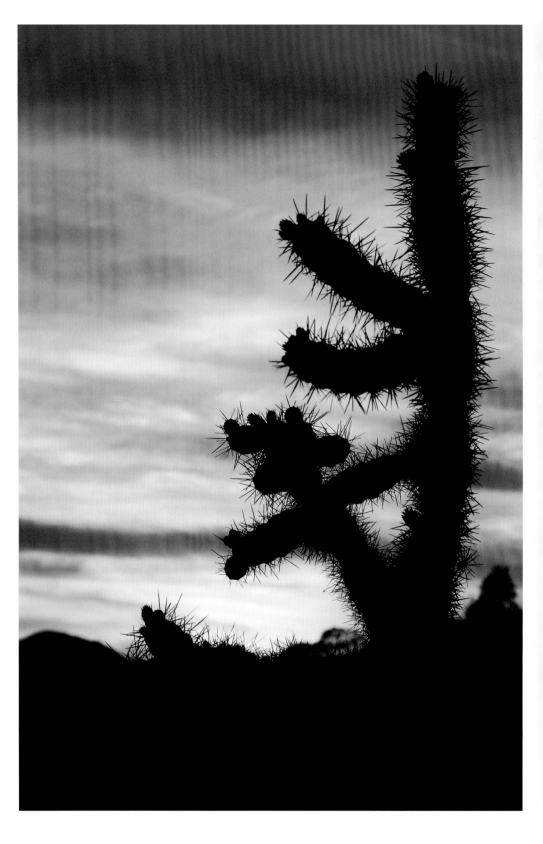

ISLAND DEER (*above*): A Kaibab mule deer pokes its head out from behind the trees on Santa Rosa Island. The deer on the island are a non-native species and currently hunted.
📷 JAMES GLOVER II/VENTURA COUNTY STAR

UPHILL BATTLE (*top*): How did I get here? Every once in a while during offshore winds, you can find random ladybugs at the beach, in the sand, on rocks, and one time I found one resting on my surfboard while out in the water. Photo taken in Rincon Parkway, Ventura.
📷 DESIREE EAST

CACTUS AT SUNSET (*right*): Photo of Opuntia prolifera (Coast cholla) taken at sunset on March 7, 2008, at Potrero Regional Park, Newbury Park. 📷 BENJAMIN KUO

YELLOW DOTS (*opposite*): Close-up shot of a very colorful flower. 📷 HENRIK LEHNERER

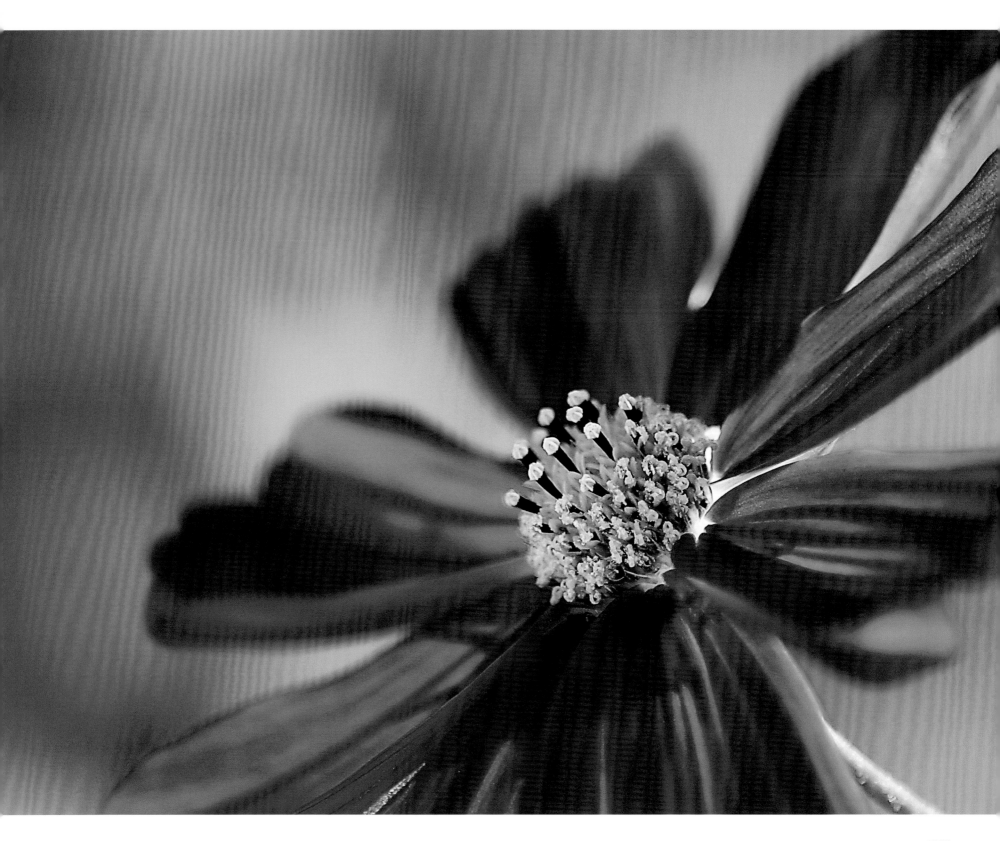

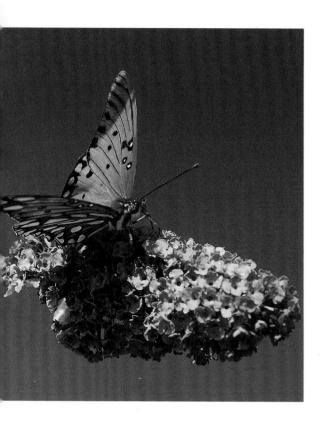

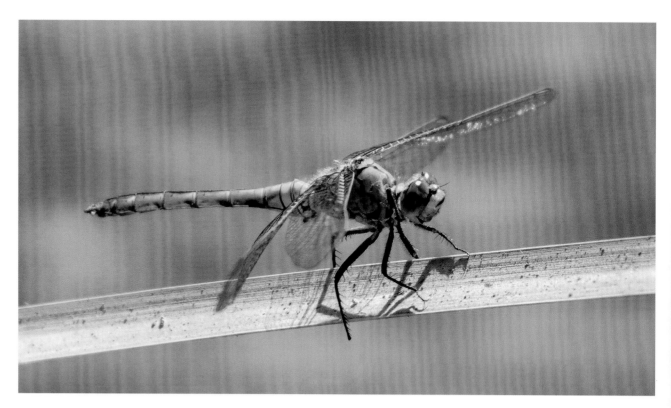

GULF FRITILLARY BUTTERFLY *(above):* I guess this is why they call it butterfly bush. 📷 ERIC BOLDT

DRAGON FLY *(top right):* A beautiful dragonfly resting on a reed on a hot summer's day. 📷 STEVE WHITE

PEPPERS FOR DINNER *(right):* These peppers should last me all week. 📷 JEFF MUTH

TRUMAN THE JUMPING SPIDER *(opposite):* Truman, the jumping spider, patiently waits in the shadows. 📷 MARILYN GOULD

★ **AFRICAN WOODSORREL** *(following left):* I discovered this plant growing next to a fence shared with a neighbor. It seems to have grown under the fence and taken up residence in our yard. 📷 ALETA RODRIGUEZ

UNTITLED *(following right):* Yellow drops after a rainstorm. 📷 AMERY CARLSON

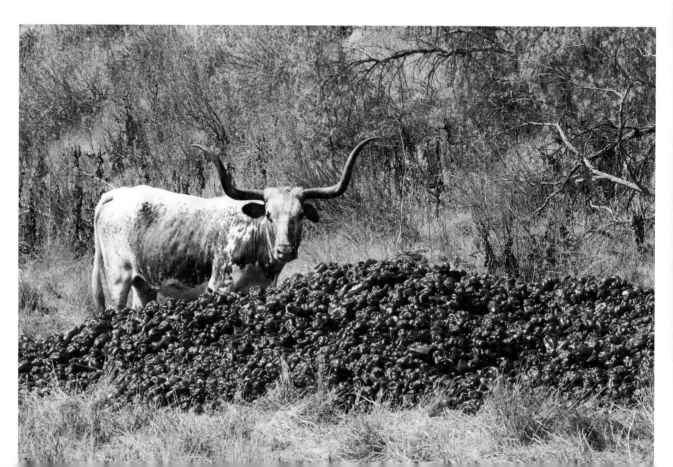

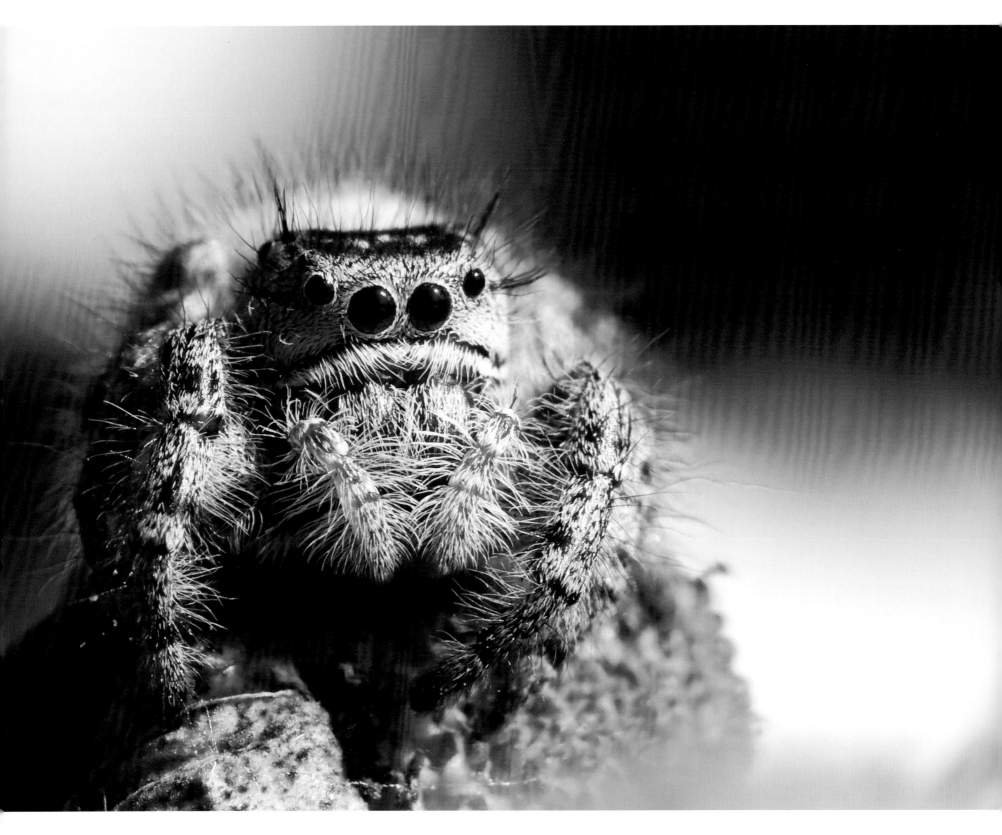

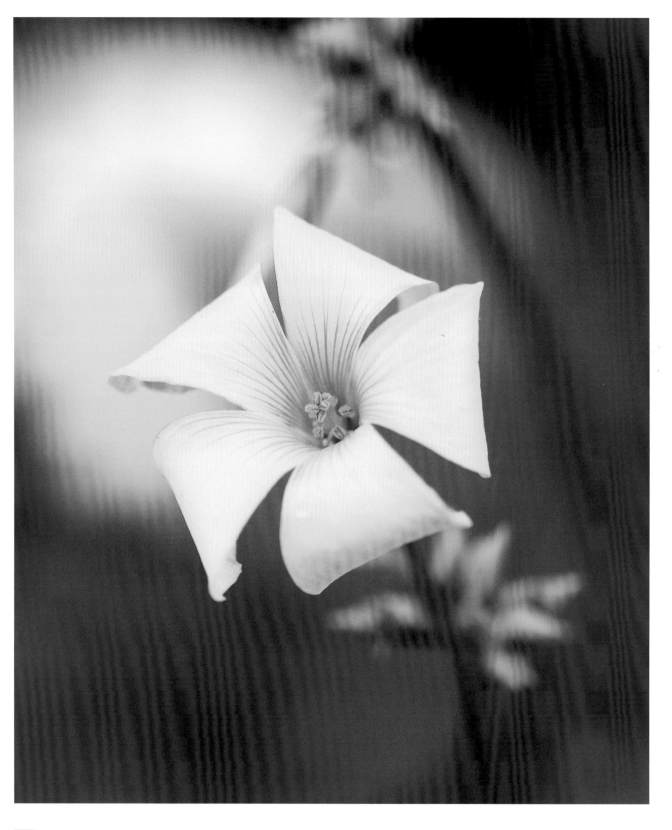

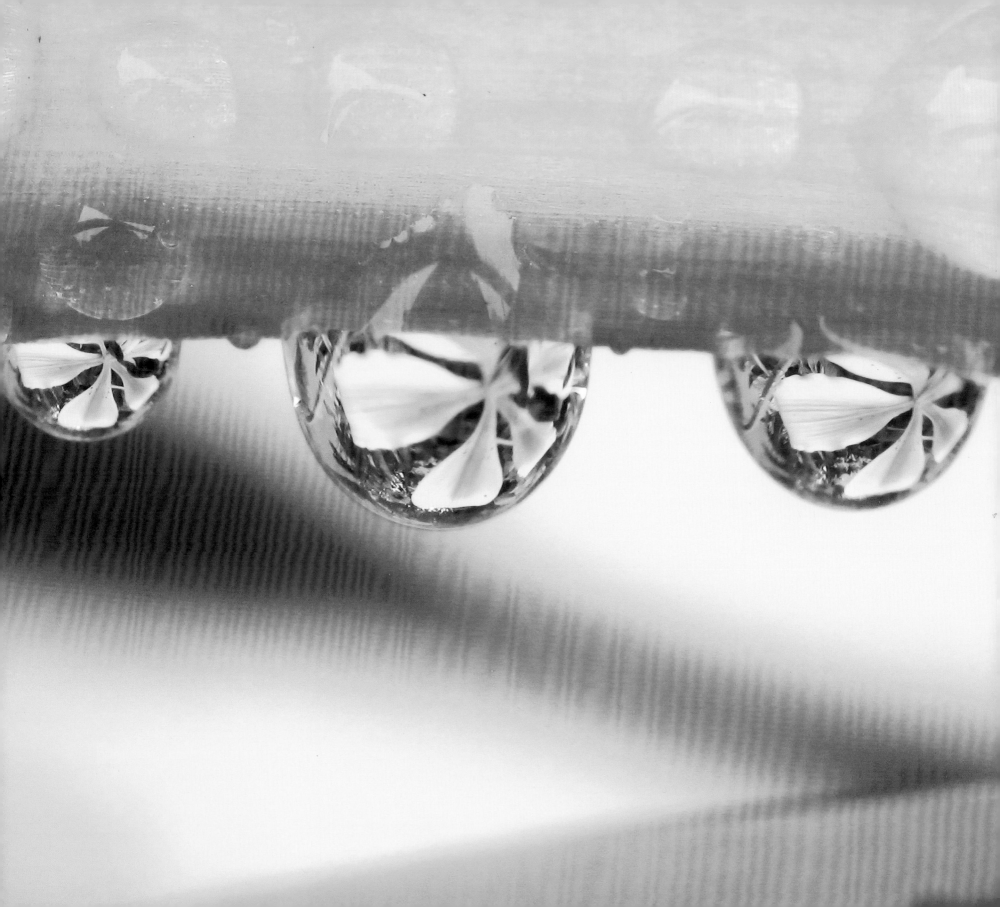

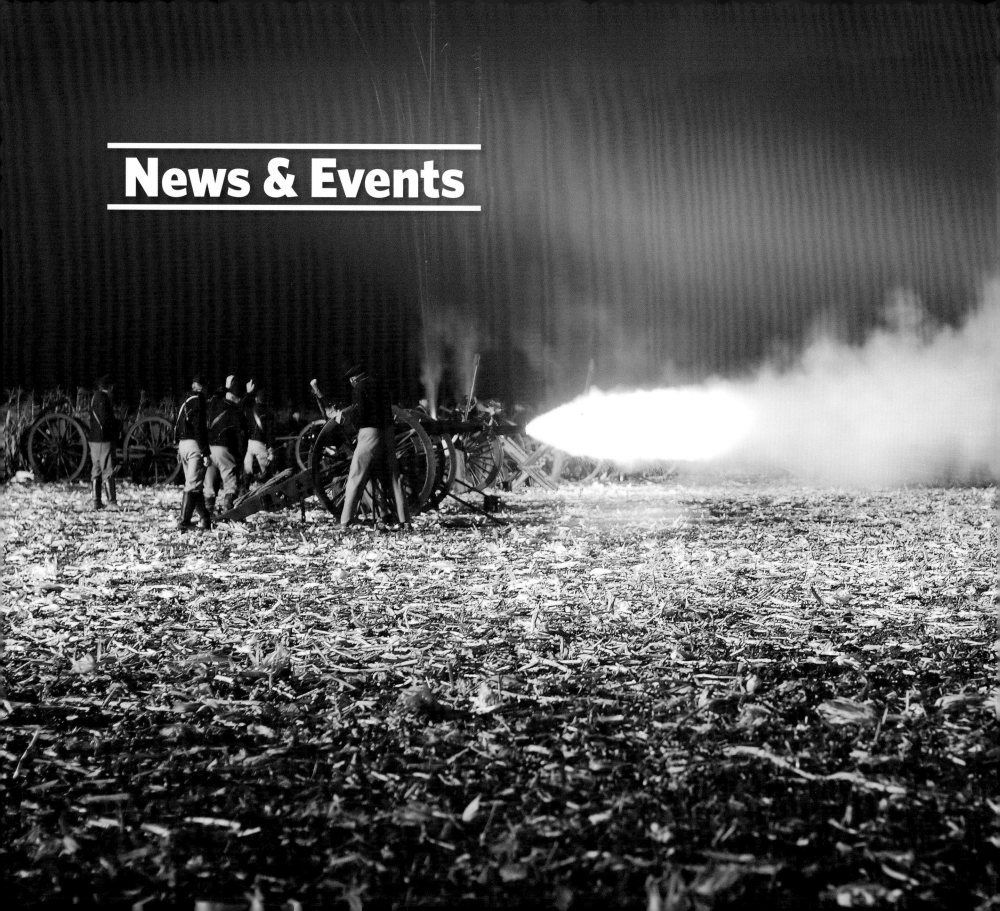

News & Events

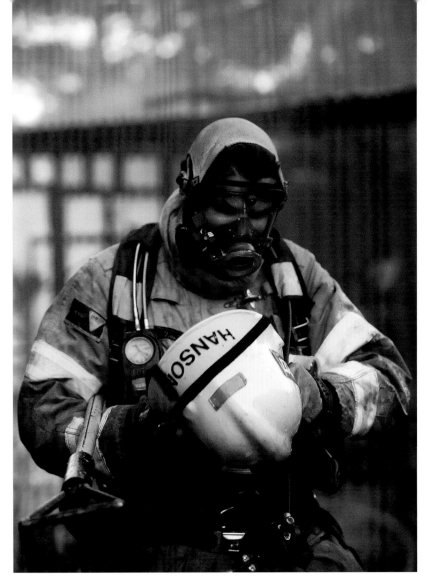

ON THE JOB *(left):* A house fire erupted around 6:30 p.m. on Sept. 6, 2008, in Santa Paula. According to a city official, the flames engulfed a garage-workshop. The fire threatened four other neighboring structures. No injuries occurred and the fire was quickly put out.
📷 ERNESTO ELIZARRARAZ

FIRE! *(far left):* Firing of the cannons at night at the 2007 Moorpark Civil War Re-enactment at Underwood Farms.
📷 LEIGH LOPEZ

RANCH FIRE *(following left):* A smoke plume created by the Ranch fire stunts the town of Piru. High winds carried smoke and ash more than 20 miles covering Ventura County and the Channel Islands on Sunday afternoon.
📷 KAREN QUINCY LOBERG/VENTURA COUNTY STAR

★ **SCHOOL CANYON FIRE BEHIND TWO TREES** *(following right):* All day the School Canyon fire had raged in the hills behind Ventura. As the sun set that night, the fire still burned hot, reflecting into the smoke. 📷 JOE VIRNIG

★ **VENTURA FIRES** *(below):* I don't remember exactly where I took this, but it was somewhere in the county off the 126. This is looking toward the 2007 fires. 📷 TOM BAKER

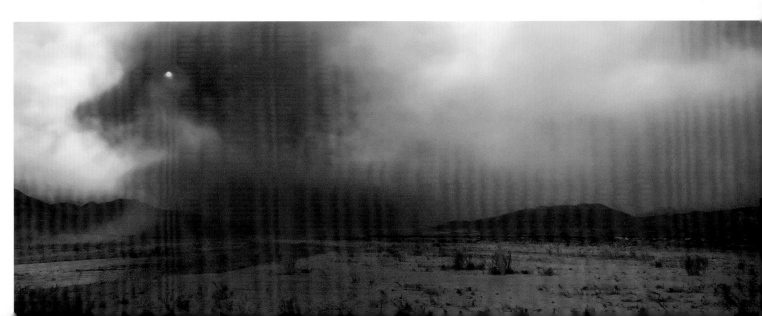

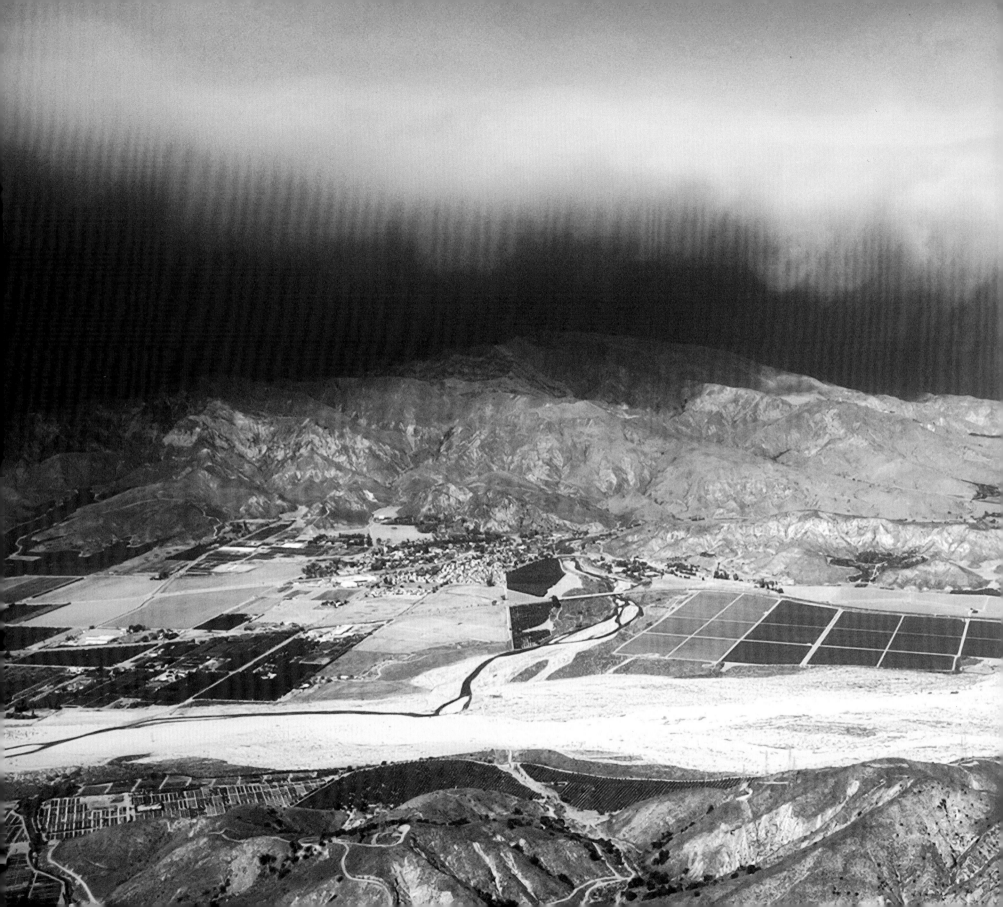

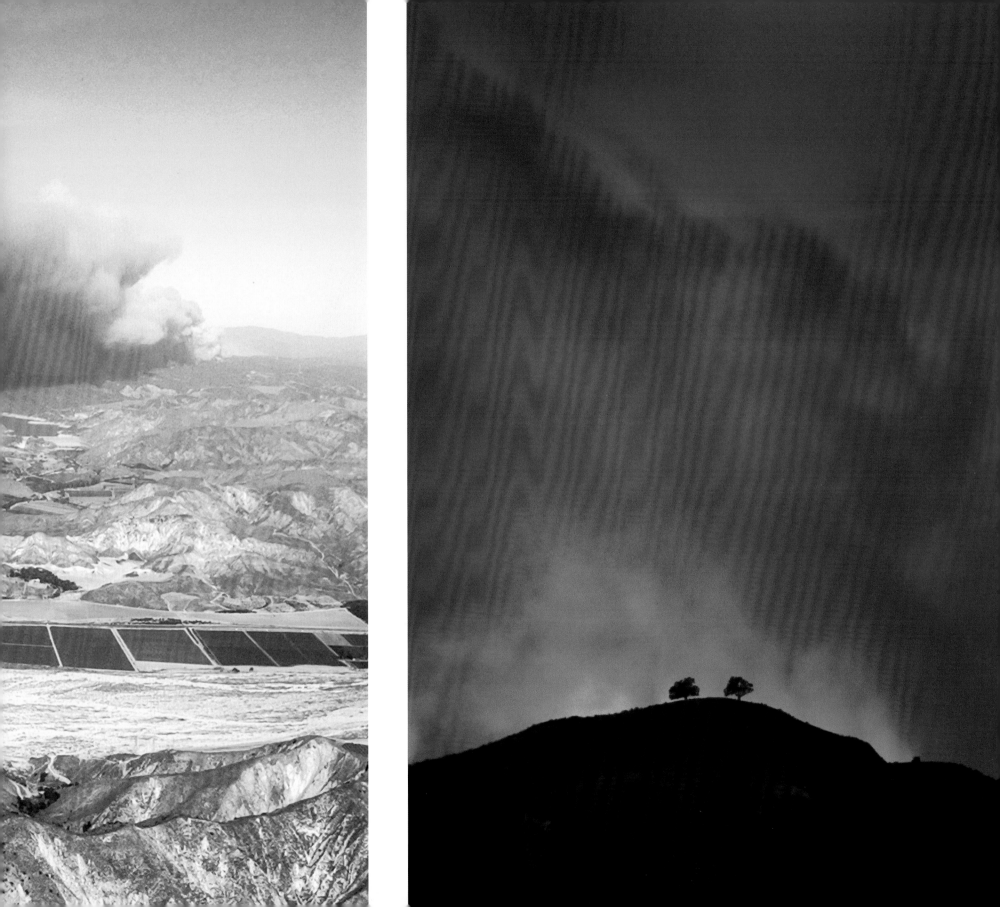

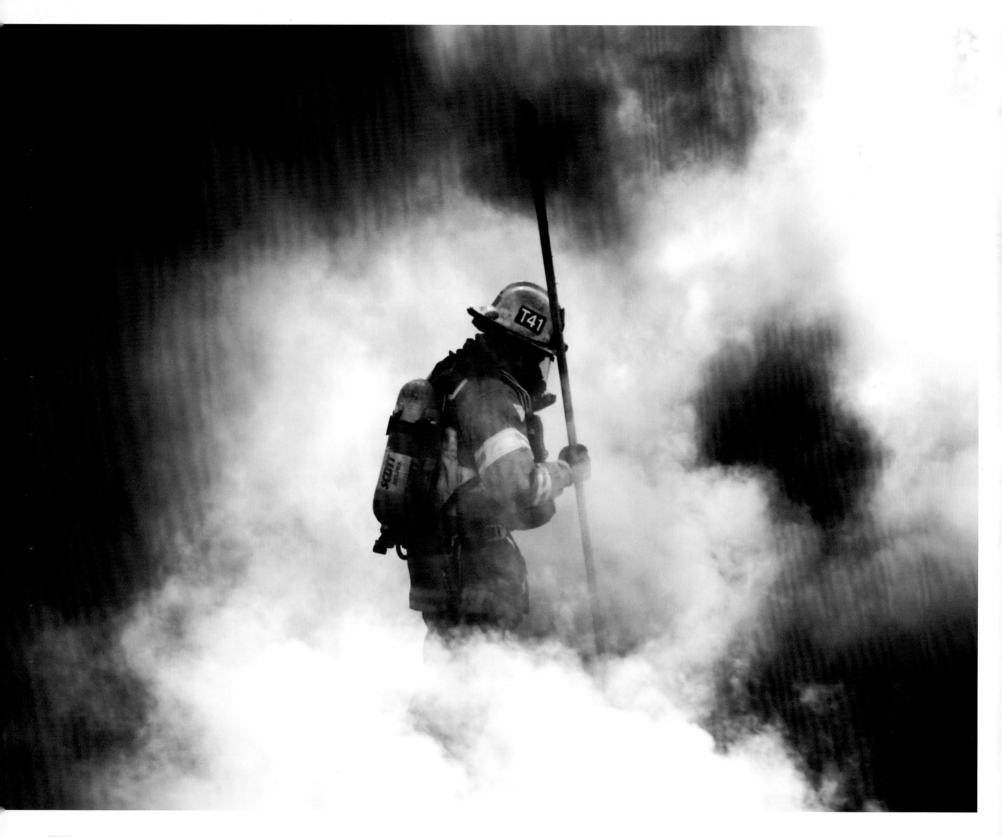

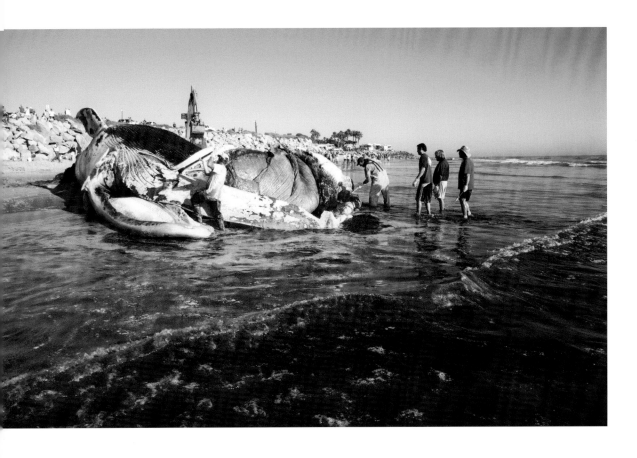

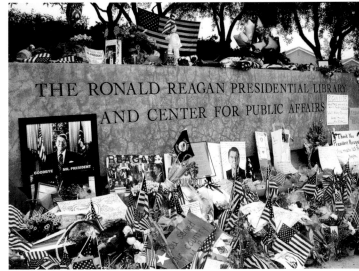

MEMORIAL *(above):* Reagan Memorial. 📷 MARC LANGSAM

GREAT BLUE WHALE *(left top):* This is an 80-foot-long blue whale that washed up dead on the beach on Sept. 16, 2007. It weighed 80 tons and was one of three that week found dead in the area. It was super gross (probably the grossest day of my life) to stand in all that whale blubber and blood water. It clung to my legs and wouldn't come off, so I took the nice shirt I was wearing and cut it into pieces so I could sit on it in my car. It took an hour with the hose and in the shower to finally get the blubber off myself. My car (which had to cleaned by the pros) and I smelled for days and I had to throw away all the clothes I was wearing, including my new shoes. 📷 TOM BAKER

A NEW DRIVE-THRU *(left bottom):* A vehicle crashes into a storefront in downtown Oxnard after the driver loses control during a turn on Dec. 29, 2007. No one was hurt but the driver was later arrested. 📷 TERRANCE DOBROSKY

★ **IN THE MIDDLE** *(opposite):* A member of the Ventura County Fire Department works on a smoke-filled rooftop. 📷 KEITH PYTLINSKI

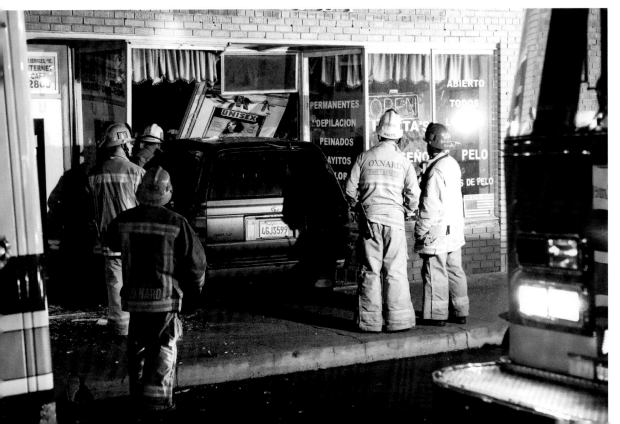

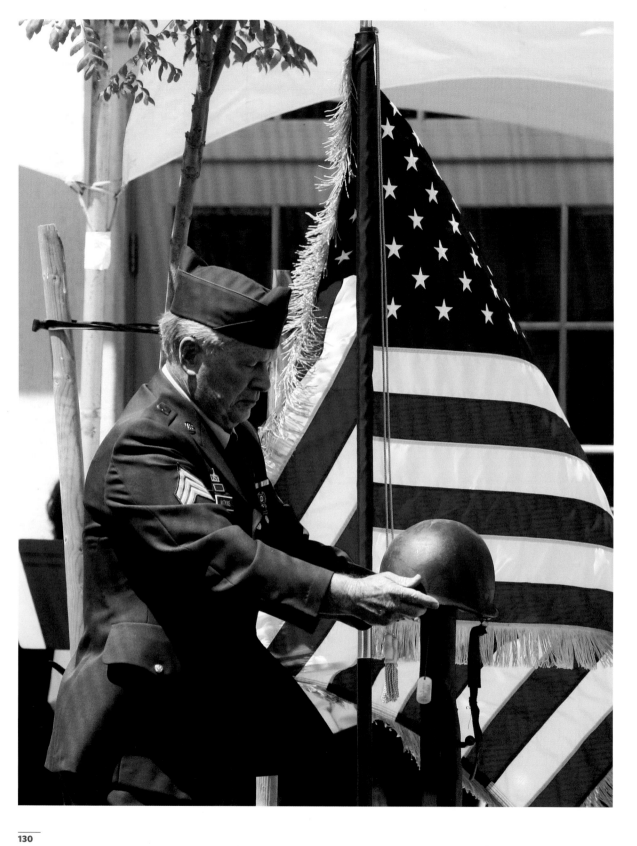

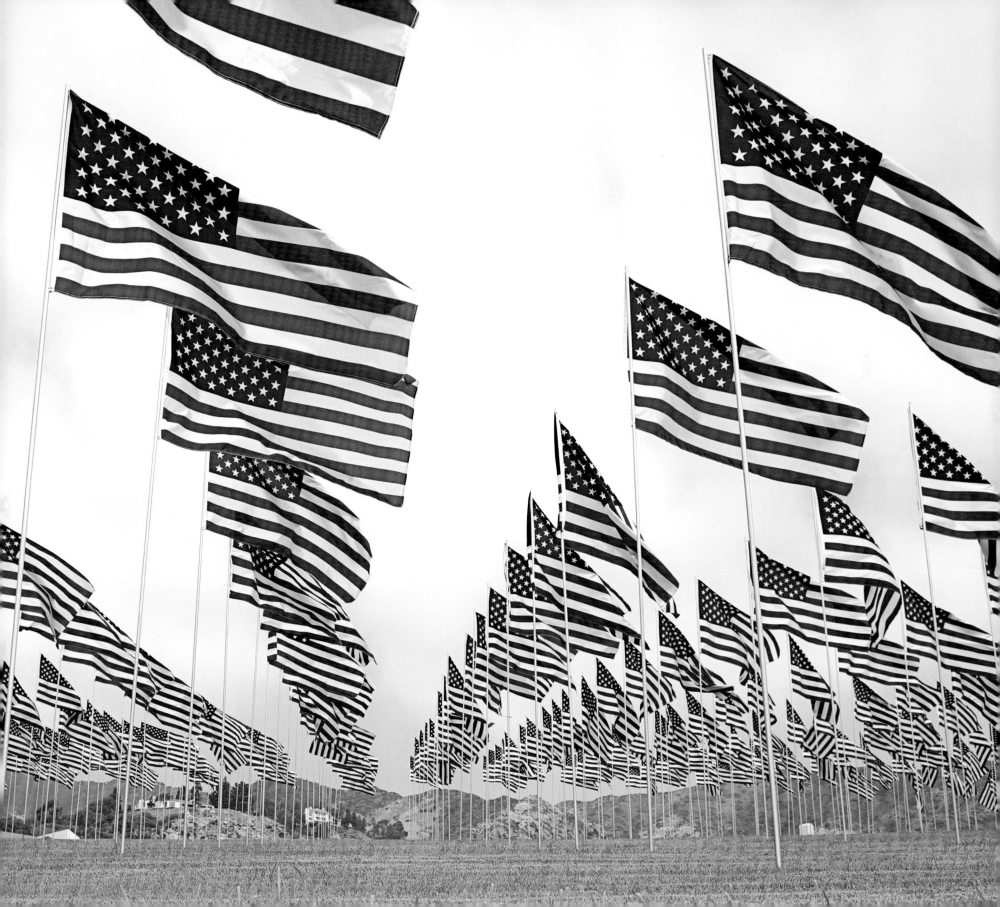

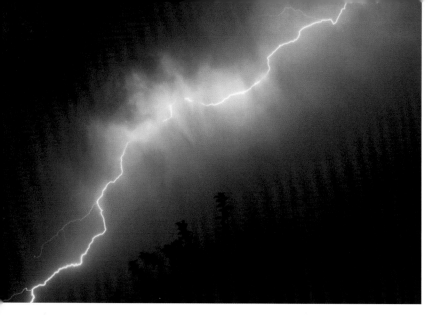

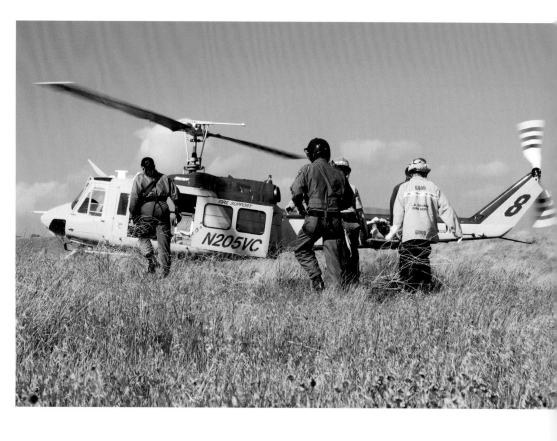

LIGHTNING (*above*): It's worth getting up in the middle of the night to witness one of the rare times Ventura gets a lightning storm. 📷 SHARON DEMELE

HELP IS HERE (*right top*): Ventura County's air squad has lifted many patients in need out of Hungry Valley. 📷 JOSH GRANT

MOURNING (*right bottom*): Desti Mabee, left, and her mother, Pat Centineo, are moved to tears as the friends of Mabee's late son, Jack Mabee, 17, gather at their home a week to the day and hour of his death in Oxnard.
📷 KAREN QUINCY LOBERG/VENTURA COUNTY STAR

HOLY CHILD (*opposite*): Hundreds of Catholics from in and around Los Angeles, Ventura County and other areas participated in a religious farewell pilgrimage in Santa Paula honoring The Holy Child of Atocha or (in Spanish) El Santo Niño de Atocha, who is known by believers as the patron saint of those unjustly imprisoned and helps those who are in need or danger, June 8, 2008. Traditional indigenous dancing and a marching band were predominant in the pilgrimage. The religious icon resided in Our Lady of Guadalupe Church in Santa Paula. The saint was originally brought to the United States from Zacatecas, Mexico, where the icon normally resides. 📷 ERNESTO ELIZARRARAZ

HONORING THE FALLEN HEROES (*previous left*): The fallen soldier memorial is set up by a gray-haired soldier. This photo is from a Memorial Day event held at Conejo Mountain Memorial Park in Camarillo, 2008. 📷 RANDY ROBERTSON

BREATHTAKING (*previous right*): Remembering Sept. 11. 📷 JODI LUKER

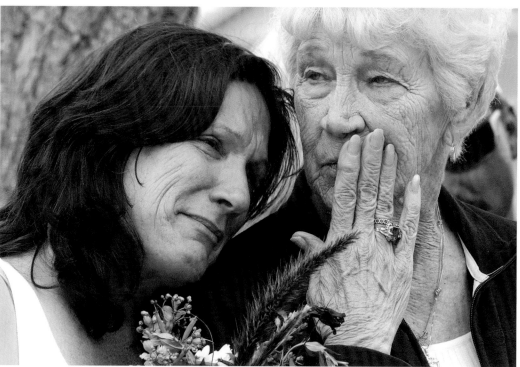

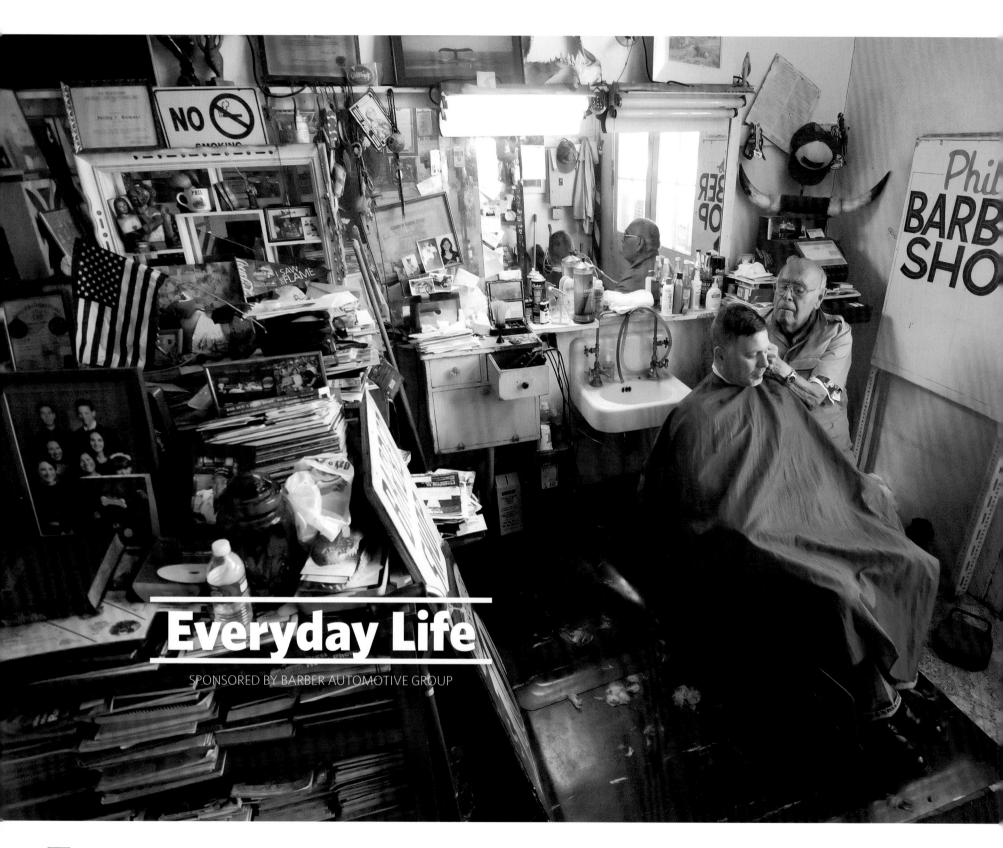

Everyday Life

SPONSORED BY BARBER AUTOMOTIVE GROUP

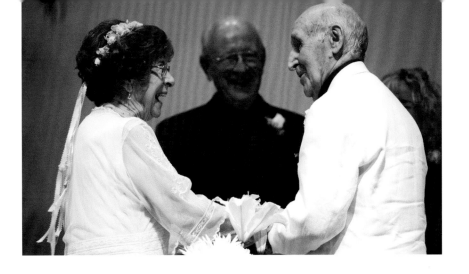

YOUNG LOVE *(left):* Bernice Jenkins and Willis 'Rich' Richard, both 95, are married by Pastor Don Lawson at Pleasant Valley Bible Church. Bernice and Rich decided to get married just a few months after Bernice's 95th birthday. "We don't have time for a long engagement," Bernice said. ⌾ DANA RENE BOWLER/VENTURA COUNTY STAR

TRIMMING THE PAST *(far left):* An overview shot of Phil's Barber Shop in Ventura.
⌾ MICHAEL THANHOUSER

WHO'S NEXT? *(below):* Our family dentist does his magic as our little onlooker isn't quite sure she wants to be next. ⌾ GLENN BAYLEN

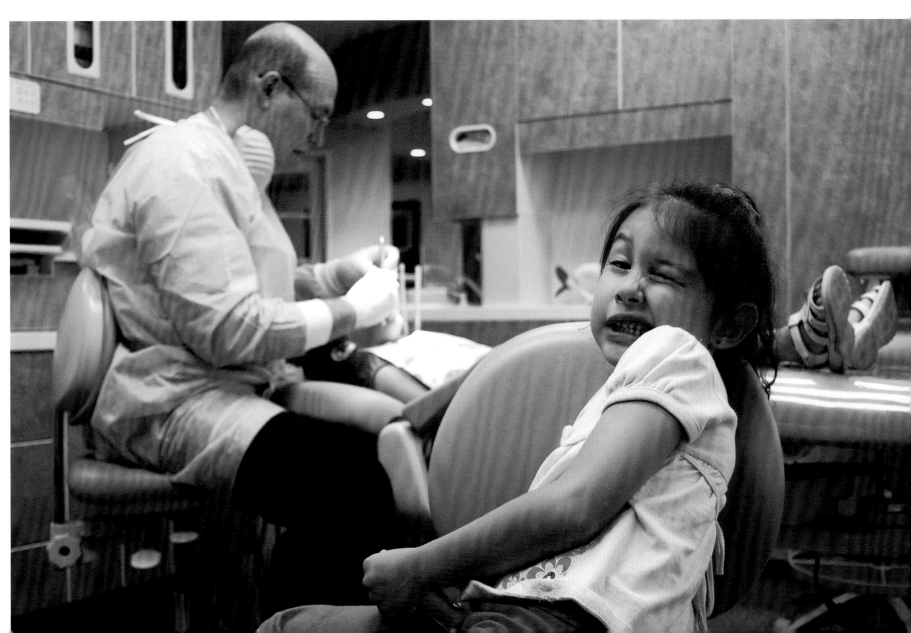

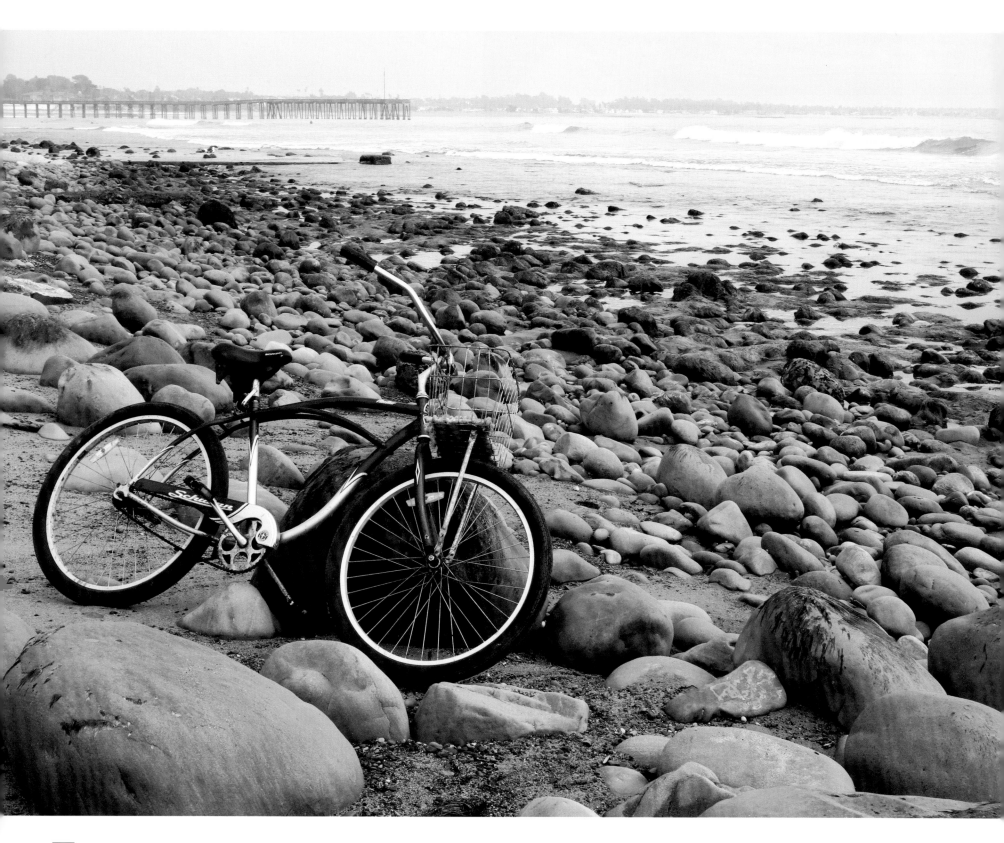

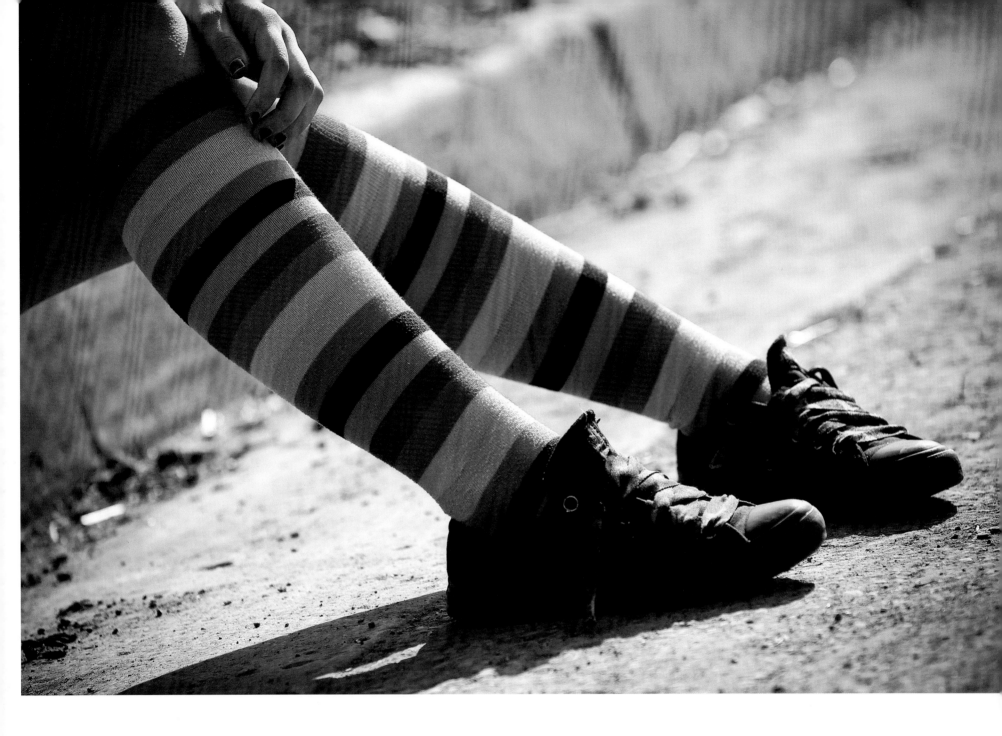

★ **SOCKS** *(above)*: Taken at the Ventura County Fair 2008. I liked the color of this young lady's socks. 📷 AL UNGAR

RED BIKE *(opposite)*: A bike sits on the rocks near Surfer's Point. The Ventura Pier is in the background. 📷 TOM BAKER

LAKESIDE DINING *(following left)*: Dining at the lake at sunset. 📷 GORDON SWANSON

VENTURA WINE *(following right)*: Wine in the evening. 📷 GORDON SWANSON

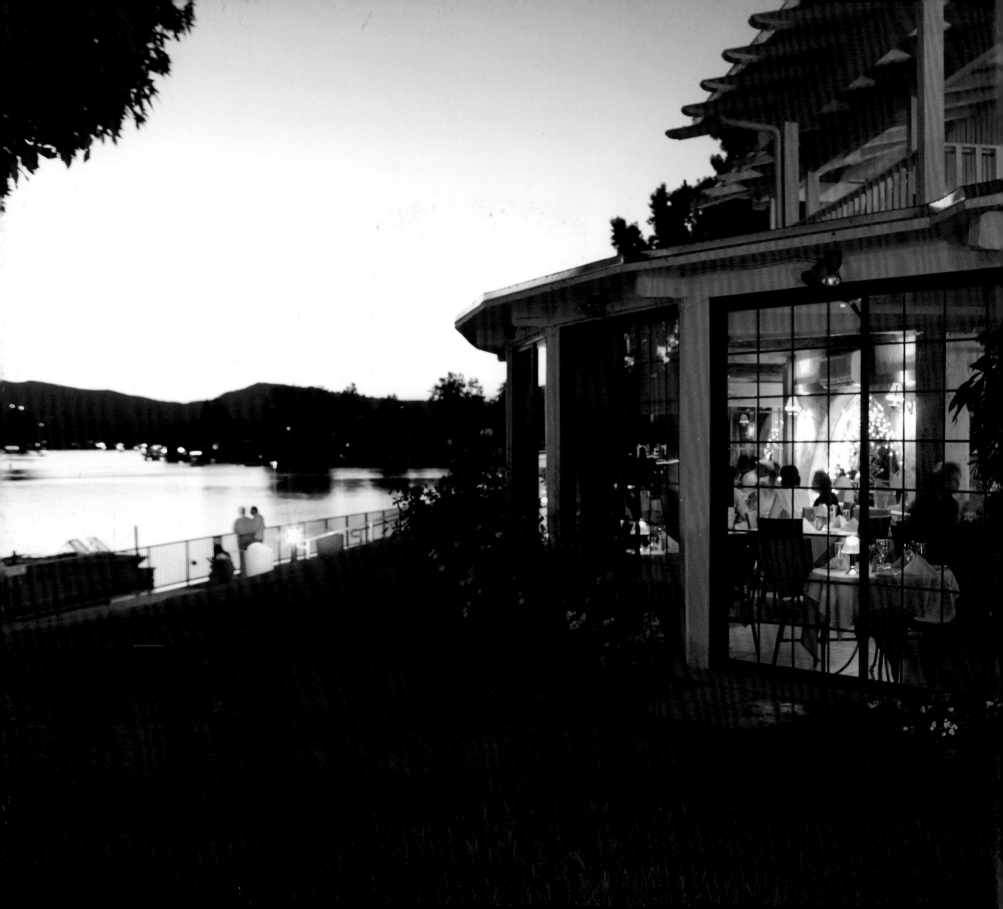

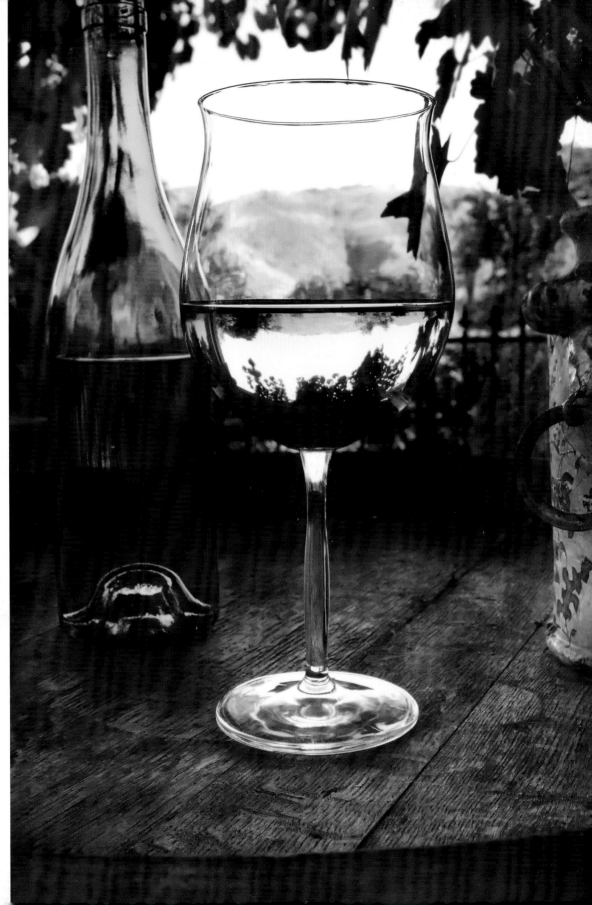

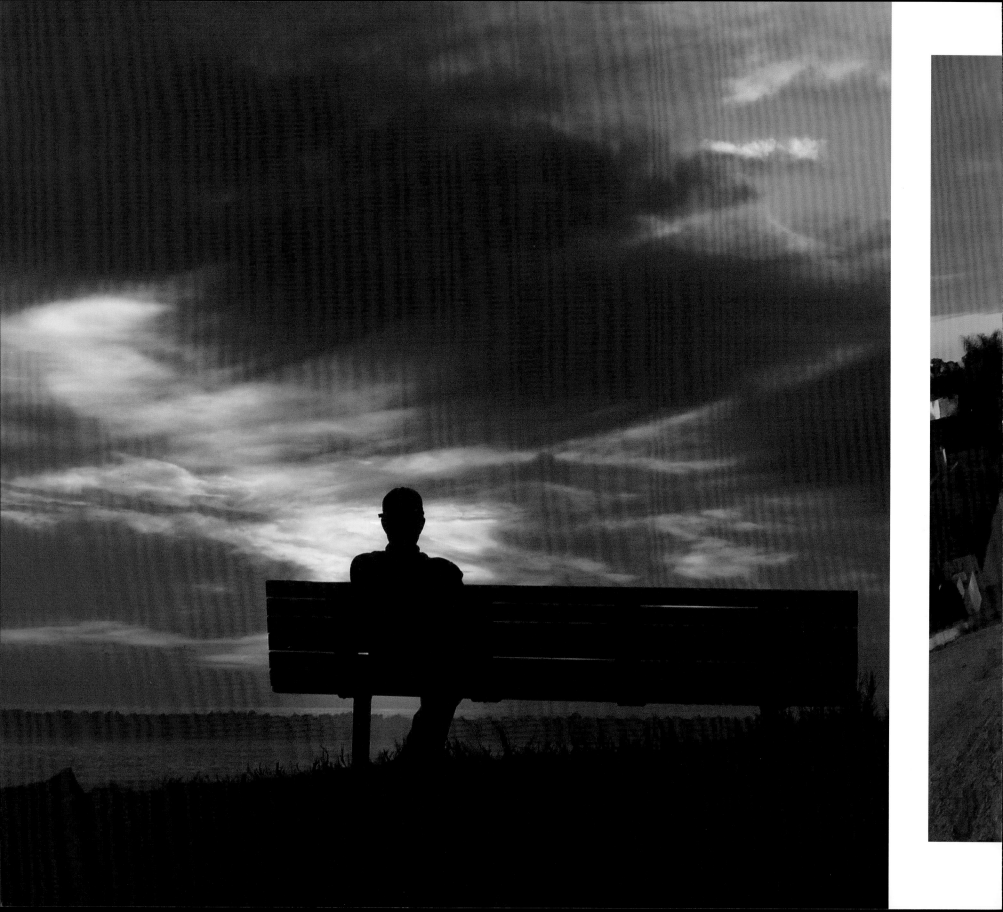

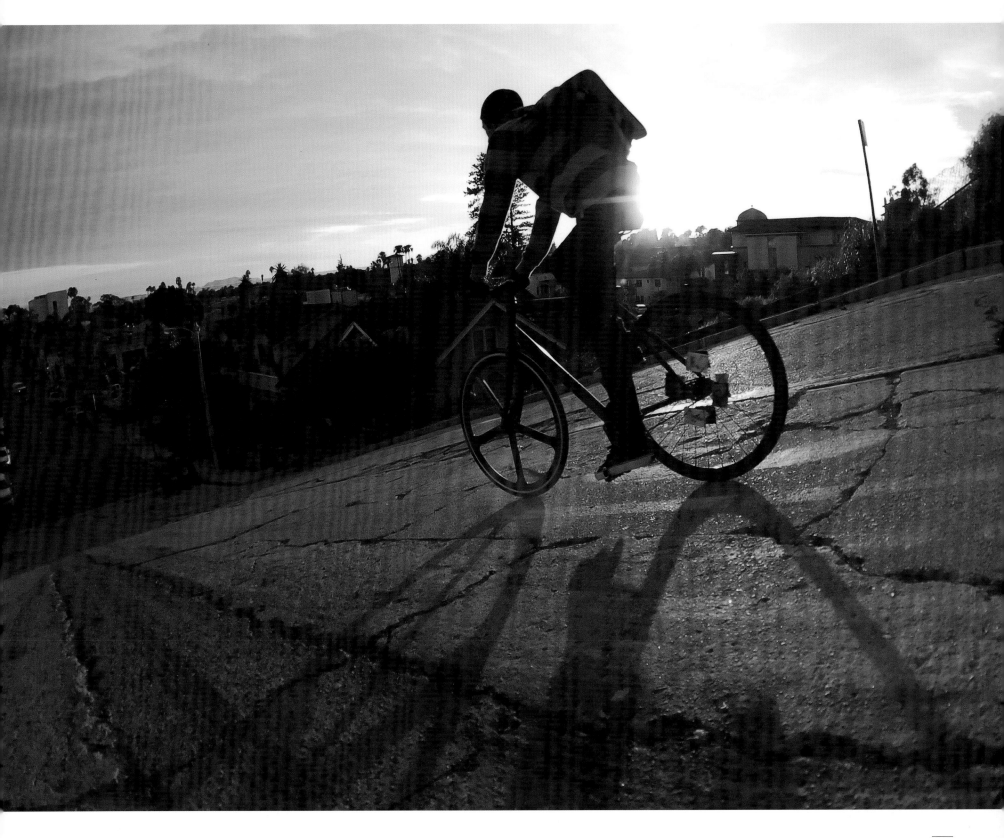

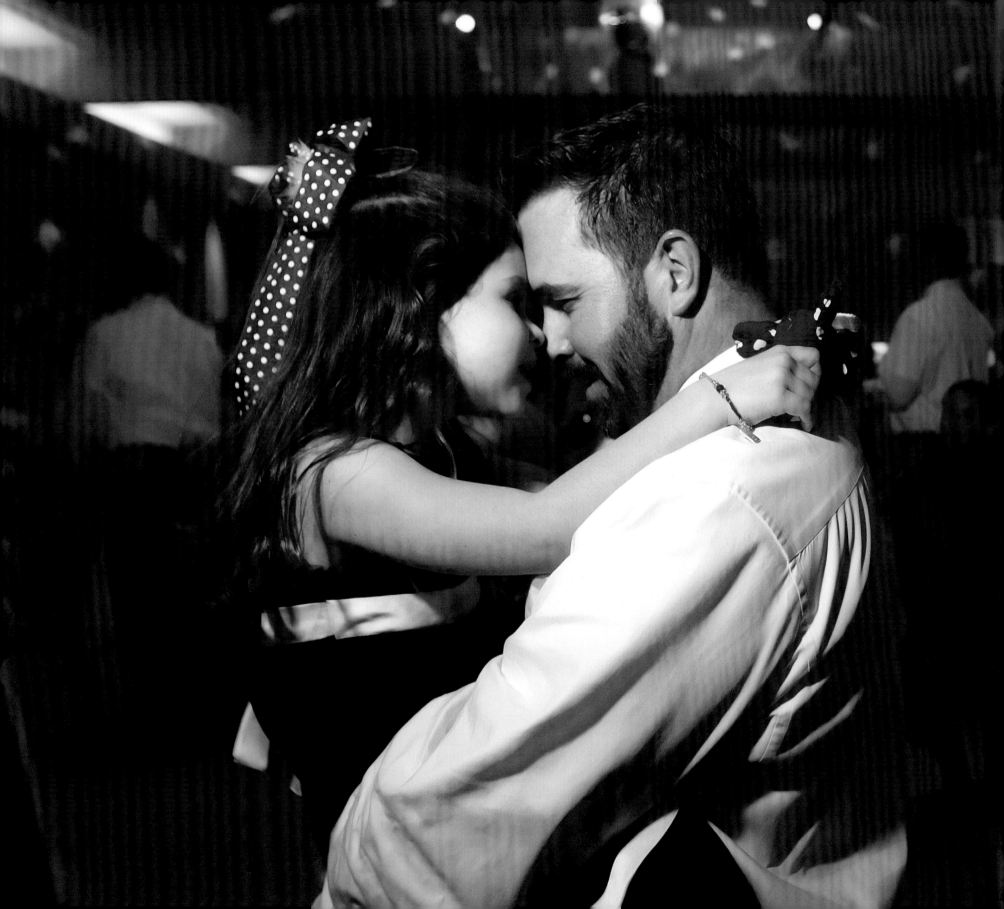

★ **UNTITLED** *(left):* Camarillo resident Manny Ferguson holds his 5-year-old daughter, McKenna, close to him as they dance during a father-and-daughter event at the Camarillo Community Center, Feb. 9, 2008. Furguson said, "This event is great; it made me fall in love with my daughter all over again." ⊚ DAVID YAMAMOTO

UNTITLED *(previous left):* A local resident takes in the sunset at Marina Park in Ventura. ⊚ AMERY CARLSON

AFTERNOON RIDE *(previous right):* Chris Lebaron rides his Fixie down Palm Street in Ventura. ⊚ ANDREW LIVINGSTON

2008 *(below):* Twelve times before I could get this right. ⊚ LARRY SPOERLEIN

PIG PEN *(following left):* Jessica Harvey, 7, of Fillmore, pets her older brother and sister's two pigs, named Mugu and Coco, one evening in the livestock area at the Ventura County Fair. ⊚ DANA RENE BOWLER/VENTURA COUNTY STAR

WAITING FOR DADDY *(following right):* This little girl was playing in an airplane hangar while waiting for her father to return from service in Iraq. God bless our troops. ⊚ STEVE WHITE

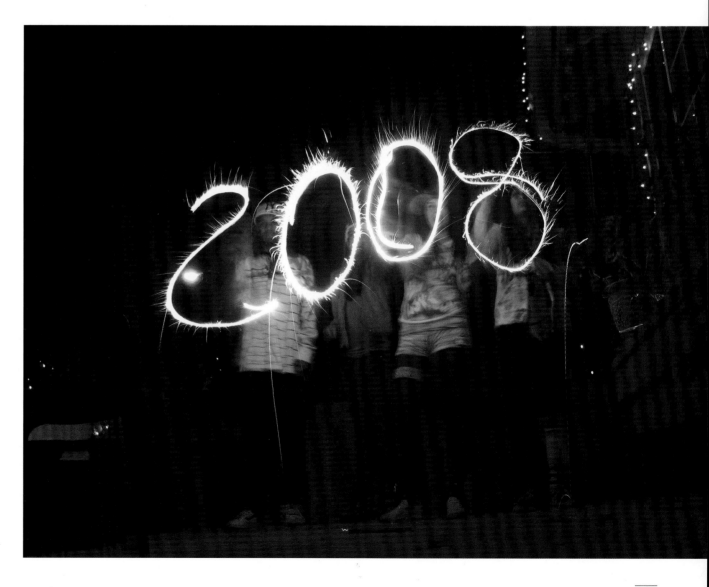

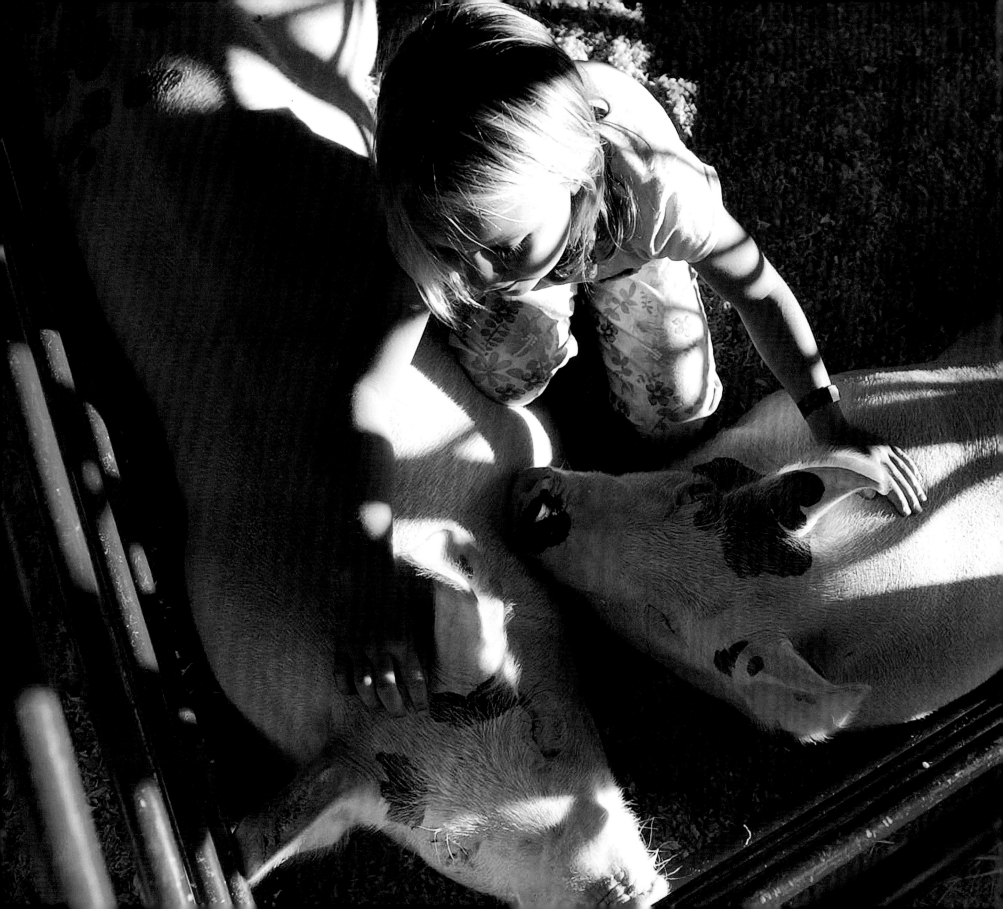

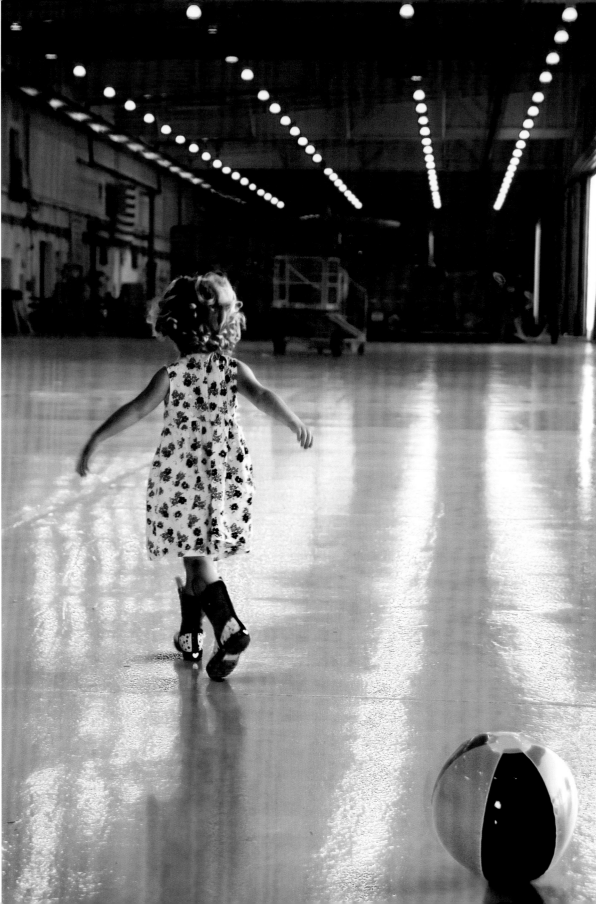

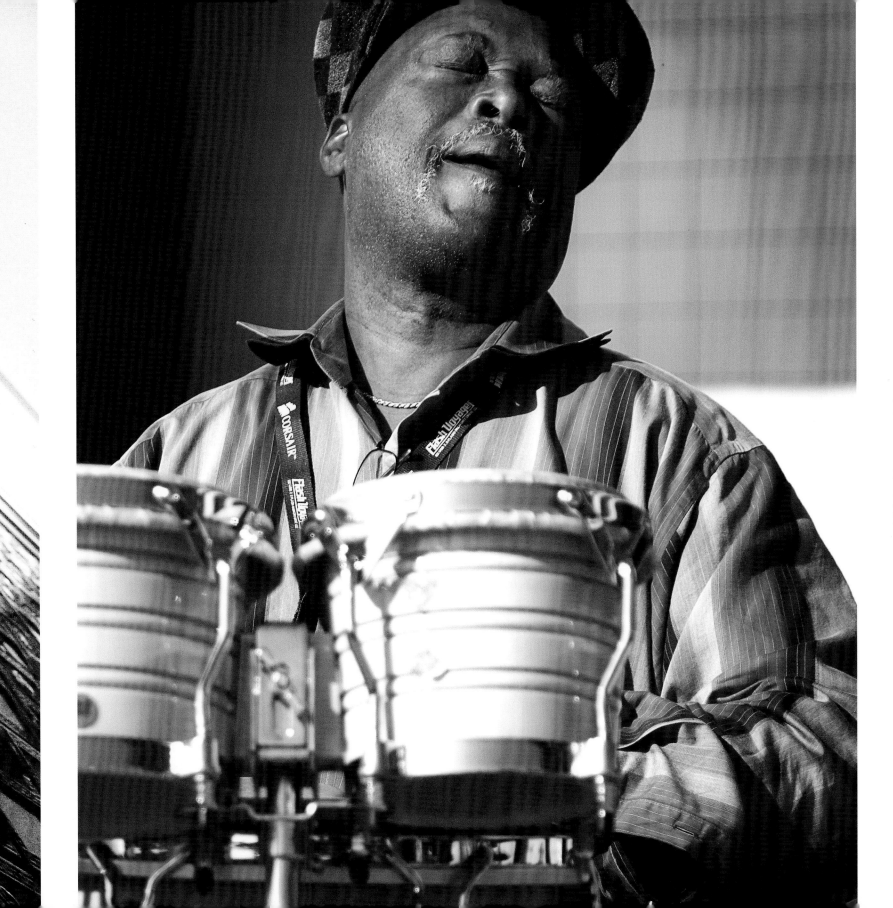

MAIL *(previous left):* Mailboxes. 📷 JESSICA TRAINOR

STREET PERFORMER *(previous right):* Near Ventura Pier. 📷 AL UNGAR

FIELD WORKER *(right):* Miguel Melchor, of Oxnard, picks bushels of parsley near sunset in the fields on Fifth Street near Del Norte Boulevard in Oxnard.
📷 DANA RENE BOWLER/VENTURA COUNTY STAR

★ **FOCUS IN TRAINING** *(below):* Focus in training. Sixty-three-year-old hands training 26-year-old hands on focusing for your next

move. 📷 THOMAS WOTKYNS

FOGGY MORNING PICKING STRAWBERRIES *(following left):* I travel this road on the way to work often and the same scene has so many different moods. 📷 JOE VIRNIG

CHUMASH TRAIL *(following top):* Hiking along the Chumash Trail. 📷 ROB HERR

OIL WELL PRODUCTION RIG *(following bottom):* This is a production rig servicing a well in the Sespe Oil Fields. 📷 JEFF MUTH

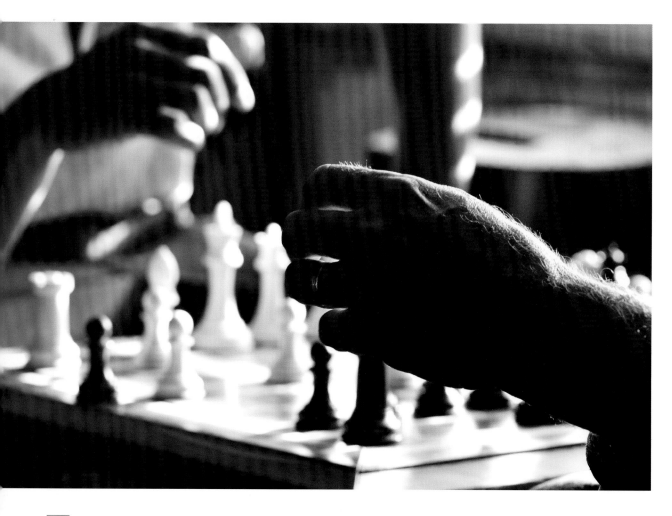

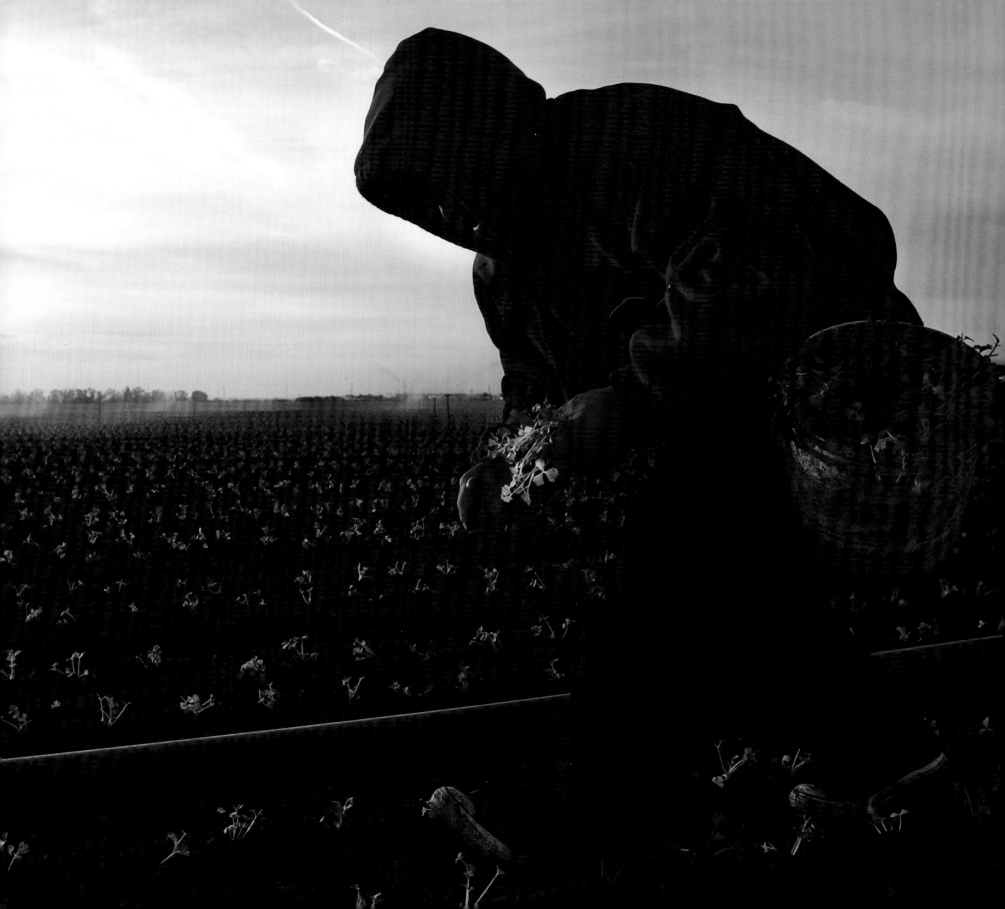

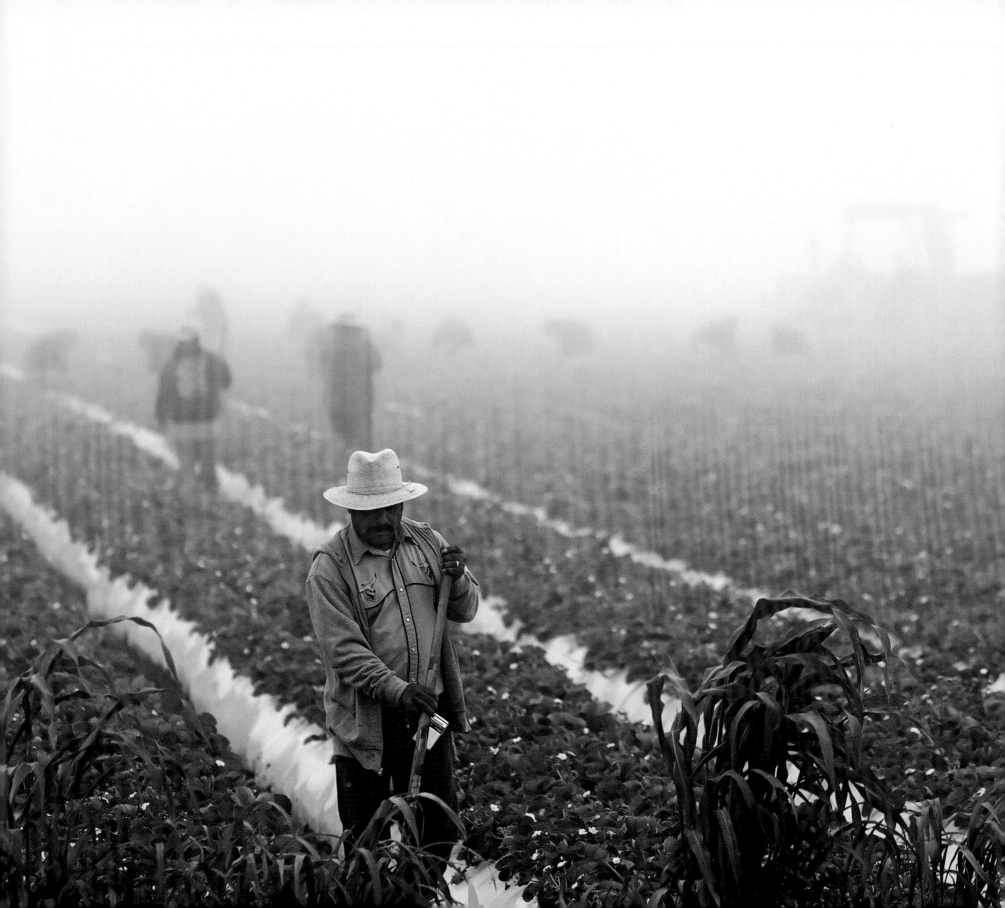

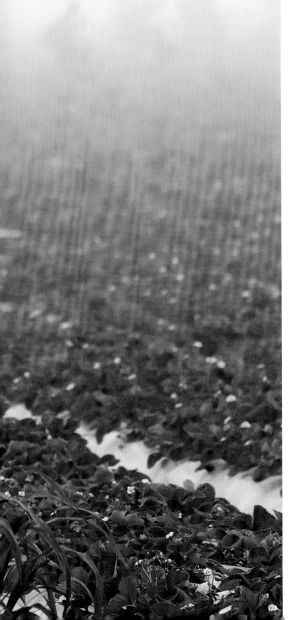

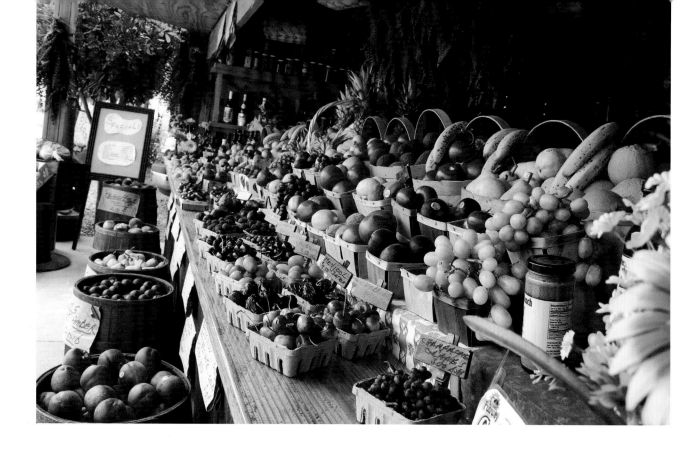

SPECTRUM OF FRUITS (above): Peterson Ranch in Somis is one of the fruit stands that display many of our local fruits, vegetables, honey, canned goods and much more. This is, for sure, a fruit stand to love. 📷 YANIRA HAVEN-WILLARS

ORANGES (bottom left): Fresh produce found at one of the many fruit stands along Highway 126 between Fillmore and Piru. 📷 JULI CROMER

SUNKIST ORANGES (bottom right): Sunkist has played a major role in our county, packing our oranges and lemons growing throughout. 📷 YANIRA HAVEN-WILLARS

UNTITLED (right): Conejo Elementary fourth-grade student Conor Oliver eats a carrot with his schoolmates, sixth-grader Evelyn Truong, right, second-grader Rishi Basu, left of Oliver, and third-grader Christopher Rasmussen, far left, at the 13th annual Harvest Festival in Thousand Oaks. 📷 DAVID YAMAMOTO

PHOTOGRAPHER AT WORK (following left): Photographer capturing the ocean waves at sunrise near the Ventura Pier. 📷 HENRIK LEHNERER

MOON LIT PIER FISHING'S GRAVE YARD SHIFT (following top): Predawn images require a tripod. These folks had likely completed a fishing session on the pier aided by the full moon. 📷 PHIL RANGER

OMINOUS (following bottom): Ventura Pier about two years ago. Clouds looked threatening, which I emphasized with this shot. The black-and-white treatment also highlights the dark feeling I felt at the time. 📷 ED JESALVA

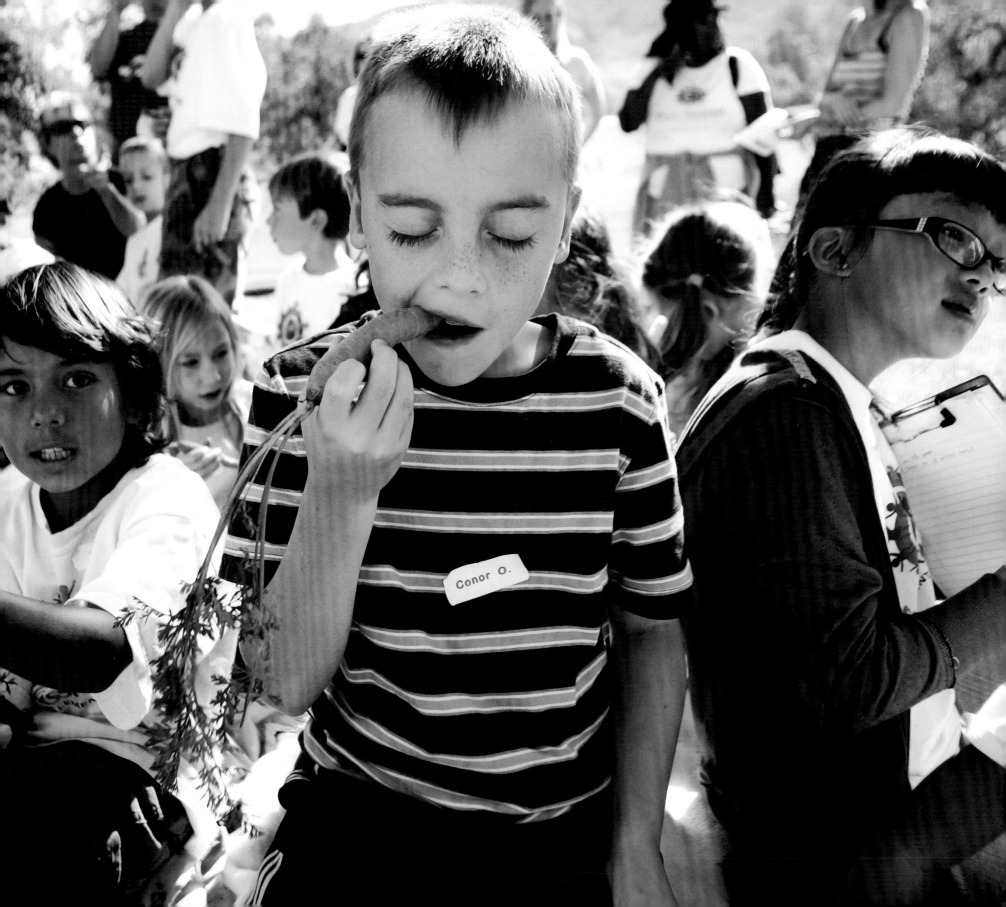

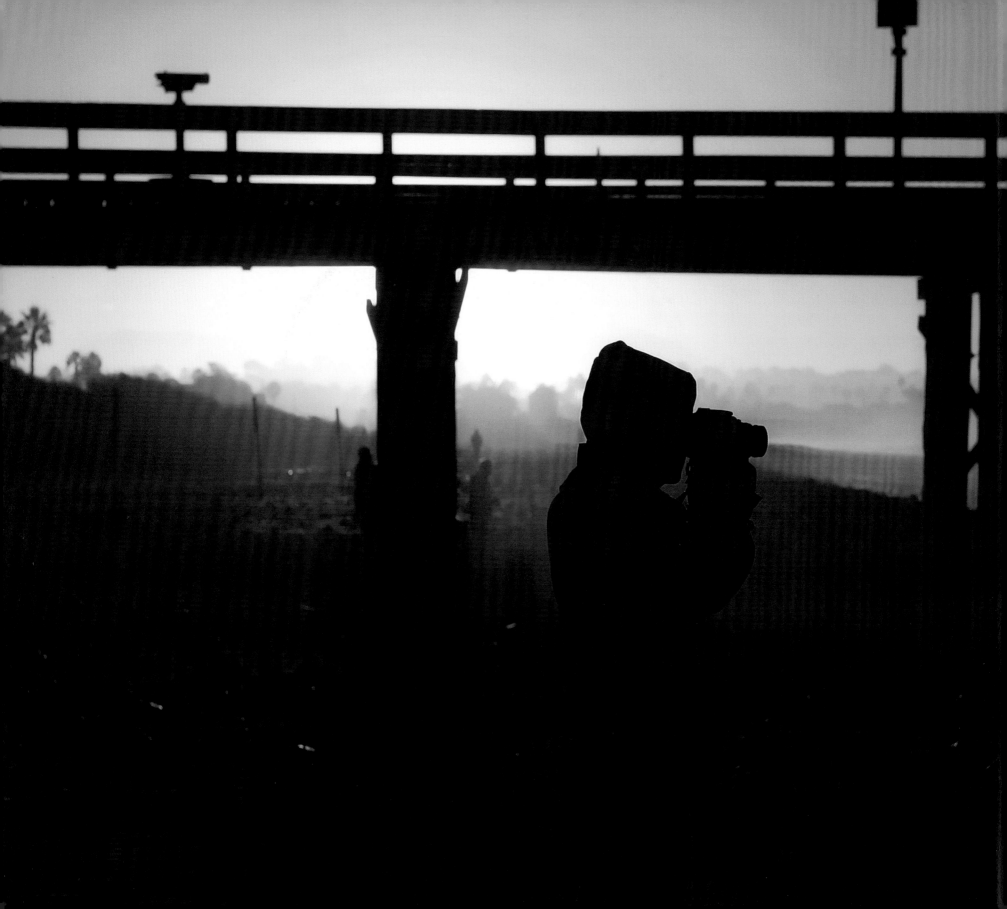

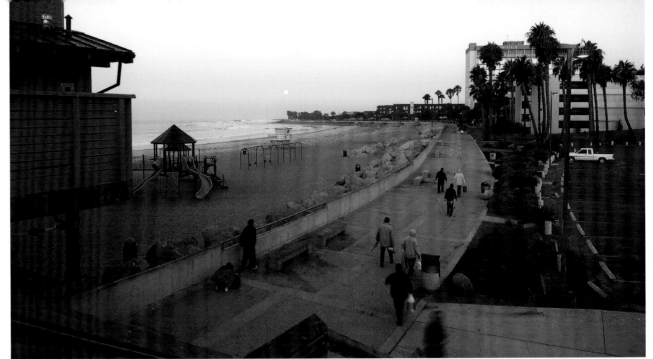
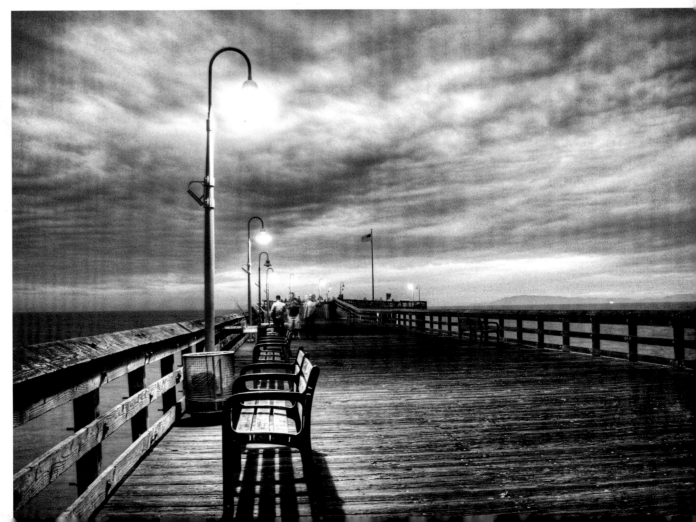

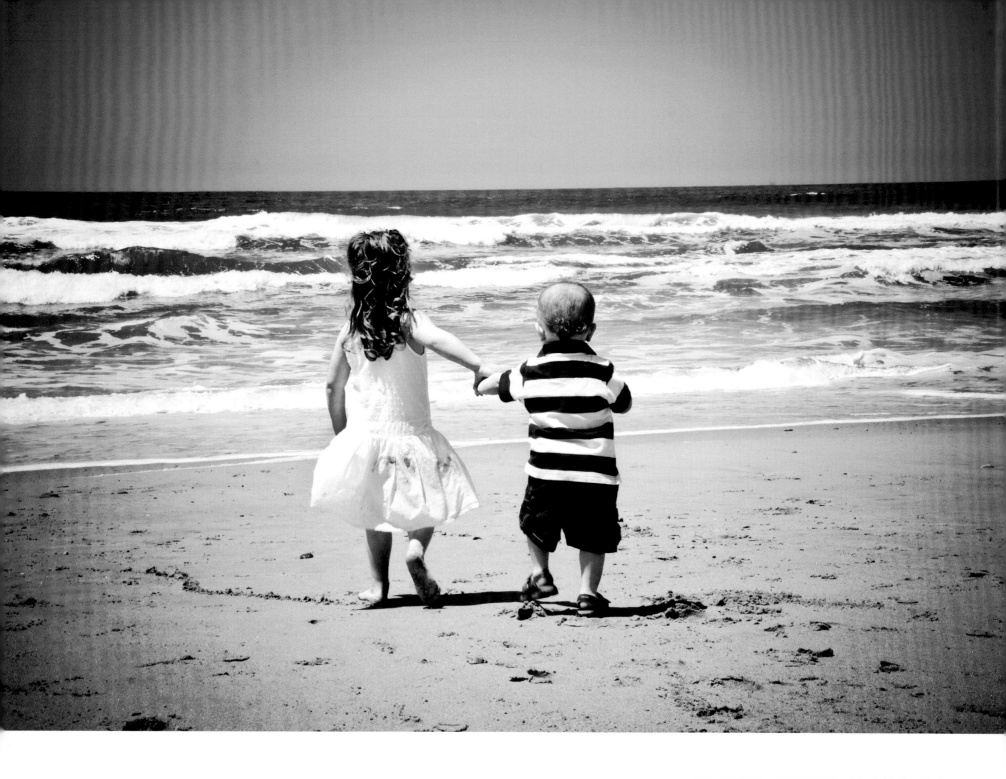

DON'T BE AFRAID, TAKE MY HAND... *(above)*: My daughter takes my son by the hand as they both meet the Pacific Ocean for the first time. We just relocated here from Cleveland, Ohio, in April 2008 and absolutely love Ventura! 📷 KRISTEN CALDWELL

Capture Ventura County was made possible by local photographers who were willing to share their talents with the rest of us. Here's a list of everyone you'll find in these pages and on the DVD. If you know any of these folks, give them a ring and say thanks for the great book! *(Photographers with Web sites on following pages.)*

S8ter 4life
Dan Adams
Alicia Adams
Jeanette Ades
Danielle Albertson
Ray Albino
Bruno Albutt
Kristi Alderson
Roy Allen
Chris Almalab
Leo Alvarez
Jane Alvarez
Shawn Amandoli
Matthew Ambriz
David Arias
Martin Armstrong
Rachel Ashley
Jana Austinson
Bev B.
Tami Bailey
Freddy Bailey
Christopher Balasa
Kevin Barber
Joseph Barr
Tracey Barrera
Cheri Barrett
Michele Barrett
Robert Bauer
Linda Beeson
Sara Bell
Elisa Bell
Dale Bennett
Ann Berg
Jean Bergenstal
Kayce Betzel
Michelle (Mikki) Bills
Gary Blum
Austin Bockelman
Lance Boepple
Francis Charles Bognar
Carol Bohlmeyer
Dion Boland
Eric Boldt
Arturo Bonifacio
Joseph Boston
Dana Rene Bowler
Kendall Bradford
Joel Brandenberg
Breslin Breslin
Carolyn Brodersen
Stephanie Brooks
Kristen Brown

Robert Burns
Denise Butler
Doug Caldwell
Maddie Caldwell
Antoinette Campbell
Nicole Campolini
Don Carey
Juan Carlo
Marlene Carvajal
Jean Castaing
Wanda Castel de Oro
Jennifer Cavola
Erica Cazares
Bobbie Cerqua
Pablo Cervantes
Richard Chaiclin
Frank Chavez
Pat Ching
Mark Chisholm
Gerry Chudleigh
Brian Chudleigh
Jan Clough
Marlene Collins
Barbara Cooney
Rudy Cooper
William Corcoran
Camilo Corpuz
Sally Cortenbach
John Cressy
Lupi Cruce
Rosa Cruz
Emily Cruz
Laura Cuevas
LeAnne Daly
Brian Dantimo
Taren Davis
Rese Davison
Armando de la Rosa
Laura De La Rosa
Carmen Delaney
John Delaney
Melissa Demyan
Elise DePuydt
Denise Dewire
Gina Diez
Faustina Dillon
Sarah Dinkler
Kathryn Donohew
Janel Dreeka
Grant Dunbar
David Dundore
Jim Eads

Sandra Ehers
Ernesto Elizarraraz
Eric Enriquez
Edward Escobedo
Stephanie Escoto
Todd Eskridge
Teri Espinosa
A Espinosa
Haley Evans
Daniela Failla
Janni Fang
Cameron Farrell
Daisy Fernandez
John Ferritto
Ron Fischer
Naydeen Fish
Julianne Fishell
Miss Fit
Earl Fitts
Sarah Flesher
John Flinders
Tony Flores
Ivonne Flores
Katie Flores
Sandra Ford
Dean Ford
Julie Foster
Sabrína Frailich
Lianne Frame
Suzy G
Shelby G
Sylvia Gabrie
Mike Gainer
Jenny Gamez
Sharon Ganser
Joseph A. Garcia
Andrew Gardner
Stephanie Gartner
Julie Gaynor
Kristine Gill
Jacques Girod
Jeni Glanzner
Marion Glennon
James Glover II
Ailene Godinez
Angela Goldstein
Matthias James Gonzales
Marilyn Gould
Colleen Graven
Jeremy Greene
Anita Griggs
Nicole Gruetzmacher

Terri Guerena
Derek Gulden
Rick Gulden
Brandy Hall
Alexandra Hamilton
Tasha Hamilton
Lisa Hammond
Timothy Hanson
Monica Harrer
Kris Hashimoto
Yanira Haven-Willars
Scott Heffelfinger
Jeremiah Hernandez
Chuck Herrera
Manuel Herrera
Ann Hildebrand
Dennis Hill
Monica Hill
Bill Hinkle
Amber Hixon
Ricardo Holden
Bob Homkes
Robert Hooper
Dan Hope
Violet Hope
Rick Horn
Steve Hunter
Mary Ingalls
Keo Jac
Darrel Jefferies
Craig Jennifer
Diane Johnston
Randy Jones
Natalie Jones
Janell Jones
Lorena Juarez
Chelsea Keating
Wayne Kelterer
Patrick Kennedy
Judd Kennedy
Melanie Kenney
Chuck Kirman
Talon Klipp
David Koszela
Mariann Kovats
Karoli Kuns
Emese Landman
Barbie Lange
Marc Langsam
Collette Lash
Lauri Laskoski
Jennifer Lawrence
Ty Lawson
Troy Lawson
Cheryl Laymon
Corrine Lee
Albert Lemus
Bob Lewis
Randall Lewis
Patricia Lincoln
Cherie Lind
Karen Quincy Loberg

Carrie Lopez
David Luff
Jodi Luker
Robert Luria
Kevn Ly
Katie Lyons
Jim MacDonald
Austin Macias
Theresa Macias
Susana Marin
Gretchen Mars
Jennifer Marshall
Rich Marshall
Erin Martin
Brandie Martin
Daniel Martinez
Trevor Mauk
Donna May
Chylene May
Lorri Mayer
Debbie Maynard
Ashley Mazzella
Crystal McAbee
Meggan McCarthy
Sinclair McCauley
Robert McCord
Patt McDaniel
Kevin McHenry
Jason Medina
Gabriel Medrano
Kim Metcalf
Doug Mew
Mary Meyer
Victor Meyer
Tara Miller
Bob Miller
Ashlee Miller
James Mills
Jeannette Minjares-Medrano
Yvonne Mitchell
Darlene Mitschke
Michael Moffatt
Nicole Mohr
Chris Moore
Mabel Mora
Ryann Moresi
Matt Morrisset
Cassie Mosman
Shawn Mulchay
Sharon Mullin
Lorlee Murray
Bob Muschitz
Jeff Muth
Kathleen Navin
Barbara Nelles
Jeff Nessen
Linda Newhard
Stephanie Newton
Cynthia Ngiratmab
Mark Nielsen
Angel Nunez
Floyd Nunez

Susan o'Brien
Susan O'Conlon
Hugh M. O'Connell, Jr
Andrea O'Reilly
Sunny Oberto
Su Oh
Linda Ordonez
Nicole Ortiz
Vanessa P
Kim Page
Gayle Parker
Christopher Parmenter
Eric Parsons
Juan Partida
Lorenzo Payan Jr
Victor Hugo Perez
Mark Perry
Michelle Petersen
Christopher Pettit
Carol Philipp
Michael Pinner
Jackson Piper
Ray Pizarro
Margaret Plaat
Suzanne Platner
Caitlin Polowchak
Keith Porter
Paul Powers
Linda Pratt
Sara Preciado
Kurt Preissler
Jim Pretorius
Garth Price
Arlene R
Phil Ranger
Christina Raymond
Jason Redmond
Cindy Redmond
Julie Reiter

Richard Reveles
Leeta Rice
Lonnie Richesin
Kelsea Richmond
Ted Rivera
Stephanie Robbins
Roland E. Roberts
Iliana Robles
Salvador Rodriguez
Bert Rollins
Henry Rollins
Roz Romero
Crystal Rough
Mo Ruz
April Ryland
Christy Saint
Sarah Nicole Saito
Rodrigo Salgado
McKenna Sandifer
Deborah Sands
Michael Sargent
Carol Sautter
Stephen Schafer
Norman Schiele
Angela Serate
Rozelle Shafer
Lucia Shaw
Sandra Sidoti
Michi Sim
Roy Sitler
Joe Skercevic
Jeff Sletten
Tiffany Smith
Janice Smith
Jaclyn Smith
Teresa Smith
Susannah Sofaer Kramer
Michelle Solomon
Ben Solomon

Tracey Somerville
Amanda Soto
Ashli Spellman
Jack Stafford
Liana Staniland
Linda Stetson
Tara Stivers
Paula Stoltman
Jim Stoltman
Nicole Straky
Kelly Swift
Katie Swinburne
Adriana Szetela
Taissa Tafoya
Gary Talbot
Roel Tamase
Travis Tarpo
Maya Teague
Alum Tekeste
Jazmin Tempske
Sandy Tenenbaum
Michael Thanhouser
Chuck Thomas
Wendell Thompson
Terry Timmons
Margaret Tobin
Bren Tomaszewski
Therese Tomlinson Hostetter
Mae Tong
Leslie Tong
Jessica Trainor
Amy Tripp
Anna Tuitama
Norma Turner
Heather Ulilang
Kat Valdez
Clasina Valkenberg
Rob Varela
Peter Vasko

Thomas Vasko
Paul Vasquez
Noel Verdin
Sonia Villegas
Candace Wakefield
Charlotte Wakenhut
Donald Wallace
Carol Wan
Howard Wang
Sarah Watson
Emily Weatherford
Terry Weaver
Sam Webster
David Wender
Robert Wetterau
Monica White
Ken White
Dwight Williams
Lena Williamson
Ron Wilson
Jay Windsor
Daniel Winter
Beverly Wood
Wendy Worman
Robert Wright
Michael Yeaman
Larry Yee
Elizabeth Zuber

If you like what you see in the book and on the companion DVD, be sure to check out these photographers' Web sites. A few even sell prints so you may be able to snag your favorite photos from the project to hang on your wall.

Daniel Agredano
danielagredano.com

Chris Allen
Allen-Photos.com

Tom Baker
tombakerphoto.com

Zach Barker
alliancephotoz.com

Glenn Baylen
flickr.com/photos/28039829@N08/show

Steve Bright
sail-with-me.com

Doug Brucher
DOUGBRUCHER.COM

Kristen Caldwell
kristencaldwellphotography.com

Scott Calvert
badgerpixx.com

Tony Carino
flickr.com/photos/tony_carino

Amery Carlson
amerycarlson.com

Donald Cecil
flickr.com/photos/bullcecil

Deborah Cockrell
Deborah4RealEstate.com

Lee Corkett
weathervaneimages.com

Johnny Corona
myspace.com/jcorona91

Juli Cromer
jcromer.com

Christopher Cuttriss
blog.Studio386.com

Stanya Deibert
imagesbystanya.net

Sharon Demele
myspace.com/photo47color

Eileen Descallar
photography.edgunlimited.com

Terrance Dobrosky
eternallyyoursphotography.com

Richard Duncan
richardsphotographs.com

Desiree East
snapshotsbydes.smugmug.com

Kristine Ellison
KEllisonPhotoArt.com

Deborah Flowers
westcoastexposure.org

Chrissy Furness
trademarkmammoth.com

Thomas Gapen
tresgatos.net/visualkaos

Stephanie Gill
TinyTotSnapshotPhotography.com

Shad Giordano
flickr.com/shadinsb

Josh Grant
jodag.net

Tzvia Guernsey
dawntoduskimages.com

Nicole Guernsey
myspace.com/victimtogravity

Devon Haberstich
devdevie.deviantart.com

Kirsty Hadjes
littlepumpkinsphotography.com

cindy Lea Hall
cindyleahall.com

Whitney Hartmann
whitneyhartmann.com

Thomas Hartmann
whereisthomas.blogspot.com

Mike Hayward
mikehaywardphotography.com

Staci Hendershot
stacihendershot.com

Rob Herr
robherr.com

Megan Hook
meganhookphotography.com

Laura Horton
myspace.com/anasaziminion

Ed Jesalva
flickr.com/photos/psycho29890

Kent Kanouse
flickr.com/photos/kkanouse

Robin Kanouse
flickr.com/photos/15327252@N00

Beau Kelsey
beaukelsey.com

Andy King
normlife.com

Melissa Kuns
flickr.com/photos/shutterberry

Benjamin Kuo
flickr.com/photos/12103981@N03

Kathy LaForce
Oakcreekprintworks.com

Paul Lamar
linkedin.com/in/paullamar

Ray Laser
firstratereverse.com

Henrik Lehnerer
photo.hlehnerer.com

Andrew Livingston
artsington.com

Anthony Lombardi
liquidpix.com

Leigh Lopez
leighsphotos.com

Ron Luker
11geeks.com

Jeff M
VisionsByJeff.com

Patricia Marroquin
patriciapix.com

Shane Martin
safet-tec.com

Teahni McCoy
flickr.com/people/teahni

Kelly McGraw
flickr.com/photos/20888990@N07

Bruce McLean
venturacountystar.com

Charles McPadden
charlesmcpadden.com

Brian McStotts
flickr.com/photos/mcshots/sets

Lara Mercer
flickr.com/photos/laram777

Amy Mew
flickr.com/photos/mewtate

Laura Milner
lauramilner.com

John Mueller
johnbmueller.com

Karyn Newbill
karynn.smugmug.com

John Nichols
sespe.wordpress.com

Thomas O'Mara
teoinnovations.com

David Orias
pbase.com/sbdigitalimages

Cindy Pitou Burton
ojaistudioartists.com/cindy_pitou_burton/index.html

Darrel Priebe
DazzlingPhotography.com

Keith Pytlinski
m5photography.com

Nancy Raymond
buenaventuragallery.org

Jessica Reinhardt
JessicaReinhardt.com

Ashley Rios
profile.myspace.com/index.cfm?fuseaction=user.
viewprofile&friendid=50569780

David Rivas
rivasart.com

Randy Robertson
flickr.com/photos/randysonofrobert

Miles Robertson
flickr.com/photos/micros101

Bill Robinson
bzus.com

Miguel Rodriguez
INVOKINGTHEMUSE.com

Aleta Rodriguez
flickr.com/photos/wanderingnome

Amber Rodriguez
myspace.com/kohakushadow

Chris Rodriguez
deep-down-productions.com

Christie Ryan
christie-ryan.com

Mateo Salas
inspirebethyname.blogspot.com

Kathryn Salmon
kactuskandids.com

Lyndy Scofield
flickr.com/photos/lyndylou

DeAnna Scott
venturascotts.net

Dean Sergi
DINOSERGI.COM

Kris Sheppard
krissheppard.com

Larry Spoerlein
vcrides.com

Holly Steen
cakesandkisses.com

Terry Straehley
photos.strassoc.com

Gordon Swanson
shadowsandlightimages.com

William Tasca
myspace.com/willytango

Wendell Thompson
home.roadrunner.com/~buddy75

Jorge Tovar
greenmoonphotography.com

Don Treadwell
dontreadwell.homestead.com/musings.html

Al Ungar
auphotography.blogspot.com

Andrew Uvari
flickr.com/photos/uvariphotography

Daniel Valdivia
valdivious.deviantart.com/gallery

Jared Varonin
ccwphoto.com

Joe Virnig
VenturaCountyVistas.com

Grant Volk
grantvolk.com

Connie Wade
ticopuppy.com

Wendell Ward
flickr.com/photos/intherough

Jennifer Weak
masonspals.bravehost.com

Sylvia Wells
betterphoto.com?sylvia

Steve White
stevepix.zneudar.com/main.php

Larry White
fotobud.smugmug.com

Garry Wilmeth
venturabuccaneers.com

Brenton Woodruff
betterphoto.com?brentonwoodruff

Thomas Wotkyns
aperture101.com

David Yamamoto
dkyphoto.com

Prize Winners

When picking from nearly 10,000 photos, it's difficult to nail down what separates the best photos from the rest — especially when so many photos are so good. To help, we enlisted thousands of local folks to vote for their favorite shots. The response was epic: almost 500,000 votes were cast. The voting helped shape what would eventually be published in this book. Please note, Ventura County Star photographers were not eligible for prizes. Along the way, the votes produced the prize winners below. Beyond the obvious and self-explanatory prize categories (Editors' Choice, People's Choice and Most Loves), there are a few we ought to explain:

Consensus Best: This is a combination of the voters' will and our editors' will, so it was a well-balanced and prestigious award. A complicated algorithm determined a photo's score. This award took the photos the algorithm deemed great and pushed them to the top of the pile. Then our editors picked their favorite of that batch. In essence, it's the best of the best.

Secret Surprise: Every contest needs a wild card. This is ours. We'd tell you what the parameters were, but we didn't know ourselves. At some point a photo jumped out as the obvious Secret Surprise winner, and boom! A winner. Obviously, it's gotta be good, but other than that... no real parameters.

The Stable One: This award goes to the photo that stays near the top of the pile for the duration of the contest. It may never be the photo with the most "dig it" votes, or the most loves, or the best score, but it's a photo that has stuck around near the top for a long time.

Ninth Best: This award goes to the photo that garnered the ninth most "dig it" votes in a chapter. Why ninth place? We've all seen the first-place, blue, fancy-pants ribbon, and the second-place one, and third, and fourth, and so on. We've even seen an eighth-place ribbon. But we've never seen a ninth-place ribbon. Have you? We think it's time ninth place got some recognition..

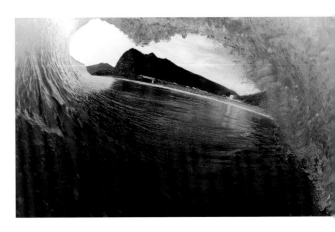

GRAND PRIZE WINNER
PHOTO BY CHRIS ALLEN
page 74

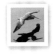

Sponsors

The Barber Automotive Group dates back to late 1960 when R.E. Barber purchased Ventura Ford, then located on the corner of Main Street and Ventura Avenue. It moved to 3440 E. Main Street in 1963. Larry Meister joined the firm as general manager and partner in 1968.

There have been many franchises associated with Barber Automotive Group. Today there is Barber Ford at 3440 E. Main Street, Barber VW and Barber RV at 3650 E. Main Street, Barber Subaru at 1969 E. Thompson, Barber Transportation at 2465 E. Thompson and the Barber Body Shop at 3680 Market Street.

In 1980, R.E. Barber passed away leaving Larry Meister as President and Owner. When Larry passed away in 2005, his wife, Barbara took over the reins of the company. Everyone who has worked within the Barber Auto Group has become a part of the Barber family, each contributing their unique skills and experience to make Barber Auto Group what it is today.

The Barber Auto Group is proud of its unequalled standard of excellence. Each franchise consistently earns the highest awards available confirming that Barber Auto Group is the best at what they do. Barber Automotive Group is proud to serve the community and Ventura County.

www.barberonline.com

Cypress Place is a beautiful senior living campus featuring an Active Senior Living community and adjacent Assisted Living and Alzheimer's/Dementia Care community.

ACTIVE SENIOR LIVING
In addition to well-appointed apartments, spacious common areas and gracious dining room, residents at Cypress Place Active Senior Living enjoy the ease of a pampered lifestyle. An independent, senior lifestyle allows plenty of leisure time to enjoy the good things in life.

ASSISTED LIVING AND ALZHEIMER'S/DEMENTIA CARE
Cypress Place Assisted Living is a special place to live. Apartment choices include studio, one-bedroom and two-bedroom options. Cypress Place features welcoming common areas filled with activity and friendly neighbors for an enriching lifestyle.

www.CypressPlaceSeniorLiving.com

HOOPER CAMERA & IMAGING

Hooper Camera is a family owned specialty store that has been in business for over 62 years, beginning with its original store in North Hollywood, California. Although the original store no longer exists, Hooper Camera has grown to include locations in Chatsworth, Woodland Hills, Sherman Oaks and Newbury Park. Hooper prides itself in offering to its clients the greatest selection of camera equipment and supplies, as well as custom photofinishing services though its own photo lab. Quality, knowledgeable service and discount everyday prices continue to keep Hooper Camera at the top of its field.

2093-D Newbury Rd., Newbury Park, CA
(805) 499-2500

21902 Devonshire St., Chatsworth, CA
(818) 709-0014

Samy's Camera

Samy's Camera boasts the largest selection of new and used photographic equipment on the West Coast. Sales and services include cameras, Hi-Definition TVs, video cameras, Apple computers, iPods, accessories, and more.

Samy's features Santa Barbara's only on-site, full-service digital lab that provides custom scanning, printing, and various mounting services.

We also offer a free camera class with any camera purchase! Bring in your older camera to any of Samy's five locations and trade it in for the latest gear. Our knowledgeable and friendly staff will guide you and take great care of you.

614 Chapala Street, Santa Barbara CA 93101
(805) 963-7269 • infosb@samys.com